Telling the Design Story
Effective and Engaging Communication

When presenting projects in competitive design environments, how you say something is as important as what you're actually saying. Projects are increasingly complex; designers are working from more sources and can struggle with how to harness this information and craft a meaningful and engaging story from it.

Telling the Design Story: Effective and Engaging Communication teaches designers how to craft cohesive and innovative presentations through storytelling. From the various stages of the creative process to the nuts and bolts of writing and speaking for impact, to creating visuals, Amy Huber provides a comprehensive approach for designers creating presentations for clients. Including chapter-by-chapter exercises, project briefs, and useful guides, this is an essential resource for students and practicing designers alike.

Amy M. Huber is an Assistant Professor at Florida State University, teaching in areas of Advanced Computer Applications, Advanced Visual Communications, and Design Studios. She has presented on the topic of Design Communications at both national and international conferences, and her research has been published in the Journal of Interior Design and the International Journal of Architectural Research. Previously, Huber was a Senior Designer with Gensler in Denver. There, she played an instrumental role in projects that have been recognized on state and national venues, including a 2014 AIA National Merit Award. She has interviewed for projects and presented ideas in settings ranging from elevators to auditoriums.

First published 2018
by Routledge
711 Third Avenue, New York, NY 10017

and by Routledge
2 Park Square, Milton Park, Abingdon, Oxon OX14 4RN

Routledge is an imprint of the Taylor & Francis Group, an informa business

© 2018 Taylor & Francis

The right of Amy M. Huber to be identified as the author of this work has been asserted by her in accordance with sections 77 and 78 of the Copyright, Designs and Patents Act 1988.

All rights reserved. No part of this book may be reprinted or reproduced or utilised in any form or by any electronic, mechanical, or other means, now known or hereafter invented, including photocopying and recording, or in any information storage or retrieval system, without permission in writing from the publishers.

Trademark notice: Product or corporate names may be trademarks or registered trademarks, and are used only for identification and explanation without intent to infringe.

Library of Congress Cataloging in Publication Data

ISBN: 978-0-415-78553-2 (hbk)
ISBN: 978-0-415-78554-9 (pbk)
ISBN: 978-1-315-22613-2 (ebk)

Publisher's Note:
This book has been prepared from camera-ready copy provided by the author.

Telling the Design Story
Effective and Engaging Communication

Amy M. Huber

NEW YORK AND LONDON

TABLE OF CONTENTS

ACKNOWLEDGMENTS ix
PREFACE xi

PART 1: STORYTELLING IN DESIGN: A PRIMER

1 HUMAN RESPONSE TO STORY 3
 Introduction
 Why Does Story Matter in Design?
 The Science Behind Why We Like Stories
 Stories in Building Social Connections
 Stories for Organizing Information
 Story as Moral Guidepost
 Elements of Story
 Everyone Has a Story

2 PRESENTER MEET AUDIENCE 19
 Introduction
 Overview of the Creative Process
 Why Are You Presenting?
 Who Are You Presenting to?
 What Are Your Goals for the Audience?
 How Are You Presenting?
 What Is Your Message?

3 STORY DESIGN 33
 Introduction
 Returning to the Creative Process
 Design Presentation Areas of Focus
 Point of View
 Project
 Pitch
 Honing the Message
 Designing the Story
 Editing Your Story
 "S"tory Development
 Storyboard
 Aiding Recall

PART 2: MODES OF COMMUNICATION

4 WRITING FOR IMPACT 57
Introduction
Why Does Writing Matter in Design?
Elements of Good Writing
Words
Sentences
Paragraphs
Venues for Design Writing
Mechanics of Writing
Punctuation
Ideas for Writing
Editing & Rewriting
Things to Avoid

5 SPEAKING FOR IMPACT 75
Introduction
The Evolution of Speaking
The Goal of Your Presentation
Persuasion
Getting Started
Align Yourself With Your Audience
Align Your Message to Your Audience
Align Your Delivery Tools to Your Audience
Presentation Stages
Align Your Delivery to Your Message
Align Your Delivery Style to Your Message
Align Your Body to Your Message
Finding Your Confidence
Coping Strategies
Realign Yourself to Your Audience
Special Presentation Types

6 VISUAL STORYTELLING 101
Introduction
Is a Picture Worth a Thousand Words?
Attraction & Persuasion
Recall & Comprehension
Visual Thinking Strategies
Organizing Graphic Real Estate
Typology
Color
Bringing it All Together
Establishing a Brand Identity

7 STORYTELLING WITH INFORMATION 131
Introduction
The Significance of Information Delivery
How We Approach & Convey Information
Representation Tactics in Design Analysis
Diagram Considerations
Diagram Annotation Strategies
Diagram Creation Strategies
Testing Diagrams

8 STORYTELLING WITH IDEAS — 149
Introduction
Expressing Ideas
Design Outcomes Diagrams
Conceptual Imagery
Orthographic Drawings
Modeling
Three-Dimensional Drawings
Rendering
Four-Dimensional Depictions

9 STORYTELLING WITH VIDEO — 169
Introduction
The Role of Video in Design
Work Flow of Video Production
Pre-production
Production
Post-production

APPENDIX A — 203
Photography Terms

APPENDIX B — 204
Additional Diagrams

APPENDIX C — 205
Image File Types

APPENDIX D — 206
Video File Types

APPENDIX E — 207
Audio File Types

APPENDIX F — 208
Good Reads on Story Crafting & Delivery

APPENDIX G — 209
Good Reads on Information Design

APPENDIX H — 210
Good Reads on Story Props & Visual Messages

APPENDIX I — 212
Good Reads on Design Process & Focus

APPENDIX J — 213
Advanced Topics

APPENDIX K — 214
Storytelling Resources

APPENDIX L — 215
Events & Festivals

GLOSSARY — 217

ABOUT THE AUTHOR — 225

REFERENCES — 227

IMAGE CREDITS — 235

INDEX — 237

ACKNOWLEDGMENTS

The path leading to this book has been marked by a great many characters who have encouraged, provoked, and prompted me to do so much more than I ever imagined. To them, I am forever indebted.

To my colleagues at Florida State University, it's a pleasure to work amongst a constellation of such stars. Your quest to provide the world with the most passionate and thoughtful designers never ceases to amaze me. A special thank you to my chair Lisa Waxman, Ph.D., and Jill Pable, Ph.D., who have brought special encouragement and insight into this book.

Thank you to those who have moved this book forward through its many iterations. I am eternally grateful to my copy editor, Nancy Deyo, and to my contributors, who have added thoughtful insight and diverse perspectives, Annette Tully, Ron Honn, Eric Ibsen and Janet Pogue McClaurin, the last of whom deserves my eternal gratitude for taking a chance on me in the first place. I am also very grateful for those who have shared their work and images, Christine Titus, Anna Osborne, and Emily Swerdloff. Without the Routledge team of Judith Newlin, Amy Kirkham, Mhairi Bennett, and William Burch, this book would not be possible.

To my current and former students, you give me purpose. It's an honor to work with such amazing talent, who are fearless in tackling the world's challenges. I hope in some small way this book will contribute to your future success.

Finally to my family, Ken, Sandy, Todd, and Ethan, who have encouraged me every step along the way, showing me that anything is possible.

PREFACE

How we say something is nearly as important as **what** we're saying.

We don't just crave stories; we crave the way they make us feel. A single story can have the power to evoke laughter, tears, fear, anger, or a myriad of other emotions. Storytellers can encourage us to act in newfound ways, and believe in newfound things.

Today, our projects are increasingly complex, and as designers, we need to amass more information than ever to provide thoughtful ideas and solutions. Yet, despite our preparation, we may fail to articulate our knowledge and ideas in a way that compels our audiences toward action.

My years of practice and teaching have imparted on me the power of storytelling. Being able to understand your client, garner their attention, and leave them with a message that is clear, purposeful, and inspiring has never been more critical.

This book's aim is to demystify the elements of story, to help readers define their audience's characters, and provide useful frameworks and strategies to craft their own stories using written, verbal, visual, and video messages. Essentially, it's the resource I wish I had going into practice.

Amy

Part 1 Storytelling in Design: A Primer

While designers are undoubtedly familiar with stories, they probably haven't conceptualized the significance and potential of story in design practice. This part will introduce the concept of story, why it matters, and how it can be leveraged throughout the design process.

Ch 1 Human Response to Story

We begin by exploring the topic of storytelling, offering a brief history of the evolution of storytelling and our responses to stories, including their potential to foster social connections, aid our capacity to organize information and help us recall that information, as well as which story elements prompt these responses.

Ch 2 Presenter Meet Audience

The real "stars" of a design story are the audience. To sway these individuals, this chapter will challenge readers to question their presentation goals and then introduce strategies to help them connect with their audience.

Ch 3 Story Design

This chapter introduces the notion of both "stories" and "S"tories. All good presentations are "stories" and this chapter discusses how to generate story ideas involving the readers' point of view, their projects, or project pitches. "S"tories are the tangible representations that make ideas come to life, and the chapter closes by summarizing how to integrate these "Stories" into a design presentation.

Part 2 Modes of Communication

Even the best of stories can fall flat given ineffective communication. The second part of the book helps readers find their voice through written, verbal, visual, and video communication tactics.

Ch 4 Writing for Impact
The written word is a critical but often underappreciated tool in the designer's toolkit. This chapter explores the significance of writing in design and readers will learn how to succinctly and potently distill their messages using the written word.

Ch 5 Speaking for Impact
Some are adept at public speaking, while others avoid it at all costs. This chapter will help readers effectively present information and ideas using oratory tools such as inflection, cadence, non-verbal gestures, and audience activity.

Ch 6 Visual Storytelling
While many designers are savvy at creating visuals, they may struggle with how to fold visual messages into a design story. This chapter will summarize the basic mechanics of visual communication so that visuals support rather than distract from the message at hand.

Ch 7 Storytelling with Information
Designers are frequently asked to define project parameters from a wide array of inputs. This chapter focuses on how to tell the story of design analysis by applying information design strategies.

Ch 8 Storytelling with Ideas
Ideas are a designer's livelihood. This chapter will identify strategies to tell the story of an idea using visual messages including drawings, models, and mixed reality depictions and how these "props" can be woven into a design story.

Ch 9 Storytelling with Video
Videos are being viewed, shared, and generated like never before. However, creating an engaging video is no small undertaking. This chapter explores the appropriate use of video, the typical flow of work involved in video production, and how to conceptualize and create a design story when timing is critical.

To Ethan,
The most passionate storyteller I know.

Part 1 Storytelling in Design:
A Primer

Defining our stories.

OBJECTIVES

- Conceptualize the potential of story within design practice
- Understand how stories influence an audience
- Understand the basic elements of story
- Consider the role of story in your presentation

HUMAN RESPONSE TO STORY

This chapter will focus on why we like stories and provide a storytelling primer.

Olivia could sense the growing antipathy with each passing word. "Our firm is so well-equipped to handle the design of your library," she thought to herself. And she had good reason to; the numbers were good; they had compiled a qualified team and created a detailed action plan. They had even received several accolades for a similar project. When discussing these merits, however, she saw the board of trustees looking at their phones; some were even whispering to each other. So, she paused, and said, "Let me give you an example." As she told her story, she could see several of the board members put down their phones, lean in, and start to listen more intently.

Her story had changed the entire mood of the room.

INTRODUCTION

Campfires, water coolers, dinner tables – storytelling occurs in many places and across many cultures. From Aesop's Fables to the Trojan Horse, the most enduring stories are handed down from one generation to the next. In fact, many of today's films are rooted in classic works. Skywalker's triumph over the evil Darth Vader is likened to the hero's journey of ancient Greek mythology. Bridget Jones' endearing quest for love is a modern telling of Jane Austen's *Pride and Prejudice*. Stories can be a potent delivery tool; some even argue that they are the most powerful and enduring art form.[1]

Whether to a client, teacher, or supervisor, a designer's role is often to convince another party that they hold the key to the best possible solution. So, whether we like it or not, design is steeped in the art of salesmanship – and stories can help "seal the deal."

WHY DOES STORY MATTER IN DESIGN?

To paraphrase marketing expert Jonah Sachs, the capacity to spark change and provide inspiring solutions stems from our ability to provide great stories.[2] With more ways to *reach* an audience, it can actually be harder to *move* them. The best storytellers can use their craft to cut through the distractions of everyday life. Their stories act as an **affective primer,** steering the emotions of their audience toward the desired course of action.

As designers of products, spaces, and experiences, we too can use the art of storytelling to shape the emotions of our audience prior to sharing our ideas. If we want to empower our client to take a radical new approach, we can share a story that calls them to action. If we want our clients to be dissuaded from making a bad decision, a story highlighting another company's similar missteps can be a very powerful deterrent.

Stories can serve as a moral guidepost or as a quick and vivid means of sharing information, selling lifestyles, sparking change, or inspiring others.[3] But to harness their power, we need to understand their potential in design communication.

> **Master storytellers use their craft to convince their audiences of their own world-view.**

DESIGN COMMUNICATION TACTICS

Since designers are called to both inform and persuade their audiences, many parallels can be drawn between design communication tactics and contemporary marketing strategies. The best marketing campaigns are thought to contain three ingredients: Meaning, Explanation, and Story.[4] These ingredients help ensure that a message is relevant, understood, and captivating.

Consider these ingredients in the design communication tactics below:

	Report	Presentation	Video
Goals	Notify or Update	Simplify, Clarify, or Illuminate	Illuminate or Entertain
Delivery	Precise & Exhaustive	Believable & Credible	Express & Introduce
Results	Informed Audience	Motivated Audience	Moved Audience
Example	Case Study	Design Presentation	Online video

THE SCIENCE BEHIND WHY WE LIKE STORIES

Stories are often considered essential to the human experience. In fact, storyteller Kendall Haven refers to our species as *Homo narratus*.[5] There are several theories as to why we are so drawn to stories.[6]

The first theory is that stories are simply a byproduct of human existence. Supporters of this premise suggest that our brains are not designed to enjoy stories, but that they are susceptible to being seduced by them. The second theory is that our attraction to stories has been ingrained in our DNA via chance evolutionary adaptations. The third theory suggests that stories were a survival tool.[7] This final proposition may be surprising since stories do not outwardly seem to satisfy the fundamental needs of our hunter-gatherer ancestors (e.g., food, water, & procreation), although cave paintings suggest that our ancient ancestors used stories to recount life-altering experiences. A story about an epic hunting adventure, for example, provided lessons about which animals would make for a good dinner (and maybe even which would want them for dinner). At the same time, the storyteller likely appeared more attractive by showcasing the skills and qualities that would make for an ideal mate.

THE EVOLUTION OF STORY

Over time, stories became more complex, in turn, serving more purposes. As our societies advanced (and our survival became more secure), our stories no longer had to be grounded in facts. Our ancestors grew to love the intense drama and suspense made possible only by fictionalized stories. These stories provided entertainment and a release from the trials and tribulations of war, plague, and famine. However, even amidst the comforts of modern life, we continue to enjoy such escapes.

In fact, researchers Tooby and Cosmides asserted that our brains have a built-in reward system that attracts us to fictional experiences, even when we wouldn't enjoy an obvious payoff.[8] This may explain why, on a rainy Saturday afternoon, we may prefer to binge-watch our favorite show instead of reworking our portfolio.

However, evidence suggests that stories are more than merely tools of distraction, and research has provided some valuable insights surrounding how stories help us form social connections, organize information, and even learn right from wrong.

Figure 1.0
Stories help us form social connections, organize information, & learn right from wrong

STORIES IN BUILDING SOCIAL CONNECTIONS

We are social creatures. Belonging to something bigger than ourselves gives us purpose, and affiliation brings us comfort. Our social yearnings influence how we spend our time. We live, work, and play beside each other in families, organizations, and communities. In fact, studies have suggested that we spend 80% of our waking hours alongside other people.[9] Much of this time is spent in conversation and it is estimated that we spend 6 –12 hours of each day engaged in dialogue.[10] We might assume that most of these conversations focus on goal-oriented matters such as career aspirations or finances but, when studied, the content of most conversations was centered on either ourselves or specific individuals – even in professional settings like university classrooms and corporate lunches.[11] We don't discuss business proposals or learning objectives; we discuss ourselves and each other – that is to say, we gossip.

GOSSIP

While our mothers may have warned us about the dangers of gossip, they also taught us to look after each other. In a sign of fellowship, our primate cousins spend much of their day performing acts of social grooming. In other words, to show affection, they clean their friends and family. While we humans have similar goals for expressing solidity and social order, gossip frees up our hands to perform other tasks.[12]

Gossip has a bad reputation, but not all of it is bad. Researchers have suggested that gossip serves several purposes, allowing us to seek and share information,[13] express opinions, obtain guidance, define social norms, and satisfy our desire to belong.[14] In these intimate exchanges, there can be benefits for both parties. Those listening may gain newfound insight, while the teller might benefit from added stature or reciprocity. Essentially, since you shared something with me, I'll return the favor.[15]

Gossip has worked so well for our species that it is considered universal across cultures.[16] Whether our gossip sessions stem from factual or fictional accounts (or somewhere in between), gossip is a form of storytelling, complete with characters, conflict, and intrigue.
Psychologist Jonathan Haidt said that without gossip. . . "there would be chaos and ignorance."[17]

Gossip is a form of intimate storytelling that we use to share information and connect with others.

FICTIONAL STORIES

Gossiping about a co-worker is not the only way story shapes our social interactions. Since fictional stories simulate social experiences, evidence suggests that they also shape how we interact with others. When researchers compared both the emotional states and personality traits of individuals who read either a story-based or factual account about the same information, readers of the story version experienced significantly greater changes in their personality traits.[18] Since stories often contain vivid descriptions of a character's mental state, they are thought to improve our social awareness too.[19] Researchers found that fiction readers have greater sense of empathy,[20,21] and were more attuned to the intentions and opinions of others.[22]

STORIES FOR ORGANIZING INFORMATION

Along with building social connections, our brains have an innate desire to organize information, and stories can help us link information into a series of events, then align those events with our own experience.

LINKING EVENTS WITH A STORY

Our mothers may have also warned us about the consequences of making assumptions, and for a good reason, since our assumptions can often be wrong. To avoid accepting incorrect ideas, our brains seek to categorize these ideas into causes and corresponding effects; this is known as **causal reasoning**.[23] Stories can aid causal reasoning by helping the audience link a series of events rather than wrestle with disconnected anecdotes.[24] Author Lisa Cron explained cause and effect with the mantra of *If, Then,* and *Therefore*.[25]

> *If* there is an action,
> *then* another event will follow;
> *therefore,* we should either embark upon or avoid it.

As an example. . . *if* we work on our portfolio, *then* we might land the job; *therefore,* we should work on our portfolio.

> Stories help audiences to more seamlessly connect the If, Then, and Therefore lines of reasoning.

LIFE LESSONS WITH *IF, THEN,* AND *THEREFORE*

Let's say your 7-year-old niece cannot be convinced that she was wrong to poke fun at a friend's outfit, choosing instead to project the blame on the classmate for making what she calls "a ghastly decision." Being a good auntie or uncle, you are hoping to share with her the ill effects of vanity.

To do so, you could outline the relationship between vanity and narcissism, suggest how vanity might damage her friendships, or advise her that her comments might hurt her reputation. While such insights are rational and valid, your niece is not likely to be moved by them, much less pass down these anecdotes to her own children.

Another option would be a thoughtful retelling of Hans Christian Andersen's fable, "The Emperor's New Clothes," wherein the emperor's vanity kept him from admitting that he could not see the weaver's magical thread. The effect was that he unwittingly paraded down the streets of his kingdom, completely naked,
– her lesson, admit when you are wrong.

Figure 1.1
Stories shape how we interact with others

LINKING A STORY'S EVENTS TO OUR OWN EXPERIENCE

Another way our brains attempt to understand new information is to align it with our own experiences,[26] and stories have an uncanny way to help us do so. In a good story, when the main character is scared, we're scared, when they're triumphant, we too bask in their glory. Essentially, we share their emotions.

Our emotions are due to a chain of reactions set off in our brain. Dopamine causes our brains to anticipate the new experiences offered in the story.[27] Brain scans have shown that when the characters embark on these new experiences, various regions of the brain track different aspects of the story. Some of these areas actually mirror those that would be used by the characters themselves during the story's unfolding events; this is why we feel embarrassed when a character has an awkward conversation. We construct visual and motor representations that essentially mimic the story's events as if we are going through them ourselves.[28] This causes our brains to produce the stress hormone cortisol when our hero is struggling,[29] and oxytocin when a stranger offers kindness.[30] If the main character is pursuing a goal, even more regions of our brain are engaged.[31] Not only can we experience our hero's struggles and triumphs, but we can use them as a guide should we encounter a similar situation.

Figure 1.2
Stories can help us link events together & to our own experiences

ORGANIZATION OPPORTUNITY

To leverage the brain's naturally occurring chain of chemical reactions, designers can craft a story that helps their audience link events. For example, instead of discussing the merits of a floor plan, they can share a story about the experience one may have as they enter and move throughout the space. The designer weaves a story about the character's journey, highlighting design features along the way. The audience can then link the spaces in their minds and use causal reasoning to envision how others might use those spaces. In their minds, *if* the space is designed this way, *then* building occupants might be able to experience it in this manner; *therefore,* this is the best design. They might even align the story with a positive event in their own lives – the effect can be quite potent.

EXERCISE 1.0 USING STORY TO LINK EVENTS

Putting your linking skills to the test.

Look around the space you're currently in until you see three words.

Write a paragraph-long short story that links these three words together.

STORY AS MORAL GUIDEPOST

"Human beings share stories to remind each other of who they are and how they should act."[32]

Part **policeman** and part **teacher,** was how Haidt characterized the role of story in our society,[33] meaning that stories represent a society's values, along with the consequences of ignoring those values. And while we may no longer be asked to state the moral of a story, the reality is that whether they teach us to care for one another or warn us of the ills facing our society, almost all stories present us with a takeaway.

Many story morals are threaded into our everyday values. We shy away from giving false alarms for fear of *crying wolf.* Aesop taught us to value quality over quantity in the "Lioness and the Vixen," and not to count our chickens before they hatch in the "Milkmaid and her Pail." Greek mythology reminds us of our own vulnerabilities, or our *Achilles heel,* and even to be cautious of suspicious emails for fear of opening a *Trojan horse.* Such stories have been gifted to us so that we might know what would befall us if we were to follow a similar path. They prompt us to recall past experiences and what was learned from those experiences so that we can predict how others will react when facing them too.[34] The best part is that we can simulate these experiences without having to actually go through them ourselves, much less the aftermath. We don't have to be the naked emperor to learn from his missteps.

> Stories ask us to recall past experiences & what we learned from those experiences.

INFLUENCING OUR BELIEFS

Evidence suggests that stories can also influence how we behave.[35] If we identify with a character, we may be more likely to embody their positive attributes. And these changes are thought to be relatively stable, meaning they do not change right after the story is over. In fact, researchers suggest that beliefs changed as a result of a story may even grow stronger over time.[36] This insight led researchers to suggest that a story's ability to psychologically transport an audience is a "powerful means of altering our view of the world."[37]

Listening to the stories of others is not the only way they frame our values. By generating our own stories, we can describe our experiences, and in turn, better understand ourselves. Mental health professionals have long used this tactic when treating their patients. In fact, psychiatrist and author Bradley Lewis wrote that "psychiatrists listen to stories more than anything else they do."[38] So, when we gossip about a coworker, not only are we attempting to bond with colleagues, but the act itself can be cathartic.

Within design, stories can be used as a call to action or to justify ideals. For example, if a designer wants to defend a price increase following a voluntary pay raise for their apparel workers, they might tell a story about a young employee who can more easily provide for her family given the higher living wage. The key is to be authentic. If the same designer was to tell this story, but only to conceal their own self-serving goals, their message will likely fall flat. It will be delivered with less passion, conviction, and zeal. Worse yet, in time, they will likely be called out on their deception – especially given the access to information and the hyper-connectedness made possible with social media. Sachs defined these truth detectives as *agents of authenticity,*[39] stating that once an agent of authenticity uncovers a fabrication, they share it with others, thus destroying the teller's credibility. Stories only work if they are genuine.

ELEMENTS OF STORY

To understand why stories help the audience to connect with each other, organize information, and learn right from wrong, it's worth exploring the elements of story. Sachs likened the structure of a story to that of a baseball, the surface of which holds the story's visible elements, such as its setting and characters.[40] Under this layer lie its morals, which provide the story's structure and relevance. Finally, within its core, rests the values that inform it all.

We will begin our exploration at the core of the story.

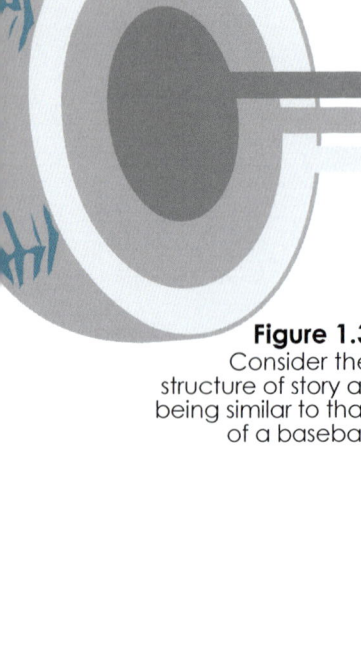

values central message
morals story structure & relevance
visible elements story setting & characters

Figure 1.3
Consider the structure of story as being similar to that of a baseball

VALUES

Values are central to a good story, but they can be easily misplaced and misconstrued in the commercials, advertisements, slogans, and political messages that surround us. These too are persuasive stories, and Sachs surmises they follow one of two aims: making the audience feel either inadequate or empowered.[41]

INADEQUACY MARKETING

Sachs attributed inadequacy marketing to Freudian drives of materialism and lust. Stories based in these values exploit a person's anxieties by stressing their shortcomings. The only cure, of course, is the product or idea that they happen to be touting. For example, wearing label "X" will help the struggling professional finally gain the respect of their colleagues. The underlining message is that the consumer does not currently enjoy their coworkers' respect, but the product will guarantee that respect. The moral of inadequacy marketing is that the product is the hero, and acquiring it is the only way to achieve happiness.

EMPOWERMENT MARKETING

The audience is the hero in empowerment marketing. Instead of being merely a consumer of a product or idea, Sachs suggested that the audience rises to the role of the *citizen*. The moral is that you can accomplish something great, and a product or idea can help you to do so. In empowerment stories, the audience rallies behind inclusive mantras such as *better together*, or *we can*. Sachs suggests this tactic is more successful. His premise is that an inspired citizen makes for a loyal evangelist for a product or idea.[42] He also observed that empowerment stories tend to be shared with others far more frequently. As case in point, would you be more apt to *like* a video that has left you feeling inspired, or one that calls out your flaws? To understand empowerment marketing, Sachs referred to **Maslow's Hierarchy of Needs** (see page 26).

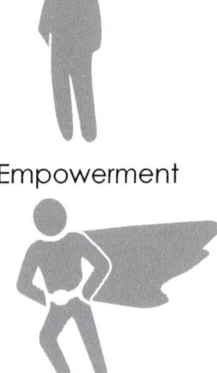

Inadequacy

Empowerment

Figure 1.4
Inadequacy marketing reminds consumers of their shortcomings while consumers are the hero in empowerment marketing

TYPES OF VALUES

Maslow was a psychologist who, unlike Freud, primarily studied people who were generally content with their lives. Instead of coveting items or goods, he found them seeking higher level needs, such as finding purpose or making a difference.[43] Sach's lists nine such values which can be used to frame persuasive empowerment stories.[44]

Your story won't call upon all nine values; doing so would only dilute your message. The key is to focus on one value that you know will resonate with your audience, which will be considered in Chapter 3.

VALUE TO MORAL

The story's moral is how its values comes to life. For instance, if the audience values *justice,* a designer might focus on how new production techniques provide better working conditions for their employees. The moral is that the audience should purchase from this brand because they care for their employees.

If the audience values *richness,* the designer might vividly narrate the experience one would have when using the product for the first time. The moral for the audience is that they too could enjoy this experience.

Figure 1.5
Nine values from which a persuasive story might emerge

EXERCISE 1.1 UNCOVERING PROJECT VALUES

Use the chart above to frame discussions for the scenario below.

You are interviewing with an airport's board of directors in hopes of winning their upcoming signage and branding project. The city itself is small but rapidly growing, and rich in culture.

List 2–3 bullet points conceptualizing how you might base your interview upon each of the 9 values.

Write a paragraph discussing which one of the values you feel is most appropriate.

Remember, more than one value would dilute your message.

EXERCISE 1.2 UNCOVERING PROJECT VALUES IN YOUR WORK

Follow the steps from Exercise 1.1 for your own project.

PLOT

The story's moral is made apparent through its plot. Plot is not only the story's events, but what happens to the main character as they encounter **conflict**.[45] Think of conflict as anything that provides the audience with a sense of urgency. This feeling of urgency can stem from the internal struggles of the main character as they battle against their demons or wrestle with their own misguided beliefs. Or the conflict can be due to an external force of evil. This foe can come in the form of another person, being, or tragic event.

Conflict is an important storytelling tool because when something is amiss, the audience will want to see how it can be resolved.

TYPES OF STORY CONFLICT

main character, (protagonist)	vs.	force of evil (antagonist)
reality	vs.	the character's reality
the character's wants	vs.	what the character has
the character's wants	vs.	what is expected of them
the character's wants	vs.	the character's fears

The best sources of conflict are interesting, relevant, & meaningful

In design storytelling, the sources of conflict will hinge on your goals and the values of your audience. These sources of conflict can range from a client battling for the hearts and minds of their customers, despite having few resources, to a designer grappling with the problems faced by homeless children. Typically, the best sources of conflict are interesting, relevant, and meaningful to your audience.

CONFLICT REVEAL

Your audience's time and attention will likely be short in supply, so your story will need to pique their interest quickly. Author Lisa Cron suggested that storytellers tease their audiences with a "breadcrumb trail," meaning that the storyteller should provide just enough information to keep the audience moving forward through the story.[46] This is similar to **progressive disclosure**, which can be thought of as giving the audience just enough information, just when they need it. The goal is to get the audience anticipating the consequences of each event. That is to say, something is amiss, or out of balance, and if it does not get resolved, something bad might happen. This type of breadcrumb trail activates our dopamine neurons, keeping us immersed in the folds of the story.

EXERCISE 1.3 EXPLORING CONFLICT

Think back to your favorite book or movie.
Write a paragraph summarizing your answers to the following:

What was the conflict?

What made it interesting?

Is the conflict best characterized as a character's internal struggle, or a battle against an outside foe?

STORY STRUCTURE

Once the conflict has been defined, consider how it will unfold within three different segments. These sections can seamlessly flow from one to the next, so their boundaries may remain unknown to the audience. But for the storyteller, each segment represents different working goals. We'll call these segments, Launch, Load, and Landing.

Think of the Launch as when the story's events are set into motion, either gradually or at breakneck speed. In either case, the conflict should be made apparent right from the beginning. Then, along the breadcrumb trail, the stakes are made known, and the characters are defined. The Launch is critical to not only gaining the attention of the audience but framing the story's elements. Once the audience understands these introductory elements, they will be used to judge every subsequent event and how these events impact the main character.

Load can be characterized as adding any elements that are necessary to move the story forward. This can range from providing context, defining the contours of the conflict, or even offering potential solutions.

At Landing, the story comes to a halt. The conflict is resolved – with either positive or negative consequences for the main character. Since the moral plays a critical role in promoting the desired action, it should either be implicitly or explicitly visible at the story's conclusion.

STORY SEGMENTS

	Goals	Description
Launch	pique interest and establish: who what when where	The introduction should include defining elements about whose story it is (i.e., who is the main character), what is happening, and what is at stake.
Load	provide context define conflict share information	This is where the action takes place. The audience is provided with more context and is offered potential solutions.
Landing	provide resolution that refers to the moral	The ending completes the main character's journey, thus resolving the story. It is important for the ending to offer the moral.

OTHER PLOT TYPES

One interesting thing about stories is how many different messaging strategies there are. Most stories aren't epic novels, and not all will follow a linear trajectory. Some may employ foreshadowing and flashbacks to provide context and intrigue. Yet, designers rarely have the time or the need to leverage these devices in design presentations.

At the same time, stories can be very short and without a proper beginning, middle, and end. Stories can be told even from a single profound image. Many of us can identify with the heartbreak behind a photo of the World Trade Center site taken on September 12, 2001, or the joy of an athlete winning an Olympic medal. See Chapters 6–8 for tactics in visual storytelling. No matter what strategy is employed, the key is to consider the values of the story first, and then decide how to tell it.

CHARACTER

Many of us already know that the main character of the story is the **protagonist** and the **antagonist** is typically the *bad guy* – which of course does not have to be a guy, or even a person at all. However, the most enduring stories, and the ones that move an audience to action, often feature characters with whom they can identify.[47] In fact, studies have suggested that if we can identify with a character, we are more likely to give to their cause.[48] This is why nonprofits often highlight the plight of a specific individual, even when their group may be helping millions of worthy people. Audiences are often more swayed by a personal story than the magnitude of the cause. This is because they can develop a relationship with a character and, by extension, the character's goals and ideals. If a likable character's life revolves around a certain value system, we too may come to value it. We can share their hope as they reach for their highest potential, and feel their pain as they face challenges along the way.

> The most enduring stories feature characters with whom the audience can identify.

Our capacity to judge characters makes it easier for us identify with them. Social intelligence theories suggest that we do this by interpreting the identity, status, and intentions of others.[49] This means that character development can be complicated. In fact, there are entire volumes dedicated to the craft. However, it is unlikely that a design story will need to provide extensive character elaboration and Sachs provides a brief, but useful, character development framework he calls "Freaks, Cheats, and Familiars."[50] Under his premise, we define Freaks as new and interesting, while Familiars remind us of ourselves or someone we know. Finally, depending on their circumstances, we either hope for or root against Cheats who have opted to challenge the status quo.

SACH'S CHARACTER TYPES

Freaks are compelling.
> Freaks are interesting because we consider them as different or new.

Familiars convey qualities that we all understand.
> We understand familiars because we already know them as a reflection of ourselves or others we know.

Cheats are those that break the rules.
> We either root for cheats to succeed because they are battling an injustice or difficult situation, or we hope that they will be punished for their shameful actions.

While characters make a story interesting, in persuasive design storytelling, there will be added focus on how to orchestrate your story for maximum emphasis on either your point of view, the merits of your design, or your potential for a position or project. We will explore these topics in Chapter 3.

EVERYONE HAS A STORY

Each of us has a unique vantage point on the world.
This gives each of us a different story to tell.

Consider your personal story ...

STORY STARTERS

People
Think of people you have known & their experiences.
What are their stories?
How did they impact your life?

Places and Events
Recall places you have spent time.
What do you recollect about them?
How did they make you feel?

Things
Think of objects that hold value.
Why are they significant?
How did they become significant?

STORYTELLING IN PRACTICE

How do you tell a client that their staff doesn't like to work there?

As an experienced designer, most clients value my opinion and recommendations, but coupled with the words and photographs from their own employees, the truth can become undeniable and design recommendations can become even more powerful. Let me explain ... I was working with a prominent "research think tank" in Washington, D.C., whose business, workforce demographics, and technology were rapidly changing, but senior leadership was in denial. Their office space and desktop computers was not in sync with their mostly Millennial workforce.

Our design team took a research-based project approach with their employees at the heart of the research. We gathered information through employee surveys, group focus groups, one-on-one interviews, observation, and camera journaling. Camera journaling is essentially an interview through photos to answer a series of questions. It gave us the richest information on what staff valued, what they liked and didn't, and where they feel the most productive. We discovered a huge disconnect between the leadership vision and how their staff were working and the technology that they needed to get their work done more effectively. We knew we needed a compelling way to deliver the message. For our presentation, we covered all four walls of their corporate boardroom with floor-to-ceiling banners containing the photo journaling of their employees. As the leadership entered the room, they couldn't help but be captivated by the photos and candid comments by their employees. By the time we presented our observations and recommendations, they were sold!

Janet Pogue McClaurin
is a Principal in Gensler's D.C. office. She is a frequent writer and speaker on design of high-performing work environments

SUMMARY

Humans are drawn to stories, and they have long served as an invaluable means of communication. Research even illustrates the influence of stories and how they set in motion a series of reactions within the brain. These reactions can alter the way we behave and how we interact with others, and can even change our beliefs.

We like stories because they can help us build and refine our social connections. They allow us to organize and understand information through causal reasoning and by aligning a story's events to our own experience. Finally, stories serve as a guide in determining right from wrong, and since we can live vicariously through a character, we can learn from their missteps without facing the same consequences.

To influence their audience's beliefs, a design storyteller should first consider the values that they are aiming to represent. The morals of the story give life to these values. These morals are tested through conflict, as the character struggles for resolution. To pique interest, the conflict should be apparent right from the beginning of the story. However, in order for the audience to care whether or not the character even resolves the conflict, they need to identify with them on some level.

While storytelling can at first feel uncomfortable, stories can provide an opportunity to not only connect with project stakeholders but to actually reach them and prompt them toward a more desirable course of action.

The following chapters will explore the contours of design storytelling by giving definition to your audience and goals, and then identifying and refining the communication tactics that will be used to share your own design story.

FOR CONSIDERATION

What if we're scared of storytelling?

While we are beginning to understand the virtues of storytelling, in professional settings, storytelling can feel unnatural, and for a good reason. Often a story requires its tellers to share their vulnerabilities, forcing them to be transparent in order to be authentic. Storytellers often need to convey emotions, which can be embarrassing. Moreover, some stories recall a personal experience that may be difficult to share.

Stories can also be sabotaged by calling on a misplaced message or even with our own delivery. With proper planning (and some practice), however, the art of storytelling can be a powerful asset in any designer's toolkit.

TERMS

affective primer
antagonist
causal reasoning
conflict
Maslow's Hierarchy of Needs
progressive disclosure
protagonist

APPLICATION 1.0

Storyteller Kendall Haven suggested that effective stories provide an audience with: context, relevance, engagement, understanding, empathy, and meaning, as well as enhance their memory and recall.[51] The aim of this book is to help you to provide your audiences with these insights by conceptualizing a design for a story for an upcoming project. To introduce this process, first think back to a previous project and consider the following questions.

1 Refer to Figure 1.5. Which value (Justice, Wholeness, Perfection, Richness, Simplicity, Beauty, Truth, Uniqueness, & Playfulness) most closely aligns to that project?

2 Focusing on this value, what would you consider the moral of the story to be?

3 What are sources of potential conflict that would best test this moral?

4 Answer the following:
Who is the protagonist?
Would the audience consider them a freak, familiar, or a cheat?
How do these characterizations influence the story?
Are there any other necessary characters that contribute to the story?

5 Using your answers, conceptualize the following aspects of your story.

Launch	Load	Landing
Introduction	Middle	Ending
pique interest	provide context	provide resolution
	define conflict	refer to the moral
establish:	share information	
who		
what		
when		
where		

OBJECTIVES

- Identify and dissect audience characteristics and goals
- Explain how knowledge of the audience can influence a presentation
- Apply principles of audience persuasion

PRESENTER MEET AUDIENCE

This chapter will focus on the "stars" of the story, the audience.

It's a nightmare scenario for any designer . . .
Having worked through the night, you excitedly step to the front of the room. Fueled by caffeine and adrenaline, you present your project idea to the entire office, knowing that this new way of thinking could finally propel your firm to the next level. However, when you finish speaking, the room is silent. There are a few passive head nods — but no one says a word. Sensing an opportunity, your colleague then steps forward. Having thought about the problem for all of ten minutes, he outlines a mediocre idea, but the atmosphere of the entire room changes. Your coworkers begin to lean forward, nodding their heads in agreement. After his presentation, many questions arise and supporters emerge.

In this disheartening situation, your colleague managed to capture the imagination of the audience.

INTRODUCTION

The strongest communicators acknowledge that while they may be creative and charismatic, the real "stars" are the audience. They recognize that their job is to design an experience that will inform, persuade, and entertain these individuals. After all, the audience members are the ones who will approve the design, assign the grade, or fund the project. The problem lies in determining the best ways to get them to do these things. So, as with any design problem, we ask questions. But if we fail to ask the right ones, we risk sharing the wrong solutions. This chapter will help prompt some important questions that any design storyteller should consider, such as the goals of the presentation, the needs and desires of the audience, and the best way to connect the two.

OVERVIEW OF THE CREATIVE PROCESS

So much has been said of the design process; it's messy, fuzzy, creative, iterative – there are about as many ways to describe the design process as there are ways to go about it. Design is also a mix of intuitive and deliberate actions,[1] such that designers may sense things in their gut, but also rely on information to make decisions. And while we may start over, go backward, and make mistakes along the way, the design process generally follows the same trajectory.

When framing the problem, we cast a wide net around it, exploring its challenges and possibilities. During idea generation, multiple ideas are conceptualized, but none are eliminated. These ideas are then evaluated during testing and refining, where potential solutions are improved upon and perfected. After several iterations, the design solution is ready to be shared. But the process isn't quite over since much can be learned and applied to future works. The best designers value reflection, which gives them the chance to acknowledge the successes and failures of both their product and process.

This process unfolds for both the design and the story about it.

PARALLELS BETWEEN THE DESIGN PROCESS & STORY DESIGN

		Design Solutions	Presentations
FRAMING THE PROBLEM *why, who, what, how*	Goal	Resolve the right problem.	Tell the right story.
	Ask	What are you trying to do?	What are your goals? Who can help you achieve them?
	Tactics	Interviews, observations, site visits, case studies	Determining the audience and how your goals align with their interest
IDEA GENERATION & DESIGN *what, how*	Goal	Generate many ideas and select the best.	Generate many ways and select the best.
	Ask	How might the problem be solved?	How might the message be shared?
	Tactics	Brainstorming, sketching	Brainstorming, sketching
TESTING & REFINING *what, how*	Goal	Ensure the best solution.	Ensure the best story.
	Ask	Is this the best way?	Is this the best way?
	Tactics	Prototyping, focus group, etc.	Practicing, refining, etc.
SOLUTION *what, how*	Goal	The best solution is put to market.	The best story is told.
REFLECTING *what, how*	Goal	Review process & outcomes.	Review process & outcomes.
	Ask	Was that the best way?	Was that the best way?
	Tactics	Post-occupancy evaluations, team reflections, consumer feedback	Reading reviews, reflecting, talking with the audience

GETTING STARTED

It has been said that if "problems are hard to see," then their solutions are "nearly invisible."[2]

Design storytellers help their audiences see the problem for themselves. To do so, they start thinking about how to "package" their ideas nearly as soon as they begin developing them.

There are two important questions that need to be answered early on in this process. The first question centers on the goals for sharing – essentially, why are you presenting your ideas? The second question hinges on who will receive them, namely, who are you presenting these ideas to? Only after those questions are answered can designers begin to think about what to share and how.

This chapter will use the early steps of the design process as a guide to answer the *why*, *who*, *what*, and *how* questions that design storytellers must answer. Chapter 3 will then move into the process of generating story ideas.

WHY ARE YOU PRESENTING?

The best presenters take time to reflect on the goals of the presentation itself.

It may seem natural to ground your presentation in the merits of your design – certainly, there are many. Though, until the audience knows how badly they *need* the design, they won't truly appreciate it. Design storytellers speak to the needs of the audience on the terms of that audience, essentially framing their design as the resolution to the audience's needs. This takes some reflection on the part of the designer.

So, why are you presenting?
Perhaps you are committed to helping others and believe that you have the best ideas to solve their problems. Or maybe you care deeply about a client and are compelled to improve their circumstances by sharing a timely message. In such cases, consider what your presentation will do for others. Will your presentation help your client obtain the necessary funds to make their project a reality? Maybe your presentation will prompt the audience to make the right decision.

Not feeling quite so righteous? It's okay if your motivation stems from goals that outwardly benefit yourself more than others. Who doesn't want to get a good grade or land the promotion? Yet, if you spend a bit of time asking yourself about the root of these objectives, you may find that these too emerge from a noble purpose. For instance, if you get a good grade, you might qualify for the internship at the firm specializing in healthcare design. Or, if you land the promotion, you might be able to share your ideas more broadly, thus benefiting more people. Keep in mind that your list of goals should be short; a long list suggests you're trying to accomplish too much in the presentation.

With your goals in mind, ask yourself how you need the audience to change in order to make these goals a reality — this determines the moral of your story. Not only does the moral inspire the audience to take the action you are seeking, it's central to helping you determine what they will need to know to prompt this action — this is the content of your design story.

How does your audience need to change to make your goals a reality?

WHO ARE YOU PRESENTING TO?

Whatever your goals might be, chances are you need the audience to connect with your message and, by extension, with you. Thus, you will need to be an attentive design storyteller.

THE ATTENTIVE STORYTELLER

An attentive design storyteller is one that attends to their audience. They create a conversation centered on their audience's needs and desires. To do this, they seek to understand who they are speaking to, and what makes these people tick. An attentive design storyteller also anticipates their audience's fears and aspirations, reacting accordingly. For instance, knowing that some board members may be hesitant to change their company's image, an attentive design storyteller may opt to acknowledge their worries before they share any new ideas.

Creating a memorable experience is critical, one where the audience is the star. Not only are they the star, but, during the presentation, audience members should feel as though they are the masterminds behind the design. This can be a difficult proposition for designers, relinquishing ownership of an idea; after all, our ideas represent our time, creative energy, and livelihoods. Do remember though, that it's the client who takes on most of the risk. In the end, it's their money, reputation, and future on the line. They'll live with the design outcomes long after you've moved on to other projects.

Consider the following design presentation scenarios.
If you were a client, which would you prefer?

> **Which would be more memorable a list of awards or a shared experience?**

Audience-focused
Concentrates little on the designer, instead, emphasizing audience concerns. Words like "your" are used to refer to the design.

Shared Understanding
Highlights mutual interests before guiding the audience toward a new belief. Words like "our" are used to refer to the design.

Presenter-focused
Designers center on themselves or "their" design. Words denoting ownership like "I" or "my" are used.

EXERCISE 2.0 WHICH IS THE BEST GAME PLAN?

Use the scenarios above to consider the following interview ideas. For each, list the strategy represented, and 2–3 risks & rewards.

Game plan Reciting your many accolades and cumulative project experience.

Game plan Recounting an experience that you both have had, and using that story to emphasize the opportunity at hand.

Game plan Acknowledge your preparation, but offer to customize the interview according to their goals, since these goals may have changed based on their interviews with other candidates.

BRIDGE BUILDING WITH UNIVERSAL TRUTHS

Think back to your favorite book or film. Whether is was funny, romantic, or thrilling, it likely struck a chord on an emotional level. Perhaps the circumstances resonated with you, or maybe you identified with the characters. While the author or director didn't know you personally, they managed to connect with you by tapping into universal truths.

What are universal truths?
Universal truths are ideas, notions, and concepts that hold true for almost anyone, regardless of their background. Universal truths are valid across time and place, for instance, love for a family member. Chances are that no matter how old you are, where you live, or how much you earn, you love a family member. Therefore you can likely identify with a message that speaks to this universal truth.

Some common universal truths include:

We were all children.
We remember childhood (even as adults).

We desire happiness, though it's fleeting.
While we pursue happiness, it is often short-lived.

Stress is inescapable.
While the sources of our anxieties might differ, chances are we all face stress and its consequences.

We are impacted by those around us.
Our societal norms influence how we behave.

We wanted to be loved and accepted.
Love validates us, and acceptance allows us to feel as though we are part of something larger.

Change and uncertainty are certain.
We will all experience change in our lives, the outcomes of which are often unknown.

An example of speaking to universal truths can be found in a recent Argentinian advertising campaign which was aimed at increasing organ donor roles.[3] Instead of a more traditional campaign targeting altruism, the video's producers started the spot with a man and his dog. Viewers witness their mutual devotion and see the two sharing in daily activities. Then the man becomes very ill and goes to the hospital. The dog sadly waits at the hospital – night and day, even in the rain. After several days, a female patient emerges from the hospital, and the dog immediately senses a kinship to this stranger. While no words are spoken, to viewers, it becomes evident that she now owns the man's heart. In essence, the man lives on, and the dog's purpose continues. If you're a dog lover, chances are you connect to the message.

UNIVERSAL TRUTH EXAMPLES

The Truth Campaign is another example of speaking to universal truths, aimed at tobacco prevention. Having utilized a range of tactics, their most recent spots humorously feature cat videos, which are ubiquitous to the Internet.[4]

Universal Truth #1- We have seen these videos (or created them).
Universal Truth #2- Cats are funny, weird, cute, etc.

Near the video's end, a message notes how many cats die of cancer due to their owner's smoking. In essence, if you love your cat, you won't smoke.

Universal Truth #3- If you won't save yourself . . . at least save your cat.

Figure 2.0
"Man's best friend" can be a subject of a universal truth

In design, we can speak to universal truths in many ways.
For instance, if you are developing designs for an Alzheimer's care unit, you may connect to the audience by speaking to their love of family.

Universal Truth- They cared for us; now we should care for them.

IDENTIFYING THE AUDIENCE

Given that the audience is so important, it's essential to identify their characteristics and motivations. In her book *Resonate,* Nancy Duarte[5] outlines a process of **audience segmentation**, in which a presenter analyzes audience characteristics, including **demographics**, **psychographics** (i.e., personality), and **firmographics** (or business setting).

However, no two audiences will be the same. Even within a seemingly homogeneous audience, individuals may have varied backgrounds and even conflicting beliefs. While it is impossible to know everything about everyone, it is helpful to gain as much insight as possible about an audience relative to who they are and what they want.

WHO IS AT YOUR TABLE?

When you're thinking about your audience, imagine them as your guests at a dinner party. Did you invite them to your table because they will help you get ready (doers), or bring the expensive wine (suppliers)? Perhaps they'll bring a distinguished guest (influencers), or maybe they tell the best jokes (idea generators). Consider these individuals as the agents of action in your audience, since they have the ability to move your idea forward, provide funding, hone your ideas, or share those ideas with others. These change agents are the real stars of your story.

There may be times when an intended audience (i.e., Board of Directors, Parent –Teacher Association, etc.) is more effectively reached through others. For instance, if your goal is to help your client generate funds for a new classroom wing, parents may be apathetic to your appeals. However, if you enlist their children (as influencers) to share your message, the parents may be more responsive to your request. You can excite the youngsters by sharing design ideas, so that they, in turn, go home and discuss the possibilities with their parents. Of course, you want to leverage such a tactic ethically, but these types of clever targeting strategies can be very useful.

Figure 2.1
Consider who in your audience can help you achieve your goals

CHANGE AGENTS

Idea Generators
Ability to help you refine your vision

Doers
Ability to act upon your ideas

Influencers
Ability to share your ideas with others

Suppliers
Ability to fund your idea through money or goods

AUDIENCE CHARACTERISTICS

DEMOGRAPHICS

Age Education Ethnicity Gender Location

PSYCHOGRAPHICS

Personality
Are they Introverted/Extraverted?
How do they feel about change?
Are they disciplined?

Values
What do they respect?
What are their priorities?

Attitudes
What is their outlook on life?
How do they react to events?

Interest
How do they spend their time and money?

Knowledge
What do they already know?
Where do they get information?

Lifestyle
What is interesting about them?

CONTEXTUAL INFORMATION

Personal-domain Public-domain

How large is their family unit? *How large is their business?*
What does their family do in the space? *What do they do?*
What is in proximity of the residence? *What types of people do they employ?*

MOTIVATIONS

Personal-domain Public-domain

Examples: *Examples:*
Better support for daily activities *Increased profitability*
Enhanced family connectivity *Employee recruitment & retention*
 Company values

WHAT EXPERIENCE WILL THEY HAVE?

Use your knowledge of the audience to speak to their needs, but keep in mind that they may not believe in the need, or believe that your design is the solution. This obviously makes your job more difficult since you will need to change their positions. At first, this can be disheartening since they don't appreciate your ideas as much as you had anticipated. But it's human nature for people to "value their own conclusions more highly than yours."[6] So plan their experience from their perspective. Essentially, what is the best way to start from their position, but change their hearts, minds, and beliefs?

EXERCISE 2.1 AUDIENCE CHARACTERISTICS

Think about the audience from your last presentation and use the chart above to reflect on their characteristics.

How much did you know about the audience?
How did that knowledge influence your presentation?
How else might this knowledge influence your presentation?

WHAT ARE YOUR GOALS FOR THE AUDIENCE?

Prior to hearing your message, your audience will likely do, think, or believe something – and may be very satisfied with that 'something.' Nevertheless, your goal is to prompt them to do, think, or believe something else (i.e., contribute, act upon, or believe in your ideas).

TYPES OF AUDIENCE CHANGE

dislike	to	like
naive	to	wise
maintain	to	change
doubt	to	believe

Hence, you want them to change as a result of the experience you're creating. For instance, a company's CEO may want to keep her private office, but your goal may be to help her see the benefits of an open office solution – thus changing her beliefs.

REWARDING THEIR CHANGE

For any number of reasons, some in your audience may not appreciate your ideas. They may feel that a new design is unnecessary, fear change, or worry that the design itself may not meet their needs. Whether their concerns are valid or unwarranted, these issues are important to them, and should not be dismissed. Your design may provide countless benefits, but remember that change is hard – and sometimes scary – so highlighting rewards can help to motivate the change.

For instance, when a company is relocating, the ensuing changes can be both exciting and distressing for staff, and there will likely be some resistance to change. Employees might have to settle for smaller workstations, and if they don't understand the benefits of this change, they will resent the design – and perhaps you by extension.

To alleviate concerns, consider how to convey the rewards of the change – both big and small. The employees might accept smaller workstations if they are rewarded with views of the outside or access to a coveted fitness center. More broadly, the new location might accommodate more employees, thus reducing their personal workloads. Ensure that you know what the client's objectives are so that you can weave them into your design story.

These rewards happen at an individual level too. For instance, a consumer may be willing to spend more on a product, if they can trust that it's reliable, or feel that it was ethically produced. Such rewards can range from basic necessities to lifelong goals; consider the rewards against Maslow's Hierarchy of Needs.[7]

Does moving to a smaller office satisfy a basic need? Probably not, but the promise of a newfound sense of openness may motivate the audience to make the change you are requesting.

WHOSE CHANGE IS IT?

It's human nature to desire personal gain, and audience members certainly like to hear about rewards that directly impact their lives, yet they may care nearly as much about the impact on others. So, while your design may not directly change their own experience (i.e., micro benefits), the design may improve the status of their company, community, or even mankind. For example, paying extra for recycling bins may not benefit one employee in particular, but doing so will enhance the firm's sustainable practices (group) and preserve the environment (macro benefit). Or a water feature designed for an emergency room waiting area may go unseen by the physicians listening to your presentation, but if their patients are calmed by its presence, it may help them to better diagnosis their patients' ailments. The key is to thread these rewards back to the lives of the target audience.

Self–Actualization
fulfillment

Esteem
confidence, respect

Belonging
friendship, kinship

Safety
security, health

Physiological
basic needs

Figure 2.2
Maslow's original Hierarchy of Needs

HOW ARE YOU PRESENTING?

We come to change our beliefs based on the different ways we approach a message. Some of us may be more likely to change our minds based upon rational evidence, whereas others trust our "gut" instincts. Your goal is to align your message with the audience's desires through your delivery, which brings us to answering questions surrounding how we might persuade the audience.

To explain the different ways an audience might approach information, scientist and filmmaker Randy Olson cited four areas of the body, each having different motivations (e.g., groin, gut, heart, and head). He suggested that speaking to our desires appeals to our groin, a nod to our intuition charms our gut, tugging at our emotions speaks to our heart, and finally, rational evidence sways our head. Olson stressed that given our biological predispositions to reproduce, appeals aimed "below the belt" affect everyone, but fewer individuals are likely to be convinced through their heads. He suggested that speakers first target the lower three areas to initially gain interest, before actually speaking to their heads.[8]

PERSUASIVE APPEALS

Olson is not the first to recognize multiple pathways to persuasion. Greek scholar Aristotle suggested that the roles of the speaker, their message, and their audience are inherently connected, and outlined three means to persuade an audience. These include the speaker's character or credibility (ethos), the logic of the message at hand (logos), and the emotional arousal of the audience (pathos). [9,10]

Ethos

Are framed by characteristics of the speaker. To employ ethos, the speaker works to gain the respect of their audience by either establishing their similarity to its members, or emphasizing their reputation, authority over the subject, or their trustworthiness.[11,12,13]

Uses
To gain respect.

Pathos

Center on connecting to the audience through their emotions and imaginations. Scholars have identified pathos tactics to include the incorporation of humor, personal stories, and anecdotes, as well as using vivid language to conjure positive mental imagery.[14,15,16]

Uses
To make the audience care.

ETHOS
speaker's credibility
trustworthiness
respect

PATHOS
affective appeal
emotional engagement

LOGOS
the logic of the message
sense making

Figure 2.3
Aristotle's persuasive appeals

Logos

Stem from the structure, clarity, and integrity of the message itself. To employ logos, the speaker speaks almost exclusively to the head by providing factual information and evidence.[17,18]

Uses
To build understanding.

WHICH APPEAL IS BEST?

While most design presentations will use all three tactics, they may vary in terms of which is emphasized. To determine which appeal is best, consider your personality (and your level of comfort), the meaning and tone of your content, and, of course, the personalities of those in your audience.

Figure 2.4
There is an inherent relationship between a speaker, their message, & their audience

There is also some evidence to help speakers identify which appeal might work best for their specific situations. TED Talks are a popular venue to convey ideas and their popularity helps illuminate the relationship between a speaker, their message, and their audience. In studies of TED Talks, whose online videos focus on Technology, Education, and Design, communications researcher Scotto di Carlo found that Talks were often introduced using story, or by providing context about a given topic. In fact, 43% percent of the talks in her study had incipits (or entry words) that recounted a personal story or experience; this suggests that pathos, or appeals to the heart, played an important role early in a Talk.[19]

To understand why some messages are more apt to be shared, communications professor Jonah Berger conducted a study examining how people opted to forward nearly 7,000 online articles. His team initially found that topics considered *interesting* and *useful* were more likely to be shared. Going further, they found that articles conveying sadness were 16% less likely to be shared, while those inspiring awe were 30% more likely to be shared. To the research team, it seemed that positive articles were more likely to be shared; however, articles that made people angry or anxious were shared at similar rates.[20]

So, what was the difference?
Articles that evoked a physiological response (i.e., heart racing, palms sweating) – whether positive or negative – were more likely to be shared. Brain scans suggest these types of articles stimulate our mirror neurons.[21] Essentially, when the emotions are deeply felt, we are more likely to care; thus, we are more likely to share.

This prompts the question, should designers aim to get their audience worked up about a problem, or simply delighted in the solution? Communications consultant Nicholas Morgan suggests that we do both.[22] In other words, a good design story uses the tools of the trade (written, verbal, and visual messages) to give the audience a sense of urgency about a problem. Only once they are convinced that the problem is dire, do we offer the solution.

WHAT IS YOUR MESSAGE?

Is your content inherently analytical or emotional?

Knowing the audience, and knowing how to approach them are just the beginning of our questions. Design storytellers should also explore how their content aligns with their audience.

Is your content inherently analytical or emotional? Evidence suggests that there is great potential in appealing to the emotions of the audience, especially if affective appeals will sway audience members. But, what if emotion doesn't inherently drive your content? The key is to wrap it in a story that does. For instance, statistics represent people. Each number accounts for a life that matters to someone else. Get the audience to care about that person's plight, then highlight how your design will improve their life — this will help the audience to better remember the merits of your design.

LANGUAGE DEVELOPMENT TOOLS

The language we use to tell the story – both visual and written – will be critical. This language should be in terms familiar to the audience. So do your homework. As you ask questions about the audience, answer these questions with words and images that represent their current characteristics and terms (i.e., slogans, adjectives, mission statements, brand imagery, pictures in the home, stylebooks, etc.). Also, compile aspirational images that best represent the tone you'd like to depict and the benefits of the design – the more of each the better. Use these to determine any underlining trends. Are there vast differences between their current language and your intended tone? What do these differences tell you about how they may react to your message? This collection of representations should serve as a reference. Use it to meet the audience where they are, and guide them toward the better destination. This is the cornerstone of your creative brief.

CREATIVE BRIEF

A creative brief can serve as an important guide during your story planning process. Start by examining the words, images, and representations that you have collected. What trends and themes do they represent? Use your assessment to write a statement that highlights your intentions. This statement should be short and direct, but with enough elaboration to provide a shared vision and collective purpose.

Steps for developing a creative brief:
1. Pose questions.
2. Conduct research to inform your answers.
3. Determine themes.
4. Define a key message.

STORYTELLING IN PRACTICE

How do you make your audience feel smart?

Over many years of designing motion media and visual effects for television and feature films, it has consistently been my experience that if you make your audience feel smart they will love you for it – and they may not even realize why. I believe this notion holds up in any medium and any venue.

Ron Honn is an animator, broadcast designer, & visual effects artist with over 20 years of experience in broadcast & film.

Once I was tasked with creating a series of "HUD" or Head's Up Display graphics for a sci-fi film. The director wanted to convey that the protagonist was receiving a massive download of information – and this in a shot lasting only a few seconds. There is always the temptation to dumb down a moment like this in the expedience of exposition to move the scene along. Instead of spoon-feeding the audience by stating the obvious, we wove the essential text elements necessary to convey the story in with diagrams and schematics of real objects and technology that had perhaps no immediate pertinence to the story – but which conveyed a visual richness and a certain ring of truth about them. Implicit in the design was the idea that the audience was sophisticated enough to surmise authenticity from information present on-screen for only a fraction of a second. The attention to what might seem like throwaway details in visual storytelling lent a certain gravitas to the moment in the film that might otherwise have seemed simplistic. The sequence was well-received because the audience got to connect the dots and derive significance in their own minds from the whole.

SUMMARY

The success of a presentation often hinges on its design. Knowing this, the best design storytellers go far beyond decisions about color and font. Instead, their presentations represent a comprehensive decision-making process. In fact, there are many similarities between designing products and spaces and designing a presentation. In both, asking the right questions is key. These questions should be aimed at defining your goals, understanding who will be receiving your message through their characteristics, backgrounds, and beliefs, and what you want them to do about your message. In other words, how will they change as a result of your presentation?

To prompt this change, consider incorporating several storytelling tactics into your presentation:

- Aim to be attentive and to connect to your audience through universal truths, or concepts that hold true to almost everyone, everywhere.

- Consider how you might emphasize any potential rewards for making the change.

- Determine which type of appeal (ethos, pathos, or logos) might prompt this change.

Once these factors are established, consider the inherent tone of your content and how it might be shared with story.

FOR CONSIDERATION

To hone your storytelling skills, consider the following:

Reflect on your favorite teacher or mentor.
- When delivering a message, what did they do differently?

Reflect on your own work.
- Refer to Maslow's Hierarchy of Needs
 Consider how your projects fulfill the needs of others.

- What kinds of changes does your work typically require?
- What are potential rewards for these changes?

Become a keen observer of messaging and advertisements.
- What universal truths are used?
- Are the messages intended to sway the groin, gut, heart, or head?
- Which appeals are used (ethos, pathos, or logos)?
- Identify effective and ineffective strategies.

TERMS

audience segmentation
demographics

firmographics
psychographics

APPLICATION 2.0

To design a powerful presentation, first some important decisions must be made about the audience. Think about an upcoming presentation and consider the following:

1 Use the Audience Characteristics table on page 25 to analyze your audience. Remember to focus on the most influential audience member (the person who has the power to advance your project).

2 Identify how you want this person to change as a result of your presentation. For example, do you want them to move from dislike to like, doubt to believe, etc.?

3 Use your audience analysis answers to identify which universal truth might best evoke the desired change in this audience member.

4 Also, use your audience analysis to identify the most effective appeal (ethos, pathos, or logos).

5 In the area below, craft a one-paragraph creative brief that responds to these goals; aim to use the language of your audience (see page 29).

OBJECTIVES

- Determine presentation focus (point of view, project story, or project pitch)
- Generate ideas for a presentation
- Determine the most appropriate role of story in a design presentation
- Decide on ways to hone the message
- Identify sub-themes that support the central message

STORY DESIGN

This chapter will focus on conceptualizing, designing, and testing stories.

The launch of John's crowdfunding site was now only a few days away, and while he was confident that his idea was solid, he knew that potential funders had to understand who it would actually help. But after prototyping and rehashing ideas with his team for weeks, he was completely drained. Feeling exhausted, he went home for the evening. Waiting at the door was his bulldog, Lilly. She had likely been waiting there for him all day. "Now that's dedication," John thought to himself. Just maybe that was an idea he could work with, "dedicated to those . . ." John went for his pen.

While it's doubtful that John will have a sudden epiphany, his idea might lead to another and then another — culminating in his pitch.

INTRODUCTION

There are two kinds of stories within design presentations. The previous chapters explored the role of "S"tories (with a capital S) which are used to represent the values that prompt audience change. These Stories are complete with characters and conflict and are often folded into your presentation. Yet, virtually all design presentations can be thought of as stories – with a little "s."

We laid the groundwork for both "S"tories and stories in Chapter 2, by identifying your goals, your audience, and determining some initial messaging strategies. This chapter will explore the ideation, design, and testing of your message, by first refining questions surrounding *what* you'll be saying and *how*. These answers will help shape the contours of your overall design story, whether it is aimed at sharing your point of view, your project, or your fit for a position or project team.

RETURNING TO THE CREATIVE PROCESS

Recall that our process will be similar to the design process (see page 20). In this chapter, your goals will be used to help determine the focus of your message. The aim of the idea generation stage is to be bountiful yet economical . . . bountiful, in that the process should result in many ideas to choose from and economical in that each idea represents a minimal investment of your time. The story is shaped during design, where you'll finalize, structure, and refine your message, then test its strength and appeal before determining how to share it.

Figure 3.0 Steps in presentation design

FRAMING THE PROBLEM — *why, who, what, how* → IDEA GENERATION — *what, how* → DESIGN — *what, how* → TESTING — *what, how*

DESIGN PRESENTATION AREAS OF FOCUS

This chapter outlines idea generation for three types of these stories (with a little "s"), each of which can be very important in any design career. The first is focused on you as a designer, essentially, your point of view. The second type involves an outcome of your work such as a project summary. The third focuses on a position or project you hope to win, in other words, a pitch.

DESIGN PRESENTATION AREAS OF FOCUS

	Point of View	Project Summary	Project or Position Pitch
GOALS	Convey your design approach & background	Highlight a project	Display your fit for an opportunity
AUDIENCE	Potential clients or employers	Potential clients, employers, or instructors	Those who are screening candidates
AUDIENCE CHANGE	Uncaring to caring	Unaware to aware	Doubt to believe
PROTAGONIST	You	The project	The opportunity
FACTORS	Your unique background Your motivations	Project challenges, opportunities, & triumphs	Your unique qualities Your interest in the opportunity

POINT OF VIEW

Discovering the source of your point of view (POV) means exploring the causes and corresponding effects of your life's events. Doing so can help you discover what drives you and your decisions as a designer. To start generating ideas for your POV, answer as many of the questions as you can from the list below. Some of these questions will likely be easy to answer while others will be more difficult. Try to answer at least 10 of the questions (or question groupings) with at least two from each category (e.g., *Yourself*, *Your Motivations*, etc.). Once you have an answer to a question, don't stop there; continue to ask yourself, why? Doing so will help you unearth a common theme.

YOURSELF

- **Why are you reading this book?**
 To the answer from above, ask yourself why?

- **List 4 characters or historical figures you identify with.**
 How are these individuals similar?

- **How would you define your life?**
 How do your actions support that definition?

- **Describe yourself in one word.**
 What word would others use to describe you?
 Are these words similar or different?

- **Who are your earliest influences?**
 How did they shape your life?

- **List 4 events you will remember forever.**
 How have those events shaped you?

- **What are you optimistic about?**
 Why do you feel this way?

- **What brings you joy?**
 What keeps you up at night?
 Are these things related?

YOUR MOTIVATIONS

- **What inspires you?**
 How do you use this inspiration?

- **What is the first thing you think about each morning?**
 What is the last thing you think of at night?

- **If you could take a trip with anyone (living or dead), who would you take?**
 Where would you go?

- **What motivates you?**
 How do you act upon that motivation?

- **What gives you pride?**
 Why do you feel this way?

YOUR CONTRIBUTIONS

- **How are you changing the world around you?**
 How might you change the world in the future?

- **What advice would you give to those just starting out?**

- **Why did you choose to design?**
 What problems do you hope to alleviate?

- **Describe an opportunity you embraced.**
 What was gained from this?

YOUR PROCESS

- **What is your typical day like?**
 Why is it like this?

- **Describe when you creatively solved a problem.**
 How did you accomplish this?

- **Describe when you overcame a challenge.**
 How did you do so?

- **Describe your design process.**
 Why is it like this?

YOUR EXPERIENCES

- **Describe a regret or mistake.**
 What have you learned from this experience?

- **Describe an accomplishment.**
 How can you take it further?

- **What decisions have brought you to this moment?**
 At the end of your career, what do you hope to have accomplished?

- **What advice would you give to your child-self?**

- **What would you remind your elderly-self?**

PROJECT

The protagonist of a project story is often the design itself, in that the project goes through a series of challenges that culminate in the best possible outcome. While such stories convey design merits, they can also provide insights into how you navigate the design process, and even your tenacity and grit. To get started, select a previous project (or one nearing completion) and answer the following questions about it. Aim to answer at least 10 of the questions (two of which should be from each category). Then repeat the process, continuing to delve into the reasons for your answer; this will help you uncover the essence of the project. You might find that the questions all point to a central theme.

PROJECT PARAMETERS

- **Who was the project for?**
 How are they unique?
 How did you identify with these individuals or come to understand their needs?

- **How would you define the project?**
 How did your design decisions support this definition?

- **If you selected the project parameters (i.e., topic, scope, size, etc.):**
 Why did you select this topic?
 Did anyone influence this selection?

- **If you were given the project parameters (i.e., topic, scope, size, etc.):**
 How have you reframed or evolved these parameters?

- **Do you feel passionate about the project topic?**
 How has your passion grown?

- **How did you come to understand the project parameters (research, observation, etc.)?**
 How did those findings influence your design?

- **What goals did you have for the project?**
 How did your solution respond to those goals?

PROJECT CONTRIBUTIONS

- **Who would benefit from knowing about your project and why?**

- **How could knowledge or ideas from your project inform or guide others in other disciplines/areas?**

- **How could knowledge or ideas from your project inform or guide future generations?**

PROJECT PROCESS

- **Describe your design process for the project.**

- **Describe the project's challenges and opportunities.**
 How did you approach these?

- **What might you do differently?**

USER EXPERIENCE

- **How would others respond to your project?**
 How might they use or experience your solution?

- **How would users see this project as unique?**
 What similarities would they see?

- **How might users view this project's accomplishments (or failures)?**

PITCH

Designers are often tasked with convincing others that they are the best possible candidate for an upcoming opportunity. In such scenarios, a pitch can make the difference as to whether the opportunity goes to you or a competitor. To start planning for this type of story, select an upcoming opportunity you're hoping to gain (either a design project or a position) and answer at least 10 of the following questions (two of which should be from each category). Once you have an answer to a question, again, don't stop there, continue to examine your response and your reasons for that response by asking *Why*. This will help you determine on a deeper level why you are the best fit for this opportunity. It may happen that your answers all center on a common theme.

YOURSELF (in this role)

- **Why are you hoping to receive this opportunity?**
 To the answer from above, ask yourself why?

- **What makes you unequivocally qualified?**
 Why are these qualities important?

- **How would you define this opportunity?**
 How do your actions support that definition?

- **List goals for this opportunity.**
 How would your solutions respond to these goals?

- **What would influence your decisions?**
 How might this shape your work?

- **List 4 events you will remember forever.**
 How would these shape your approach?

- **Describe yourself in this role.**
 How would others describe you?
 Are these terms similar or different?

- **How would you uniquely go about understanding the parameters of the project or position?**

YOUR MOTIVATIONS

- **What inspires you?**
 How does that inspiration support this opportunity?

- **What motivates you?**
 How does that motivation intersect with this opportunity?

YOUR CONTRIBUTIONS

- **How would you embrace this opportunity?**
 How would your actions support this?

- **Outline your potential contributions.**
 How might these contributions improve the project?

YOUR PROCESS

- **What would your typical day be like during this opportunity?**
 Why is it like this?

- **Describe challenges and opportunities that would accompany this opportunity.**
 How would you approach these differently from competitors?

YOUR EXPERIENCES

- **Describe a regret or mistake.**
 How would you apply what you learned from that experience to this opportunity?

- **Describe an accomplishment.**
 How does that accomplishment parallel this opportunity?

- **Describe your decision-making process.**
 How is your process uniquely suited to this opportunity?

HONING THE MESSAGE

By answering the previous questions AND asking yourself the reason for your answers (i.e., why?), you may start to recognize patterns. These underlining themes can be very valuable in framing your story. In the case of the Point of View answers, these themes begin to suggest your core values. These values, in turn, shape your decisions. For the Project questions, your answers speak to the rationale behind your design decisions. Finally, answers to the Pitch questions can help highlight how your values coincide with the opportunity at hand, making you the best candidate.

Take these overarching themes and use them to craft the essence of your story. To do so, pair the overarching theme with the change you are seeking from the audience (i.e., what you want them to do, act, think following your presentation; see Chapter 2). What parallels can be drawn? What universal truths might connect the two (Chapter 2)? This is the central message or big idea driving your presentation.

Figure 3.1
The process of honing your message involves merging goals & themes

Audience change
Themes from your answers
⎯⎯ Central idea
Universal themes
(as a starting point)

According to Nancy Duarte,[1] a presentation's "big idea" should convey your unique perspective while communicating what's at stake. Remember that the audience will likely change in response to your message, so your central idea should direct this change.

Use what you have learned from your answers and subsequent exploration to examine your creative brief, which was started in Chapter 2 (see page 29). Remember that this statement should be clear, direct, and memorable. Keep the creative brief to no longer than one paragraph. In fact, some creative briefs are so succinct that they can fit on a bumper sticker.

SEEKING INSPIRATION

While honing your messages, don't overlook outside sources of inspiration. Creative individuals are constantly on the lookout for fresh insights. As you design your story, be open to the world around you, seek ideas from a diverse range of sources. Attend lectures and events, explore online resources, read books and magazines, talk with others — absorb it all. When doing so, be hyper-vigilant, taking note of your assessments. Record your ideas using a sketchbook, digital device, or web program. Over time, you'll develop an inspiration-gathering process that is uniquely yours, and it will be a catalyst for many ideas. Choreographer Twyla Tharp calls her process "scratching," during which she places her sources of inspiration for a project in a box and saves these collections long after a project is complete. In turn, the boxes serve as a project archive and she can revist them to inform future projects.[2]

Figure 3.2
Save sources of inspiration

BRAINSTORMING

In addition to seeking outside inspiration, another way to gain ideas is with brainstorming. Advertising executive Alex Osborn offered this concept for idea generation in the 1950s.[3] His technique was quickly mainstreamed into our creative consciousness, and today it's hard to imagine design without it. Chances are you have participated in several brainstorming sessions yourself – some probably more successful than others. To make the most of your brainstorming sessions, consider the following strategies:

BRAINSTORMING TIPS

Consider if your goals are to gain diverse opinions or expert solutions and invite participants accordingly.

Aim for a small group of individuals who are interested in your project (if the group is large, break participants into groups of 4–5).

Write down your central message in the center of your workspace (either on a board or at a table).

Begin the session with a question prompt that relates to your goals.

Only focus on one question for each session.
Exploring more questions might cause participants to prioritize ideas.

Appoint a moderator to write down **all** ideas.
Remember that at this stage ideas should be cheap, plentiful, and unjudged.

Aim for bursts of ideas. Keep the sessions short and focused.

Value your unique perspective, and don't be afraid to share personal accounts (instruct others to do the same).

Value the perspectives of the other participants as well.

Avoid lingering on one idea for too long.
When things slow down, stop the session and offer a report to participants.

IDEA DROPS

Sometimes seeing a collection of ideas is more fruitful. Idea drops use visual language to collect ideas, often in the form of sketches and imagery. The goal is to represent ideas quickly and see them all at once.

Idea drops can be done individually or with a small group. If you are working with a small group, you may want to give them *homework* in advance, such as bringing reference images.

VISUAL BRAIN DUMPING TIPS

Write down the central message where it's visible to everyone.

Utilize the images from your creative brief notebook, online searches, or those provided by clients. Also, provide ample space with which to draw sketches and make notes.

Set a time limit.

Don't worry about the order of the sketches — remember, it is not yet time to evaluate ideas.

Avoid lingering on one idea; this can happen later.

DESIGNING THE STORY

Chances are your ideation sessions will have left you a little tired but also brimming with ideas. The design process helps you to prioritize those ideas. Once you have developed a central theme (i.e., your highest priority), you can begin to craft sub-themes to support it, a sequence around it, and a Story to represent it.

DEVELOP SUB-THEMES

A central theme gives meaning to your ideas, while sub-themes help you to elaborate on them. Each sub-theme is bound to your central message but adds additional depth and resonance. While developing sub-themes, explore the answers to Point of View, Project, or Pitch questions as well as your content (e.g., project deliverables). Look for patterns and areas of alignment to the central theme.

Consider the following questions:

- How do your sub-themes compare in terms of scale, context, meaning, etc.?
- How do these ideas connect, parallel, or contrast?
- How do these patterns speak to the values you're aiming to portray while encouraging the audience change you're seeking?

SEQUENCE

The structure of a message can have a profound impact on how it's interpreted. Consider this to be the sequence of a presentation. A great sequence can help the audience follow along, build and maintain their interest, and leave them willing to make the proposed change. A poorly orchestrated sequence can leave the audience confused, irritated, apathetic, and unlikely to respond positively to your ideas.

> Order your ideas so that they are logical, build in momentum, and prompt the change you are seeking

While it can be easy to get lost in the details of a presentation (and lose sight of your goals), good design storytellers view their presentation holistically, almost as if they are taking the audience on a journey – each step supporting the goals at hand. With this in mind, plan the overall structure first. It's not yet time to focus on the introduction or conclusion. Instead, concentrate on developing an ordering of your ideas that is logical and builds in momentum, thus maintaining the audience's attention.

Consider the following ways to organize your presentation:

Sequential

Themes are ordered via a step-by-step sequence (i.e., once one event occurs, it sets in motion a series of corresponding events)
For example, "if the customer wants to use this device, they simply start by . . ." or "I began this process by . . ."
This structure works particularly well for highlighting what a client wants to have happen and how that scenario can come to fruition, like actions culminating in a reward or a plan moving forward.

Pros:
Simple
Provides the potential to build momentum

Cons:
Can lose audience attention

Example: *Need to fulfillment*

Chronological

Themes are arranged according to their progression in time (either forward or backward), for example, a day in the life of a customer, or a company's past, present, and future. This order is often the simplest and easiest type of presentation to comprehend.

Pros:
Simple
Easy to understand

Cons:
Predictable

Spatial

This method describes how themes relate to each other either geographically or in a physical space. This is akin to touring a space or city, and it can help the audience see how concepts "fit" with one another, showing relative location. For example, "Upon entering the space, a client would . . ." or "While walking through Times Square, . . ."

Pros:
Suggests relationships

Cons:
Reliant on the audience's spatial thinking and their ability to create mental images

Information Significance

Themes are ordered by their relative importance — either from least to most important, or vice versa. The former provides a sense of increasing momentum, whereas the latter is similar to the newspaper editor's creed of "don't bury the lead," in that the headline provokes reader interest. More detailed information and less significant aspects of the story are reported near the end of the article. The editor's premise is that readers choose how far into the article they wish to read. However, in a presentation, the audience generally does not have the option of abandoning the message, so the danger is in knowing how much to elaborate on the information, but still retain their attention.

Pros:
Establishes audience interest

Cons:
May lose audience attention

Example: *Insight with corresponding information*

SEQUENCES WITH CONTRAST

Organizing a presentation via sequential steps, time, location, or information significance are all fairly linear methods. They are easy to follow since they have a clear starting point and a natural progression. However, if your goals are to compare schemes, highlight gaps, or point out counterintuitive ideas, you may want to contrast ideas in order to provide both explanation and added interest.[4]

Problem-Solution

The central theme in this type of presentation is solving a problem. Acknowledging the problem first can help convince the audience that they need to make a change. Once the issue is made known, they are then provided with a solution. For example, "roughly 1 in 16 Americans suffer from some form of arthritis. These individuals can face problems with . . . and this idea will help to alleviate their struggles."

Pros:
Compares something unfamiliar to something familiar

Cons:
Audience might disagree with the problem, thus invalidating the "solution."

Examples: *Impossible to possible; hope to reality*

Compare-Contrast

This strategy compares two elements or elaborates on multiple perspectives. For instance, how things are now compared to how they could be in the future. Politicians often use this tactic when challenging incumbent candidates. In essence, "if you elect me, your future will be better."

When multiple parties are involved, you can also acknowledge their unique perspectives on the theme at hand. For example, how the politician might improve the lives of children, families, and the elderly, or sharing design features of a hospital according to the perspectives of staff, patients, and visitors.

Pros:	Cons:
Highlights differences & gaps	Can confuse audience

Examples: *What is now to what could be; what was to what is now*

Advantage-Disadvantage

These presentations often start by discussing the central issue; sub-themes are then shared according to their advantages and disadvantages for the audience. This can be a useful tactic since clients want to maximize potential benefits (and often understand the reasoning behind a design decision).

While clients are likely to want to understand potential benefits, they might grow confused about which sub-theme is being discussed. As such, presenters utilizing this structure should provide visual indicators or other devices to help the audience "track" where they are in the presentation (See Chapter 6).

Pros:	Cons:
Provides relatable information	Audience may want to "cut to the chase" and hear only about the best scenario.

Example: *Ordinary to superior*

Cause-Effect

This structure uses causal reasoning to highlight the positive or negative consequences of a decision via an action and its corresponding reactions. Essentially, if *this*, then *that*. For instance, "if you build a new space, your company will likely recruit first-rate talent" or "if you continue down this path then . . . will happen."

Pros:	Cons:
Suggestive of consequences	Audience might not agree with the correlation of events.

WHICH SEQUENCE IS BEST?

There is no one simple way to determine which sequence will work best for a particular scenario and it may take a few attempts to get it right. However, editing, storyboarding, and, of course, feedback will provide you with tools to help weigh your options.

EDITING YOUR STORY

There is an implied violence in the act of editing. Film editors traditionally had a "cutting room floor," where discarded shreds of films lay waiting to be swept away. Designers are told to "kill their darlings" to decide if their most beloved idea is actually holding them back. Meanwhile, the combination of the letters "V" and "E" can send even the most stoic of architects into fits, since they mean the prospect of scaling back or "cutting" out design ideas via value engineering.

Yes, editing can be a difficult process, but it is critical. There will come a time when you will simply have too many ideas or too much content. Moreover, if you attempt to speak to everyone, you risk speaking to no one at all. And remember, as an audience-focused presenter, your goal is to tailor your message to the change agents within your audience (see page 24). If they are swimming in information, chances are they may not remember any particular parts of your message. Thus, you must edit on the behalf of your audience. Once you have determined your presentation's sequence, reexamine it against that central idea and the audience change you are seeking. Any sub-themes that fail to "speak" to that idea should be considered irrelevant and removed.

If editing is painful and doesn't come naturally to you, remember when you're receiving feedback about an idea keep yourself from thinking of it as a personal critique. A good critique isn't aimed at you as a person but is an objective examination of your work and ideas. Keep in mind that editing can actually be a liberating process as it frees you from grasping too tightly to weak ideas. And even if you think you have arrived at your best ideas, try another option. You can always go back to your original idea – or revive your darlings – so don't be afraid to grab the red pen.

STORY EDITING GOALS

- Narrow down your ideas, and aim to be succinct.
- Eliminate sub-themes that fail to support the big idea.
- Explore how the sub-themes relate to each other.
- Explore alternate options — never settle for your first idea without exploring other possibilities.
- Share your ideas with others; who can offer a new vantage point on your work.

> Chances are your audience doesn't want to hear everything you have to say, so edit on their behalf.

"S"tory DEVELOPMENT

Your presentation is a story in and of itself, but to make it tangible and relatable, consider including a singular Story. To do so, explore your presentation sequence and determine where explicit story elements support your central theme.

There are many ways a Story can be threaded into a design presentation. A "S"tory can be used to begin the presentation and be revisited at its conclusion, or a protagonist can provide structure to the presentation as the audience explores your ideas through the character's eyes. Stories can be factual accounts or fictional tales. The key is to be authentic.

Good storytellers know what facts the audience needs to understand a story, when to stretch out the details, and when to gloss over events.[5] Applying this to a design presentation means your Story will need to garner attention almost immediately, but still leave enough time to focus on the design you're presenting. To do so, include only the necessary details to spark interest and use vivid words when describing the aspects of the design itself.

In his 2004 book *Seven Basic Plots,* journalist Christopher Booker asserted that stories share common themes of: *initial anticipation, dream (i.e., unrealistic invincibility), frustration, nightmare,* and finally *resolution.* He concluded that such stories could be generalized along one of seven plots, each with their own psychological unpinning.[6] Consider the use of conflict in each:

BOOKER'S SEVEN BASIC PLOTS

Overcoming the Monster
Example: school overcoming high student drop out rate

Tragedy
Example: visiting a student who dropped out

Voyage & Return
Example: school board first decides to close the school, but then decides to rebuild it instead

The Quest
Example: a firm's quest for the best design

Comedy
Example: a class celebrating a funny event

Rags to Riches
Example: students enjoying their new school

Rebirth
Example: school celebrating a new graduating class

In addition to Booker's seven, author Kendall Haven offers 12 story types, which he refers to as models.[7]

HAVEN'S STORY TYPES

Historical	conveys a sense of resilience by looking back on a trial or tribulation
Who we are stories	highlight a group's unifying characteristics
Teaching stories	utilize analogies to help people understand something new
Framing stories	set the stage for a presentation or new way of thinking
Future vision stories	create a compelling vision of the future
Wow stories	build appreciation by focusing on complexity, precisions, dedication, etc.
Struggle stories	outline struggles faced by a character on behalf of a noble cause
Relevance stories	concentrate on a specific issue with a short, tightly focused narrative
Put a face on it stories	make something abstract like a statistic seem real and personal
Values stories	present events that embody an organization's or individual's core values
I am you stories	highlight shared characteristics between a speaker and their audience
Ongoing stories	break a complex topic into parts; think TV series or pod cast

Booker's and Haven's lists can be used to stimulate your own story ideas.

No matter the type of Story you're developing, remember that it will need to garner the attention of your audience quickly. To do so, the audience needs to understand and care about what's at stake from the very beginning. Recall the story segments from Chapter 1, Launch, Load, and Landing (page 13).

LAUNCH

The beginning of your story should quickly set in motion its events. Early on, you'll need to get the audience to care, so offer story components such as: who is involved (i.e., the characters), what they are doing, why they are doing it, when they are doing it, and where it occurs.

Read the first pages of a few fiction novels. Is there is a sense of tension or imbalance from the beginning?

Incorporate a few carefully selected sensory details so that the audience can imagine the situation for themselves. The key is not to provide too much detail. To determine what information to include, think about affective priming. In other words, what emotions does the audience need to have to prompt the change you are seeking? With this in mind, describe the scene in a way that evokes these emotions. For instance, if you want them to be angry about a problem, offer them details that are sure to fuel their angst.

The other important task of the story's beginning is to pique the interest of the audience, which isn't easy since attention is such a precious commodity. But remember by human nature, when we care about a problem, we want to see that it gets resolved. So, in the beginning, spark interest by highlighting an imbalance. Remember to offer a *breadcrumb trail* (see page 12) to build tension and the audience's suspicion that something is amiss. Or start out with a bang, by describing an inciting incident that sets off a chain of reactions.[8] The backstory highlights the events leading up to this incident, and expository scenes provide information about it, these elements work together to build interest and understanding.

THE ROLE OF PRIOR KNOWLEDGE

We are all plagued by the curse of knowledge from time to time. That is to say, our experiences bias how we see the world. This is because we call upon our **prior knowledge**, or what we know beforehand, to interpret new information and events.[9] Similarly, an audience will use their prior knowledge to judge information. Author Ellen Lupton described this as "mapping familiar territory and charting the unknown."[10] In essence, stories act as "physical, visceral, and highly visual"[11] metaphors since they symbolize familiar ideas and provide new information in a way that the audience can relate to. These relationships are indispensable as they can help the audience grasp unfamiliar concepts in vivid and tangible terms, and with emotional accuracy.

A metaphor can be established early in the story by grounding it in a universal truth that resonates with the audience (see page 23). In other words, wrapping your story around something that you know they will understand, because it speaks to the human experience. This will add to the relevancy of your message, and the audience will call upon this universal truth to judge any subsequent information that you may offer.

A metaphor can help the audience answer the question, "What does this have to do with me?"

CHARACTER

Often, when we think about a story, we focus less on its plot and more on the characters who experience its events.[12] That is, of course, only the case if we care about these characters. Similarly, an audience needs to care enough about a character to want to see their issues resolved.

While your characters don't always have to be people, they should embody a few traits that will help an audience relate to them. Master storyteller Kendall Haven stated that compelling story characters must:[13]

> **Be a physical entity**
> Having a physical form makes them more relatable.
>
> **Be an individual**
> It's easier to relate to one person than a group.
>
> **Possess the will and ability to act in their own self-interests**
> We need to know that they can act upon their goals.
>
> **Be able to communicate**
> We need to have insight into what they are thinking & feeling.

The longer the story, the more opportunities there are to express character traits. These traits can influence the audience's attitude about the character, i.e., do we root for their success or revel in their failures?[14] Yet, a character doesn't always need to be real to be relatable. Fictionalized characters can be controlled, in that the storyteller scripts their reactions, but the risk is that the audience will see through these characters and grow apathetic about their plight. Real characters are obviously more relatable, but the question becomes, do they actually support the values that the storyteller is suggesting? At the same time, representing a mass of people with a prototypical character can be useful, but it can be difficult for the audience to relate to their more general characterizations. Finally, using yourself as a character can provide the benefit of instant relevance, but doing so can leave you feeling vulnerable and exposed to more intense scrutiny. So consider this tactic carefully. A story about a silly mistake you have made may be funny, but some audiences may judge you poorly after hearing it.

TYPES OF CHARACTERS

	Fictionalized	**Real**
	Pro: Can be controlled	**Pro:** Relatable
	Con: Audiences might see through them, & be less likely to care about their plight.	**Con:** They might not always support the values of the story.
	Prototypical	**Yourself**
	Pro: Represent many people	**Pro:** Relatable
	Con: They can seem inauthentic.	**Con:** You may feel vulnerable and open to scrutiny.

Recall that Jonah Sachs defined interesting characters as either "freaks," "familiars," or "cheats."[15] Freaks are captivating as they contradict our expectations; familiars remind us of ourselves or someone we know; cheats break the rules (either for good or bad). Going further, character's built on Carl Jung's archetypes can be used to frame the moral of the story,[16] meaning that their traits can be used to represent the values you're aiming to portray (See Chapter 1).

SACH'S CHARACTER QUALITIES,
based on Carl Jung's archetypes

What values do these characters embody?

Captain
adventurous, confident, tireless, & brave

Key values
wholeness, perfection, truth

Negative traits
can hold too tightly to their power

Muse
has faith in those around them

Key values
beauty, richness, uniqueness

Negative traits
can be too passive

Pioneer
bold, curious, & unafraid

Key values
uniqueness, truth, richness

Negative traits
impatient

Rebel
creative, uncompromising, & driven to pursue justice

Key values
justice, uniqueness, truth

Negative traits
easily mistaken for a criminal

Magician
surprising, creative, & irreverent

Key values
playfulness, perfection, beauty

Negatives traits
can appear fraudulent

Defender
driven to defend the vulnerable

Key values
justice, perfection, wholeness

Negative traits
may be the last to accept change

Jester
intelligent but playful

Key values
playfulness, justice, simplicity

Negative traits
can appear frivolous

What makes the character relatable?

EXERCISE 3.0 CHARACTER STUDY

Write a paragraph answering the following questions.
Which character qualities from above do you most closely identify with?
How might your key values and flaws move a design story forward?

LOAD

The middle of a story helps the audience to vicariously experience its events. To aid this process, aim to provide context, define conflict, and share information during Load. When designing your story, ask yourself what "pictures" you want the audience to generate and recall. Then, what sensory details are needed to help them form these mental images? Aim to include a few details that appeal to our sense of sight, sound, touch, smell, or taste. These details can be scenic, in that they describe the setting of an event, or be event-specific, by recalling the thoughts, feelings, and motivations of the characters as they experience the story's unfolding events. A design story might include a combination of these tactics to add richness and intrigue.

TYPES OF STORY DETAILS	**Scenic Details** Use vivid words to describe the setting of an event.
	Event-Specific Details Recount the thoughts, feelings, and motivations of the characters involved in an event.

Whichever types of detail you choose, remember that they will be used by the audience as a substitute for their own observations. However, too many details will leave the audience buried and bored, so each detail should relate back to your central message. If this is proving difficult, the middle can actually be written after the Launch and Load segments since it serves as a bridge between the two.

EXERCISE 3.1 ADDING DETAIL

Determining the appropriate types and quantities of details can bring a dull story to life. Read the story below, and revise it by adding sensory, scenic, or event-specific details. Then share your version with another person to determine if you have added an appropriate amount of detail.

> Despite her age, Gina was facing a number of health problems. These made even the most mundane daily activities difficult. Her fingers could barely move and her wrists ached. She knew that there had to be a better way to improve on some of her activities in the kitchen. After all, her family depended on her, and fast food wasn't an option. So she picked up the cheese grater and got to work looking for a new form that might ease her pain and still allow her to provide healthy meals to her children. Many attempts ended in failure. Yet, she was driven. After nearly a year of trial, error, feedback, and revision, she was ready to share her prototype with others.

LANDING

When the audience has had the chance to become fully involved in the story's events, their Landing can be either a hard or soft one. That is to say, you can end abruptly on a profound point or slowly bring events to a close. Either way, the story's end should embody the moral you're aiming to convey.

Many designers don't offer this type of closure, instead opting to pivot their audience's attention toward their design outcomes prematurely. This can leave the audience feeling like the story is unresolved, which can be a missed opportunity since the story's resolution can play a central role in prompting the audience change you are seeking.

Author Kendall Haven has explored the link between a story's resolution and the audience's emotional state, calling this Residual Resolution Emotion (RRE).[17] He posited that an audience is deeply affected by their emotional state at the end of the story – whether they are feeling upbeat or downtrodden. Haven refers to these as positive or negative RREs. While they each affect audiences differently, he asserts that both are influential. He was led to this conclusion after studying the reactions of multiple audiences to different stories.

THE INFLUENCE OF A HAPPY ENDING

Haven found that stories with a powerful happy ending, i.e., those that were considered eye-opening, gripping, inspiring, impressive, commanding, powerful, heroic, or life-altering, have little immediate effect, but can have a long-lasting impact.

Yet, he found that the most influential positive RRE stories aren't the result of an entirely rosy scenario for the character. In fact, the character still faced turmoil and conflict. Haven suggested when the audience identifies with the main character and sees their success, in the end, their takeaway is "I should do the same thing, should a similar opportunity arise." Thus, they may not act immediately, but when the time is right, they will be more likely to undertake the same actions as the character. However, this implicit message hinges on audience's involvement in the story. The best way to ensure their involvement is to leave a little bit of doubt that the character will resolve the problem. That is to say, the character struggles. Without this sense of the character's struggle, the path toward resolution appears too easy, and thus the audience is less likely to care.

THE INFLUENCE OF A TRAGIC ENDING

Haven also found that negative outcomes can be effective in prompting audience change. Stories described as abhorrent, heinous, loathsome, despicable, detestable, outrageous, atrocious, or intolerable created a demand for action from the audience. Haven suggested that it was as if the audience was driven to change the outcome of the story.

> Happy endings may have little immediate effect, but can have a long-lasting influence on an audience; negative endings tend to prompt them to take action.

LEVERAGING THE STORY'S ENDING

If your goal is to have the audience do something quickly, negative stories can stimulate a "call to action." In fact, the more distressing the story's resolution, Haven wrote, the greater the tendency for that audience to take immediate action (i.e., donate, protest, boycott, etc.) – "It is as if they feel compelled to correct the situation."[18] So, keep your goals in mind when determining your character's fate.

CHARACTER CHECKS

Haven offered some checks to help storytellers understand the possible effect their story's characters will have on their audiences.[19]

> **CHARACTER CHECKS**
>
> Determine which character the audience actually identifies with (it may someone other than your protagonist).
>
> How bad (or good) is the story's ending for that character?
>
> Who is blamed (or rewarded) for that ending?

You'll want to ensure that your audience will identify with the intended character. You may be surprised to learn that they are more likely to identify with someone other than your main character. If so, revise your story to make your protagonist more prominent or relatable. Remember that if your goal is to evoke an immediate response, the ending should be bad for this person. If your intent is for a more sustained response, then the story's resolution should be good for this character. This way, the audience will want to mimic the actions of the protagonist, so that they too might enjoy the same outcome. Finally, make certain that the right foe is being "blamed" for a negative outcome. For instance, if the main character is an employee struggling to be productive despite working in a poorly planned office environment, the blame for his struggles should be placed on the environment and not some irrelevant foe, such as an unreasonable boss. On the other hand, if the outcome is positive, you'll want to make sure that the main character is credited.

STORYBOARD

Part organizer, part archivist: a storyboard is a vital tool in storytelling. When working on a storyboard, start broad, thinking of the overall story. Then add sub-themes and details as they become known.

FIGURE 3.3 Storyboards start broad & details are later added

LAUNCH — GOALS:
LOAD — GOALS:
LANDING — GOALS:

Early storyboards start as basic outlines.

LAUNCH — CHARACTER: SCENE:
LOAD — CHARACTER: SCENE:
LANDING — CHARACTER: SCENE:

Subsequent versions add more detail about characters & scenes.

THINGS TO AVOID IN STORYTELLING

"There are only three rules for creating great stories . . . unfortunately, nobody knows what any of them are," wrote Haven.[20] While we know there is no one "right way" to move through a story, established storytellers do provide some tips as to what a storyteller should avoid.[21]

THINGS TO AVOID

Bragging	An audience would rather hear about their successes than yours.
Using Jargon	Be sure to define unfamiliar terms.
Talking **at** the Audience	Illustrate with sensory details, but let the audience make their own conclusions.
Exaggerating	Do not claim a story is true if it is not.
Being Impersonal	Avoid intangible statistics. Instead, personalize a story with one central character.

AIDING RECALL

If you have managed to change the beliefs and actions of the audience, you will want to ensure that they will remember this change. To do so, consider how to help your audience members remember your message.

LEVERAGE A LOGICAL SEQUENCE AND SERIAL POSITION EFFECT

The audience is more likely to remember the first & last parts of a message.

Tip: Orientation is important.
Ensure that the audience is connecting pieces of information as they should.

Example:
A designer may include a table of contents or verbal guide on what they will cover.

HELP THE AUDIENCE DRAW CONNECTIONS

Help the audience connect new information to familiar ideas.

Tip: Consider the use of metaphor.

Example:
A designer may refer to a hospital's design as being "like a mountain spa."

MAKE THE AUDIENCE WORK

Having the audience work provides them stimulus & opportunities to think for themselves.

Tip: Ask the audience questions and pause for reflection.

Example:
A designer may ask an audience to think about their first experience with a product.

EXERCISE 3.2 EVALUATING STORIES

Think back to your favorite book or movie.
Can you identify the character qualities of the protagonist?
Does that story have a clear beginning, middle, & end?

HOW TO COLLABORATE

Remember the adage, "Two heads are better than one"?
Similarly, collaboration can result in better story ideas and more thoughtful presentations. While the benefits of collaboration are many, it can be a difficult process.

To manage collaboration, consider the following:

Try to work in close proximity
which will allow more opportunity for sharing and clarifying.

Teams that play together, stay together
find opportunities for everyone to enjoy the process.

Identify formal or informal leaders
these leaders can help keep a project on track by delegating tasks.

Accept that conflict is inevitable, but not necessarily bad
no two team members will share all of the same ideas, but by acknowledging and considering the opinions of others, the best ideas may emerge.

Hear and be heard
it is important for each party to value the backgrounds and contributions of others. No one will have the same experience and background as you, and your team members will rely on your unique perspective to help shape the idea.

SUMMARY

Designers use both stories and "S"tories. Presentations themselves are stories, while "S"tories can help make your ideas come alive.

Designers may find themselves crafting stories that speak to their own points of view, highlight a key project, or pitch for a potential opportunity. The design of these presentations is similar to that of the design process. In both, the early stages are marked by a multitude of ideas. These ideas are mined to unearth a central theme, which is akin to the values of your message. To hone your message, examine how your themes and sub-themes align with your goals and the characteristics of the audience – especially when it comes to how the central message prompts the desired change. The arrangement of the themes and sub-themes, also known as the sequence, should be considered holistically, wherein the overall structure is determined prior to deciding specific details.

"S"tory
To make the presentation relatable, overlay aspects of Story to pique audience interest. During your Story, provide sensory details to help the audience build mental images. Be sure to offer them a character they will care about. The Story's resolution can influence the audience. Research suggests that strong positive stories elicit delayed, but long-lasting responses, whereas negative stories compel the audience to a more immediate action.

Recall
After all of this effort, you'll want your audience to remember your message, and they are more likely to do so if:
- information is arranged to leverage serial processing,
- ideas are presented relevant to their prior knowledge,
- they have a chance to reflect on it or work toward a solution.

TERM

prior knowledge

APPLICATION 3.0

As you develop your presentation further, consider the following:

1 Based on your goals, answer questions in the point of view, project, or pitch sections (see pages 35-37). Remember to ask "why" to your answers to unearth their deeper meaning.

2 Explore how your answers represent common themes, the most prominent of which becomes your central theme. Remember, the aim of this central theme should harken the change you are seeking from the audience.

3 To develop sub-themes, explore the answers to your questions alongside your content (e.g., project deliverables). Look for patterns and any potential alignment to the central theme.

4 Using your sub-themes, explore the most appropriate sequence for the presentation (see pages 40-42).

5 Then develop a Story that represents the values of this central theme. Consider how this Story should be woven into your presentation.
 How do the characters embody the values?
 How might the audience relate with the characters?
 Are there any metaphors that would make its events more relatable?

6 Using your answers, conceptualize your overall presentation below.

Launch	Load	Landing
Introduction	Middle	Ending

Part 2 Modes of Communication
Defining our medium.

OBJECTIVES

- Gain a broad understanding of the role of writing in design
- Understand how to distill information with words
- Understand how words can convey different meanings
- Understand how to write succinctly and clearly

WRITING FOR IMPACT

This chapter will focus on written communication.

Jack had worked late into the night. He knew his boards were stunning, and Jack was confident that the jury, three esteemed designers from Chicago, would judge his project as the best in the class. In his confidence, Jack decided that the written summary, a required component of the project, was not important. Consequently, he spent little time crafting it.

When Jack failed even to receive an honorable mention, he politely pulled one of the jurors aside and asked why. "Your design was interesting," she said, "but your statement was lacking a coherent point, and your writing was riddled with errors." Then she told him,

"Your writing is a reflection of your ideas."

INTRODUCTION

Good writing draws us in. We understand it and identify with it. As we read along, we hear the rhythm of its words in our heads, while our minds construct mental pictures of its unfolding events. On the other hand, bad writing leaves us bored, confused, or annoyed – or perhaps asleep. The point? Good writing engrosses us in a message; bad writing causes us to abandon it. If the message were about you (or your work), which would you choose?

While writing is often a core component in design communication – necessary in cover letters, project proposals and narratives – many young design professionals fail to recognize its value, choosing instead to shy away from what they see as a burden. But we must accept our responsibilities as design storytellers; our calling requires us to use all of the tools at our disposal to inspire our audience. If our words leave them confused or uncaring, we have been careless. We have failed to make our writing clear and potent. Writing is hard work, but great designers have a story to tell, and we owe it to our audience (and our ideas) to sculpt, revise, and refine our writing. This chapter will help you do so.

WHY DOES WRITING MATTER IN DESIGN?

Design communication is awash with written messages. As designers, we use our words to describe our work, ourselves, and to craft our talking points. Storyboards reflect these messages on a broad level, but our words will define them. Whenever you begin writing, start by recalling what it is you are trying to say and why. Then, draft a simple outline based on these answers. This outline should serve as your aim, but not your burden to bear. So don't worry about using the proper Roman numerals.

IN THE BEGINNING (LAUNCH)

With a written story, it will be especially important that readers know why they should spend their precious time with your words. The beginning of your story should give them this answer. In journalism, they call this the lead, and it is incredibly important. A lead has to garner the attention of the audience – failure to do so means that they will stop reading. Some leads work quickly to do this by enticing the reader through humor or surprise; others exert more of a slow, steady pull – building over the course of several paragraphs. There is no definitive length for a good lead; just remember to nudge the reader's curiosity. A little intrigue will leave them wanting more.

IN THE MIDDLE (LOAD)

After the audience is hooked, you can relax your tone as your efforts move from entertaining the audience to informing them, essentially loading in a bit of context and detail. This is the time to provide your readers with enough information to set the stage, but not so much that every aspect is revealed. As you write each sentence, ask yourself what the readers need to know next. Remember that the goal is to keep their interest so that they want to know how the story is resolved.

THE END (LANDING)

There are many ways to end a written design story; the key is knowing when to do so. A well-written story does not ask its readers to slog along any longer than necessary. As you write each sentence, continue to ask yourself what readers need to know next. If nothing else is needed, end the story – make your point and bring the readers home. You can opt for summative endings by concluding with a sentence that is unexpected or refreshing. Or your ending can refer back to the story's beginning, which can help convey a sense of resolution. Author William Zinsser calls this an echo. Quotes can also be a great way to end a written story since they can add finality, wit, and a humanizing element.[1] Whichever way you choose to end the story – aim to make it memorable.

FIGURE 4.0 Considerations for written stories

LAUNCH	LOAD	LANDING
Why should readers care?	What should readers know?	What should readers remember?

ELEMENTS OF GOOD WRITING

Good writing is cohesive, concise, and clear. At the same, time it conveys the author's voice with an appropriate tone. Consider the following strategies when writing a design story:

COHESIVE WRITING

Inconsistency can be distracting to readers. Yet, cohesive writing can be difficult to achieve, especially in longer passages that are written over a period of time. To unify your writing, consider how you want to address your readers and share your content according to predetermined guidelines.

To help guide your writing, answer these questions in advance.

- As a writer, will you take an involved or impartial stance?
- Will you be an active participant in the events (writing in first person) or an objective observer (writing in third person)?
- What pronoun (he, she, they, it, we) & tense (past, present, future) will you use?

ECONOMICAL WRITING

"Writing is like a good watch – it should run smoothly and have no extra parts," wrote Zinsser.[2] Similarly, designers are taught that unnecessary lines in a technical drawing can cause confusion. The same can be said about extraneous words in a sentence. This means you should write with economy in mind; few words make a more direct point. At times, it's tempting to defy this principle with common expressions, but good writers aim to find the shortest path to the same meaning, which makes their ideas clear, and their writing potent.

AVOID UNNECESSARY WORDS
If your sentences still convey the same meaning without several words eliminate them.

Instead of...	Consider
She is the person who	she
In a quick manner	quickly
His upbringing was an unusual one.	His upbringing was unusual.

AVOID UNNECESSARY PHRASES
Similarly, if your ideas can be conveyed without the use of a phrase, eliminate it too. Some common offenders include:

Who is, which was, the fact that, in order

AVOID HEDGING
Timidities such as "a bit," "a little," and "sort of" are unnecessary qualifiers that conceal your voice and dilute your message. This is known as hedging, and doing so can make it seem as though you don't fully stand behind your message.[3] Constraining your language behind hedges not only adds words, but it cheapens your ideas, causing you to be less convincing. So if you know your words to be true, write with conviction and avoid tame, dull, noncommittal language.

Instead of The curved form is, perhaps, a bit out of place.

Consider The curved form is out of place.

CLARITY

It is critical that readers understand your writing. This is done by clustering similar information and reducing areas of ambiguity.

CLUSTERING INFORMATION
Consider the following tactics to organize your content:

Parallel Construction
For readers to understand that ideas are similar, offer them in a similar manner. This is called **parallel construction.**

Instead of	In the past, consumers had only a few choices for materials, while now numerous choices are available.
Consider	In the past, consumers had few material choices; now they have many.

Place Related Words Together
Place titles alongside their corresponding items.

Instead of	Christopher Alexander, in his book, *A Pattern Language*, discusses ways to work with others.
Consider	In his book *A Pattern Language*, Christopher Alexander discusses ways to work with others.

Pronoun Placement
Relative pronouns such as who, whom, whoever, and whichever should follow their antecedent.

Instead of	This is an image of Dieter Rams, an industrial designer, who coined ten principles for good design.
Consider	This is an image of industrial designer, Dieter Rams, who coined ten principles for good design.

Modifier Placement
Modifiers are the words that change or clarify another word's meaning. They should be placed next to the word they modify.

Instead of	He only proposed two ideas.
Consider	He proposed only two ideas.

REDUCING AMBIGUITY
To reduce uncertainty, the reader should always feel as though they have a sense of orientation and an understanding of the relationships between ideas. This is especially critical when presenting contradictory information. If ideas conflict, prime the reader for this change so that they don't become confused or frustrated. Alert them with transition words such as "But," "Yet," and "However" at the beginning of the sentence or with correlative expressions like "either," "both," or "not only" near the terms they are referencing.

Instead of	The idea gave new perspective and it came at a good time.
Consider	The idea was both fresh and timely.

Zinsser stated that it is okay to start a sentence with "But"[4] (even if our elementary teachers told us not to). "But" announces a total contrast with the previous sentence so that the reader is ready for the change.

VOICE

A writer's voice can be the difference between sounding confident or cowardly. In writing, voice stems from whether your sentences have the subject act (active voice) or be acted upon (passive voice). An active voice is seen as more direct and dynamic than a passive one. To write in an active voice, consider how to compose your sentences so that the subject precedes the action. Essentially, they do something, instead of having something done to them.

Instead of	The sketch was drawn by Jeff.
Consider	Jeff drew the sketch.

A subject should act, not be acted upon.

TONE

The tone of your writing depends on your goals and your audience. If the audience is unfamiliar, it may be best to use formal writing. If you know the audience, or you are confident that they will appreciate an informal tone, casual writing may be more appreciated. Whichever you decide, keep your tone consistent throughout your writing. Do your homework about the client, but don't lose sight of what makes you most comfortable. You want to be authentic – just be aware that your audience may perceive your writing differently than you may expect.

Positive Tone

Aim to write in a positive tone, meaning eliminate the word "not" whenever possible, and avoid double negatives.

Instead of...	**Consider**
Did not remember	forgot
She did not pay attention...	She ignored...
He needn't refrain...	He should keep...

HUMOR

We like to be around those who can make us laugh. Beyond adding levity, humor encourages readers to let their guard down, potentially causing them to be a little more receptive to your message. In short, humor is a valuable tool, though difficult to master since it's subjective – not everyone finds the same things funny. However, we don't have to be the next Kevin Hart or Kate McKinnon to master the tools of the trade, which include mockery through satire or parody, irony, and sheer nonsense.[5] The key is control and connection.

Forced humor often feels contrived and lame. Humor works best when it's understated, so control your use. Let the readers see the humor in your words for themselves.

Humor also relies on connectedness, meaning things are funny because we can identify with the situation. The best humor is based on aspects of life that we can all relate to, such as eating, working, or growing up. Zinsser wrote that humorists exert a "special angle of vision,"[6] since they can find the humor in seemingly mundane situations.

So, it may be worthwhile to craft a zinger; just don't tell your readers to laugh.

WORDS

Words are a writer's greatest tool.[7] To make the most of this tool, make your words work for you. Each one should support your purpose, suit your personality, and signify meaning. Consider the following:

SELECT SHORT WORDS

Short words often have the greatest impact. If you find this hard to believe, consider that 71% of the words in Gettysburg Address were just one syllable.[8]

So, why must we "attempt," when we can simply "try"?
Why should we provide "assistance," when we can just "help"?

If there are shorter words to convey the same meaning – use them.

CONSIDER THE RHYTHM OF YOUR WORDS

When selecting words, listen to how they sound.
Are key words emphasized through rhythm, such as occurring on a beat?
Do they make use of alliteration (i.e., start with the same letter)?
These stylistic devices can make the reading more enjoyable.

AVOID JARGON

While **jargon** may make us feel clever, our readers will often resent our pretentiousness. Avoid the temptation to use jargon. If you need to use a specific word that may be unfamiliar to the audience, explain it within the sentence.[9]

Example
The room was to have an exposed plenum, meaning that since there was no ceiling, all of the pipes and wires would be visible.

AVOID CHEAP & EMPTY WORDS

Cheap and empty words fail to convey meaning. They often leave your writing feeling stale, and your message buried.

Check that your use of the following words is necessary to convey meaning:
very, literally, like, certainly, or just

AVOID BUZZ WORDS

Avoid overused words, which can make you seem unoriginal and superficial.

AVOID THE TRAPPINGS OF MISUSED WORDS

The English language is rife with words that are used incorrectly – far too many to cover here. Below are some of the most common culprits.

EFFECT vs. AFFECT
Effect is a noun, whereas affect is a verb.
The effect is clear. The audience was affected by the film.

WHOM
Whom is often incorrectly substituted for *who*. A simple rule of thumb is that: "Who" works best when using the pronoun "he" or "she." Whom works best when "him" or "her" is the pronoun.

LITERAL
Literal (or literally) can often be avoided; it should never be used to support an overstatement, such as "She literally nailed the project."

RESPECTIVELY
Respectively can often be removed; it's only necessary in more technical writing when it is clarifying relationships.

SENTENCES

If words are your tools, then sentences are your toolbox. Compose them so that their meaning is clear. Consider the following:

REMOVE UNNECESSARY WORDS

"Clutter is the disease of American writing," wrote Zinsser.[10] It's worth stating again that sentences should only contain what is necessary to convey the intended meaning. Anything beyond that is clutter, which diminishes the power of your message.

Review each sentence several times, hunting for unnecessary words. When one is spotted, try reading your sentence without the word. If the meaning remains, hit the delete key.

USE A SIMPLE SYNTAX

The clearest and most powerful sentences follow a straightforward **syntax**. That is, they make their points succinctly using a simple sentence structure.

If your sentence contains multiple commas and semicolons, it is likely too long.

PLACE KEYWORDS AT THE BEGINNING OR END

To avoid burying your key points, ensure that they are emphasized by placing them either at the beginning or the end of your sentence.

LEVERAGE PUNCTUATION

Punctuation can change the meaning and cadence of your sentences. Ensure that the punctuation stresses the points you want emphasized (see pages 68-69).

CLICHÉS & IDIOMS

Avoid **clichés** and **idioms** in your sentences. Phrases that are overused can make your message feel tired and unoriginal.

How many clichés did you spot in the statement below?

So, let your creative juices flow, and make your sentences pop by taking them to the next level.

STUBBORN SENTENCES

Some sentences simply don't work well. Either they are too long, unclear, or they are choppy. So, what should a writer do when facing a stubborn sentence?

Answer: break it up or remove it altogether – chances are it was trying to cover too much material and is not worth your trouble.

EXERCISE 4.0 SHUNNING SLOPPY SENTENCE SYNTAX

Rewrite the following sentence 3 different ways using the guidelines above.

> Embodying a palpable sense of complexity and purpose, the design for the hotel exudes a wide-ranging repertoire of lavish services amidst unrestrained amenities which sport ornate surfaces and masterful forms.

PARAGRAPHS

If sentences are your toolboxes, then paragraphs are what you're building. Paragraphs express an idea, thus helping the audience to know how you've organized your thoughts.[11]

Short paragraphs appear more inviting since the negative space around the paragraph gives the eye an area to rest. However, readers will interpret paragraph breaks as a place to pause, so don't lose momentum by ending paragraphs amidst a train of thought.

In most cases, paragraphs can be structured similarly to below:

TOPIC SENTENCE
The first sentence introduces a new point or refers back to the previous paragraph.

EXPLANATORY SENTENCES
The following sentences explain or develop your introductory statement.

SUMMARY SENTENCE
The final sentence is the conclusion of the thought.

PARAGRAPH LINKING STRATEGIES

Each paragraph should build upon and amplify the last.[12] To aid the overall flow of your writing, consider how to link one paragraph to the next. In general, begin each paragraph with a lead, or an introductory sentence.[13] If the paragraph follows another, consider how this introductory sentence will help the reader transition to this new idea.

Linking paragraphs can be done in several ways, such as:

- Restating the last paragraph's summary sentence in a new way
- Contrasting the previous paragraph against a new idea
- Giving a specific instance that illustrates the previous paragraph
- Adding a transition word or phrase to start the paragraph, such as: *therefore, for the same reason,* or *at the same time.*

RHYTHM
Short sentences tend to sound sharp, while longer sentences are lulling. When structuring your paragraphs, Zinsser suggested that "all sentences should not move at the same plodding gait."[14] So, as you write a paragraph, review its tempo. Not all sentences in a paragraph should follow the same syntax and contain the same number of words.

To avoid lifeless sounding writing, consider adding some variety to the structure of your sentences by:

- Changing one of the sentences to a question
- Reversing the order of a sentence
- Substituting one of the key words for another that is fresh or surprising

ENDING
The last sentence of a paragraph warrants special attention. Its job is to not only end a thought, but also to entice the reader toward the next paragraph. As Zinsser said, "Make the reader smile and you've got him for at least one more paragraph."[15]

VENUES FOR DESIGN WRITING

There are many venues for design writing, including proposals, letters, image captions, talking points, design concept statements, and bios.

DESIGN CONCEPT STATEMENTS

Think of a design concept statement as a rallying cry for project stakeholders. These statements should provide readers with a sense of your creative vision, and how your design intent speaks to the users' needs and desires. The best design concept statements succinctly discuss physical, functional, and experience-driven attributes of the design. Concept statements are generally short but aspirational.

EXAMPLE

"Students learn best in dynamic and flexible spaces," evidence suggests. — *acknowledge user needs*

With this in mind, the design for *Project Name* was informed and inspired by the notion of journey. — *introduce concept*

To evoke this sense of journey, the forms within the space will encourage movement, and every surface will be put to work. Writable walls, floor decals, and integrated technology are among some of the features that will support multimodal learning. — *functional & aesthetic description*

At the same time, students will feel uplifted by the space's bright colors and views of the outdoors. — *description of the user experience*

These and other features will promote student learning and engagement, foster social interaction, and stimulate curiosity. — *aspirational close*

EXERCISE 4.1 DESIGN CONCEPT STATEMENT

A design concept statement is an important opportunity to share your intent for a project. These statements provide clarity and direction while expressing the ideas behind the project, including how users will experience the design, its forms and aesthetics, and any important functional characteristics. To generate a design concept statement consider the following:

1 List the following attributes of a previous or upcoming design project (if you don't have one available, use a magazine article to the surmise attributes of a professional project):
- characteristics of the intended users
- concept and its appropriateness to the users
- forms & aesthetics
- user experience
- important functional characteristics

2 Write at least two design concept iterations.

3 Review these options with a collegue. Have them consider each statement's ability to pique reader interest and explain the intent of the design. Be sure to have them look for errors, and help you decide which option is best.

4 Select the preferred statement, and revise per your reviewer's comments.

5 Be sure to proof read the final version another time, and if possible, have someone else proof the statement as well.

BIOS

A personal bio is an incredibly valuable tool for networking and career development. A bio helps readers acknowledge who you are, by giving them to get a sense of "you" beyond your resume. Many designers hesitate to write a bio for fear of sounding pompous or self-centered. But don't wait until you need one to write your bio. If you are pressed for time, chances are your bio will not be the best representation of you and your potential.

EXAMPLE

characteristics —— Eternal optimist, shameless morning person, and avid dog lover;
what is offered —— Jane Doe brings her own combination of insight and strategy to each of her clients, which range from local mom and pops
background information —— to Fortune 500 companies. Jane is a graduate of Awesome
for credibility State University with a degree in Design. She is a fellow in the American Awesome Society and was recently recognized as
relatable conclusion —— 'Awesome Person of the Year' by Design Mag. In her free time, Jane is an avid bowler, finger painter, and mountain climber.

STEPS TO GENERATING YOUR BIO.

Start With Your Values.
Generate a list of your core values.

Identify Your Audience.
Keep in mind who will be reading the bio and your relationship to them.

Review Parameters.
If you're writing your bio for a specific purpose, be sure to check for any restrictions such as length and desired content.

List Key Achievements.
Generate a list of your key academic and professional achievements. Depending on the audience, you may want to list hobbies or personal anecdotes.

List Characteristics.
Think about how people have described you in the past.

Determine Writing Style.
Consider whether you will be writing in first or third person, and be consistent with your style.

A personal bio is an increasingly important asset in professional networking. The best bios reflect the author but are tailored to their specific audiences. Depending on where it will be shared, your bio may need to be of different lengths and levels of formality. Some sites have a more informal slant. In these venues, it's likely appropriate to share hobbies and personal anecdotes. Still, other venues are aimed at business professionals, so formal business writing (highlighting your accomplishments over personal characteristics) may be more relevant. At the same time, some venues will have stringent restrictions on length, whereas, on your own website, you can add more detail to your statement.

While bios naturally evolve and change, remember that once you post something online, that message can live on forever (even if deleted), so avoid inflammatory or inappropriate statements at all costs.

EXERCISE 4.2 PERSONAL BIO

Bios crafted at the last minute can turn out dull, lifeless, and even erroneous. With this in mind, many design professionals keep several bios handy so that they are available for last-minute speaking engagements or career opportunities. This exercise will help you to do the same.

1 Refer back to the Point of View questions (page 35). What themes emerge from your answers?

2 Recall what makes you interesting, both professionally and in life. How do these aspects highlight your positive attributes for the given audience?

3 Using the steps from the previous page, generate bios for the following scenarios:

- Informal Social media (160 characters max)

- Formal Social media (160 characters max)

- Professional Web page
 (i.e., short-form bio, approximately 200 words)

- Informal Web page
 (i.e., short-form bio, approximately 200 words)

- Formal Application package
 (i.e., long-form bio, approximately 500 words)

4 Review your bios with as many people as you can. Ask them if the content reflects you in a positive, but truthful manner, and have them look for any errors.

5 Revise your iterations per their comments.

MECHANICS OF WRITING

Yes, mechanics matter. It may have been a while since your last composition class, so below are some things to remember when writing:

VERBS

Use active verbs. Zinsser suggested that the difference between an active verb and passive verb lies in clarity and vigor; passive verbs drain the reader's energy and add confusion, while active verbs "push the sentence forward."[16] So, don't set up a firm – launch it. The difference is propelling the reader forward, or sheepishly dragging them along.

Instead of...	She was seen by Todd.
Consider	Todd saw her.

ADVERBS & ADJECTIVES

Good writing is lean and confident.[17] However, some words can add unhealthy fat, and they can be tempting to writers who want to make their sentences seem more interesting. To avoid sentences that are longer than they need to be, remove any unnecessary adverbs and adjectives.

For instance, adverbs that describe verbs with obvious information should be deleted. There is no reason to say things like "*quickly launching*" – it is unlikely one would launch slowly. Similarly, avoid using adjectives to describe something that the reader would already know, like "heavy stone," since we have yet to unearth a lightweight stone.

PUNCTUATION

When determining which forms of punctuation are most appropriate, consider their influence on readers. Does the punctuation cause them to pause, halt, or direct their attention where they should?

PERIOD

It has been said about the period, "Most writers don't reach for it soon enough."[18] If a sentence is long or clunky, use the period to break it up.

SEMICOLON

A semicolon causes the reader to a pause or halt.[19]

> My drawings are due tomorrow; I simply have to work on them tonight.

EXCLAMATION POINT

Exclamation points often add unnecessary fluff. If you construct your sentences in a way that emphasizes your point naturally, you should rarely need to use an explanation point.

DASH

The dash is used in two ways. The first is to amplify or justify what was said in the first part of a sentence.[20] The second use of the dash is to set apart a parenthetical thought within a longer sentence.

> "Our clients laughed – they had been thinking the same thing – so we started to sketch out the idea together."

COLONS

Use a colon after a complete sentence to explain or clarify a point.

> The client had two choices: stop the project or move forward as planned.

CONTRACTIONS

Contractions can be controversial. In fact, you may have had an English teacher suggest that you avoid them altogether. But, Zissner suggested that contractions convey a warm, approachable, and informal tone,[21] which may be very suitable for your audience, goals, and content. Go with your instincts.

COMMA

Commas can be one of the most confusing types of punctuation simply because they have so many uses. Below are some general rules:[22]

COORDINATING CONJUNCTION
Place a comma before the coordinating **conjunctions** *and, but, for, nor, or, so,* or *yet, if* they introduce an independent clause (i.e., clauses that have their own subjects and verbs).

> The design has changed many times, yet the original sketches have disappeared.

If the clauses are not independent (i.e., they share the same subject), no comma is needed.

> I knew the design had changed but couldn't find the original sketches.

If there is no conjunction, a semicolon or two sentences would be more appropriate.

> I knew the design had changed. Peter was searching for the original sketches.

ENCLOSE PARENTHETICAL EXPRESSIONS
Place a comma when you have a thought within a thought.

> The best way to see Chicago's skyline, if you don't mind the wind, is by a river cruise.

Commas are sometimes used after single words, if readers should interpret a considerable pause.

> The room was loud. However, she continued to work.

IN A SERIES OF THREE OR MORE TERMS
In a list, the last comma does cause controversy, with some sources saying it should and shouldn't be used. Be consistent.

> I knew orange, blue, and teal were colors they disliked.

AT APPOSITIVES
Place a comma when you are providing an **appositive**, or title for a subject.

> Nancy, our first client, stopped by the office each week.

AT NON-RESTRICTIVE CLAUSES
Commas should be used at **non-restrictive clauses** which provide extra information about the subject.

> The client, who was initially terrified, grew to love the idea.

WHEN ATTRIBUTING QUOTES
> Nancy said, "I dislike orange, blue, and teal."

FREESTANDING WORDS AT THE BEGINNING OF A SENTENCE
> Yes, the final design had changed a great deal.

BETWEEN TWO ADJECTIVES THAT DESCRIBE THE SAME NOUN
> I was worried that the dark, dank room was my new office.

TO OFFSET NUMBERS AND ADDRESSES
> The budget is $1,423,721.

IDEAS FOR WRITING

Considering that we can read faster than we can speak,[23] written communication is essential in design. To become a better writer, write. Look everywhere for material to write about. Write descriptions about things you have observed, the people you have encountered, and your sources of inspiration. Writing doesn't always have to be a formal activity; consider keeping a journal or writing about your projects.

When you have a topic at hand, collect more references than you'll likely use, so that you'll have ample material. With some time and practice, writing can become an asset rather than a burden.

EDITING & REWRITING

Your first draft could be unclear, illogical, verbose, clunky, pretentious, boring, or any number of other things that might cause readers to turn away. Given the importance of your task, rewriting should not be viewed as a burden, but your opportunity to reshape, refine, and tighten your message.

QUESTIONS TO ASK YOURSELF DURING REWRITES

SEQUENCE
- Is the flow of ideas logical?
- Does the order build momentum and retain the reader's interest?

FLOW
- Do your words, sentences, and paragraphs maintain a good rhythm?

CLARITY
- Is your writing cohesive?
- Is your writing clear?

PURPOSE
- Is your product suitable to your goals?

Writing late at night in the studio is a practice rife with potential errors. When you're tired or rushed, chances are you'll make mistakes. These flaws can represent the quality of your work. So, when you're ready, be sure to have others review your work. Their perspectives are invaluable and their feedback will not only help you improve the piece at hand but also help you to hone your writing skills.

EXERCISE 4.3 REWRITES

The words of others can be used to help you develop your own skills.

Read the first 2–3 paragraphs of a feature article in a design magazine.

Determine the writer's tone & tense. Then highlight any unnecessary words.

Rewrite these paragraphs at least two different ways, retaining the meaning. Experiment with changing the tone and rearranging the sequence.

Do the same exercise for the article's last paragraph. This time, explore techniques like using a quote, providing a fresh summary sentence, or echoing the first paragraph.

Share both the original and your revised versions with a peer (avoid letting them know which was the original piece). Discuss which version each of you feels is most successful.

THINGS TO AVOID

Some sins are certain to sidetrack readers from your message. Consider the following:

DON'T LOSE SIGHT OF YOUR VOICE.

While it's important to be professional, don't forget the sound of your own voice. Remember that you bring something unique and original to your stories. Be authentic and don't alter your voice so much that it's no longer yours.

DON'T APPEAR CONDESCENDING BY STATING THE OBVIOUS.

Chances are your readers are competent professionals, and they might feel as though you are patronizing them if they are told what to think. So don't annoy readers by stating the obvious. Let them draw their own conclusions about the information. This means avoiding terms like "predictably," "surprisingly," and "of course."

At the same time, ensure that it's easy for readers to derive the correct meaning from your words. Have several others read your passage and ask them if anything was unclear.

AVOID OVERSTATEMENTS & HYPERBOLE.

Don't trap the truth behind overstatements and **hyperbole**. "There is nothing more interesting than the truth."[24] Exaggerations tend to bury the beauty of your material, concealing its quirkiness, drama, or any number of other important qualities that your audience deserves to know about.

Thinly veiled overstatements can also damage your credibility, and once the audience catches on to your exaggeration, they will scrutinize everything else about you and your message. So while statements like "the classroom looked like an atomic bomb had struck," may be easy and convey a very vivid mental picture, they're not worth the risk to your credibility.

DON'T CONCEAL THE TRUTH.

Your credibility depends on your transparency. While you may inadvertently use vague or inappropriate language, the danger is that the audience may feel as though you're trying to mislead them. Avoid vague conceptual sentences that lack a person or an action. Renowned professor Edward Tufte refers to this an "effect without a cause."[25] For example "the common reaction is crying" gives the reader no one to visualize performing the action. It would be far better to say "most people cry." Sentences lacking a subject are at best, vague, and at worst, creepy, so give your audience someone to identify with whenever possible.

Euphemisms conceal the truth by hiding it behind softer language. For instance, layoffs become "corporate downsizing," or "price increases" become "market rate adjustments." Unless the term is recognizable and clearly understandable, don't use it.

DON'T SETTLE.

Don't settle for your first draft, or your second and third, for that matter. Rewriting is "where the game is won or lost."[26] While we may love our first drafts dearly, since they represent a considerable amount of time and emotional effort, they are often clunky, unclear, and riddled with errors. So don't treat them as though they are your first-born child. Do-overs are okay and encouraged. Treat writing not as a burden, but as an opportunity to reshape, refine, and tighten your message.

Your audience will thank you for it.

SUMMARY

Writing is central to design storytelling. While novice designers may not always be enthusiastic about writing, design professionals understand its value, using their words to express themselves and their ideas.

To get started, ask yourself what it is you are trying to say and why. At Launch, your readers will want to know what's in it for them; in essence, what will they get out of reading the material? You can pique a reader's interest with humor, surprise, or by building tension.

Remember that each paragraph needs to encourage readers to move to the next. To do so, keep the reader curious. Once you have gained their attention, your focus can shift from entertaining to informing them. Finally, strive for a powerful ending so that your readers will remember what you have said, which can be done with an unexpected or refreshing sentence, echoing back to the beginning of the story, or by sharing a witty quote.

Convincing stories are cohesive, concise, and clear. When authoring your own design story, give thoughtful consideration to your words, sentence composition, and paragraph flow. Poor mechanics can quickly distract readers from your story, so also consider your syntax and punctuation carefully. Practice writing with design concept statements and personal bios. Developing these pieces before you need them can make the process less stressful, and result in a better outcome.

Whatever you're writing, remember to avoid overstatements, stating the obvious, and settling for your first draft. And remember, the best way to improve your writing is by writing.

FOR CONSIDERATION

As designers, we need to be critical consumers of information, carefully assessing what we read so that we are not misled. At the same time, we need to become better writers, and to do so, we need to examine the work of others.

- Visit your favorite design blog or design magazine.
- Read through 3–4 of its latest entries.
- Can you find any of the sins from the previous page?
- If so, consider what could you change to improve the statements.

TERMS

appositives	hyperbole	non-restrictive clauses
cliché	idiom	parallel construction
conjunction	jargon	syntax
euphemism	modifier	

APPLICATION 4.0

The aim of this book is to help you design a story for an upcoming project. Consider the following:

1 Review your storyboard from Chapter 3.

2 If your next presentation will be in person (i.e., you will be there to discuss your ideas), then follow the **Talking Points** steps.
If you're sending a document, then follow the **Written Summaries** steps.

or

Talking Points
conversational tone to be used in a verbal presentation

Written Summaries
more formal tone to be used in written descriptions such as narratives, captions, or analysis papers

Use your storyboard to craft a series of story-orientated talking points for the Launch, Load, and Landing of your presentation. Remember that the goal in the beginning is to pique interest (Launch). During the middle, aim to inform the audience (Load), and end with a memorable point (Landing).

Use your storyboard to write descriptive texts with the goal of informing the audience. These narratives can include introductory paragraphs, image captions, and summary statements.

3 Have someone else read these talking points to you. Reflect on how your words sound. Ask the reader if the information was clear and engaging.

Have someone else read your statements back to you. Consider how they sound and ask that person if the writing was clear, cogent, and convincing.

4 Revise your writing based on your analysis, then read the revised talking points to a trusted ally. Ask them about any remaining areas of ambiguity, dullness, or distraction.

Revise your writing based on your analysis.

OBJECTIVES

- Understand how to distill information with verbal messages
- Understand how to use the mechanics of oratory to affect the audience
- Explore the influence of nonverbal cues on your audience
- Be able to succinctly summarize projects

SPEAKING FOR IMPACT

This chapter will focus on verbal presentations.

Andrew would have to give the speech of his life; failure meant lifetime exile from Athens. Since he was representing himself in court, the chances of him ever seeing his wife, children, or aging mother again would rest on his next few words. As he got up to speak, he looked out anxiously at the crowd – many of whom would determine his fate.

But, just before he spoke, modern-day Andrew woke up. While modern Andrew did have a high-stakes presentation in the morning (likely the cause of his dream), success or failure, either way, he would see his family that evening.

INTRODUCTION

The ancient Greeks mastered the art of persuasion and oratory, often, because they had to. Historians estimate that the average Greek man went to court a half dozen times during his life, frequently defending himself.[1] In such cases, the need to connect with audiences, sway them, and move them toward a favorable action was of utmost importance. Most of what we learned about persuasion and public speaking from ancient Greece is still relevant today, except for one very profound development which permanently changed audience expectations.

Public speaking is essentially performance art. And yes, many of us might cringe at the notion of having to give such a performance, but presentations are simply part of being a designer. This chapter will explore the power and potency of spoken design stories.

THE EVOLUTION OF SPEAKING

August 28, 1963, was a warm late summer day. On this day was the "March on Washington for Jobs and Freedom." The day's 10th and final speaker was a 34-year-old Southern minister. His use of metaphor, universal truths, alliteration, vivid words, and rousing oratory became forever known as the "I Have a Dream" speech.

If you were one of the 250,000 people on the Washington Mall that day, chances are you didn't actually see Dr. King deliver his remarks since you were likely far from the stage. However, those watching on national television (one of the first live telecasts) saw Dr. King from a different perspective. It was a much more personal view than what those on the crowded mall could enjoy. In a word, television provided a very different experience, and it fundamentally changed our expectations of speakers.

While the Greeks, Lincoln, and Churchill gave their speeches at an arm's length from their audiences, they called on their proud voices and sweeping gestures to connect with them. What television cameras made possible were tight shots focused on the head and facial expressions of a speaker; this helped audiences to feel as though they were close to the speaker. Communications consultant and author Nick Morgan suggested that television caused a disconnect between many speakers and their audience's expectations of them.[2] While large audiences may still physically need to be at a distance from a speaker, we now want to feel as though we could reach out and touch them. We want to hear a conversation and have opportunities to exchange ideas. But instead, we are often presented with a linear, formal path marching toward an idea.

EVOLVING AUDIENCE EXPECTATIONS		Pre-Television	Post-Television
	DISTANCE	Across the room	At the table
	TONE	Formal	Colloquial
	GESTURES	Broad, Sweeping	Conversational
	VOLUME	Booming	Moderate

Today, cable television, internet videos, and social media platforms offer us sound bites and succinctly packaged ideas. At the same time, many speeches can go on for up to an hour. This growing disconnect between audience and speaker can be especially problematic for designers who are seeking approval for their ideas. But there remains something very special about being face-to-face with an audience. In-person presentations offer more opportunities to connect with our audience. That said, some of us dread or even avoid public speaking altogether. But doing so can be costly to designers, who may miss out on pivotal opportunities.

THE GOAL OF YOUR PRESENTATION

Public speaking has a unique role in design, and when carefully crafted, presentations can offer a powerful expression of your ideas.

Think of public speaking as a guided conversation, during which the goal is to move your audience from asking *why* an idea or design is appropriate to *how* they are going to implement it. When audience members begin asking how (instead of why), they believe in your idea. Admittedly, engendering such a change can be difficult, but for anyone who has ever sat through a long lecture struggling to maintain their focus, they know that listening is also hard work for the audience. To make listening easier, designers should make their ideas accessible. You'll need to organize your content in a way that is meaningful to the audience, craft your message with laser-like focus, and determine how to connect to your audience through your design story. It's no small task, but to paraphrase the Earl of Chesterfield, *anything that is worth doing is worth doing well.*

Chapter 3 laid the groundwork for your presentation via your storyboard and Chapter 4 outlined your talking points. To determine your goals for your verbal message, reflect on how you want your audience to change as a result of your presentation (see Chapter 2). Essentially, how will their attitudes, beliefs, or actions differ from beginning to end? Then channel your passion into designing and delivering on a journey that prompts this change.

BACKGROUND

It is helpful to understand a few communication and persuasion frameworks as you start designing your verbal messaging.

COMMUNICATION

Mathematician Claude Shannon and engineer Warren Weaver proposed one of the most widely cited models of communication still in use today.[3] In their model, the sender is the source of the message, and the channel is the medium of that message, while the receiver is the audience. How the receiver comprehends the message is influenced by noise, which is comprised of all of the things that potentially distract the receiver from interpreting the message accurately. This can include environmental distractions, internal distractions, and message ambiguity.

As speakers, it is easy to think about them in that order (i.e., sender, channel, and receiver). We are inclined to think about our own needs (and anxieties) first, then how we will convey information, and finally our audience's background and desires. Morgan suggested that successful speakers flip that order, considering the receiver first with pre-planning and by evaluating real-time feedback, as well as giving careful consideration to noise suppression such as eliminating distractions or clarifying confusing messages.[4]

Figure 5.0
Shannon's Model of Communication

PERSUASION

Public speaking and persuasion go hand-in-hand, though the art of persuasion can be a challenging undertaking. As business researcher Jay Conger noted, "persuasion involves careful preparation, proper framing of arguments, the presentation of vivid supporting evidence, and the effort to find the correct emotional match with our audience."[5]

Nevertheless, researchers have long studied the topic, providing us an understanding of human motivation. Their insights suggest that designers can appeal to an audience based on their instincts, their reason, learned information, or environmental stressors and emotions.[6]

Given what we know about persuasion, consider the following:

We tend to evaluate our frames of reference in simple either/or categories.

Tip: Align your messages within frames of references that the audience will associate with being either good or bad.

We expect these frames of references to fit within our previous experience.

Tip: Consider how to help the audience recall either a single vivid event or multiple experiences that support your message.

Our accumulated experience accounts for many beliefs, yet our limited scope may lead to inaccurate conceptualizations of the world.

Tip: Consider the background and prior knowledge of the audience and how to contextualize your ideas from their perspective.

We tend to distort messages to make them adhere to our needs.

Tip: The audience might misinterpret your message based on their own ideals, so give special consideration on how to align your ideas with their needs.

We tend to construct frames of reference that underscore similarities, yet ignore differences.

Tip: Since we tend to group ideas, explicitly state any differences between ideas.

We tend to only perceive attributes of a message.

Tip: Help the audience appreciate the "big picture" so they can see the relationship between your ideas and societal issues.

We tend to ignore relationships that are not contiguous in space and time.

Tip: Make use of sequential or spatial relationships to present information.

The process of persuasion can be summarized in two steps; first, securing the attention of the audience, and second, prompting them to care about your message by showing its relevance to their lives.

1 SECURING ATTENTION → **2 HIGHLIGHTING RELEVANCE**

FACTORS

Does the communication catch and hold attention?
Propose & reinforce design ideas with vivid language & compelling evidence.

Does the audience understand the message?
Reduce ambiguity and any potential areas for misunderstanding.

Is the message relevant to their needs and wants?
Frame your message in a way that relates to their daily lives.

Does the audience believe the message?
Use evidence to describe the advantages of your proposed design.

Does the change you propose fit the audience?
Ensure that your design proposal is not out of their range of ability, or means to supply.

Figure 5.1
Persuasion involves securing attention & highlighting relevance

> "Think of a presentation as an opportunity to listen to your audience."[7]

GETTING STARTED
Getting Over Your Nerves So You Can Get to Your Audience

Remember that your presentation is about your audience, so you will need to put your own anxieties aside when preparing so that you can focus on their needs. Morgan suggested that an audience's interest level is inversely proportional to the distance of your message from their own concerns.[8] In other words, if they don't care about an issue, they are unlikely to be interested in a presentation about it. To combat apathy, help them understand how a seemingly irrelevant topic actually matters to them. Tailor your presentation to their concerns, which, of course, can only be done after you have done your research (See Chapter 2). What are their goals? What keeps them up at night? A presentation is a prime opportunity to tell audience members new things about themselves, which is almost always guaranteed to pique their interest.

Remember that an audience cares about characters they identify with. So think of yourself as a character, and make yourself relatable. Ask yourself, how are you like the audience? Also, try to personalize their experience, use their names, try to get (and effectively use) the inside joke, incorporate their latest triumphs or concerns into your message. If you can, get to know your audience members in advance at social events. Knowledge is power, and the more you know, the more routes you will have to connect with your audience.

ALIGN YOURSELF WITH YOUR AUDIENCE

While the temptation may be to launch directly into your discussion about the design, doing so may leave the audience feeling as though you are either too nervous to connect with them, too indifferent, or that you just want to get the presentation *over with*. These are messages that you do not want to send.

Instead, take the time to align yourself with your audience. Building rapport can help show them that you care about their problems. This is done through the shaping of your content and the method of your delivery. To engage audience members, you will want them to contribute, and that means you might not always know what thoughts they will offer. This can be scary, but remember you're "giving" your speech to your audience, which means you won't control every aspect of the presentation.

ALIGN YOUR MESSAGE TO YOUR AUDIENCE

The most important aspect about aligning yourself with your audience is showing them that you care about their problems; this is done by stating a problem that you know your audience has — whether they know it or not. However, you don't want to give away the solution to their problem too soon; in other words, don't reveal your design just yet. It's best to let them wallow in their emotions so they can sense the gravity of the problem for themselves. Then lead them through a decision-making process, but trust them to use evidence to make the right conclusions. The goal is to sway your audience by taking them on a journey that feeds both intellect and emotion.

GETTING STARTED BY CRAFTING AN ELEVATOR PITCH

An **elevator pitch** serves two functions: 1). To help you craft an advertisement for your presentation, and 2). To serve as a natural organizer for the presentation itself.

What is an elevator pitch for a presentation?
Think of an elevator pitch as a succinct summary of what you plan to address in your presentation. Imagine sharing it with someone you have just met while riding from the ground floor to 4th floor in an elevator; you should be able to give your elevator pitch in less than a minute. Also, make it easy to remember since you never know when opportunity will strike. Morgan suggested that an elevator speech should:[9]

- Highlight benefits for the audience if they attend, i.e., what do they get out of it.
- Contain the word *you*.
- Reference an emotion.
- Focus on only one idea.

Also, consider the level of need that your design addresses on Maslow's pyramid (see page 26). Remember, solving for lower level needs will evoke a more visceral response, so consider which level will resonate with your audience.

EXERCISE 5.0 PERSONAL ELEVATOR PITCH

While you're writing an elevator pitch for your presentation, consider crafting one for yourself as well. A personal elevator pitch highlights your potential in a very succinct, engaging, & direct manner.

To get started, recall your themes from the Point of View questions (see page 35).

Use these themes to craft a short-form version of your Point of View.

ALIGN YOUR DELIVERY TOOLS TO YOUR AUDIENCE

We know that no two audience members are alike and they will each have different preferences for receiving information. While it is critical to target those key change agents that you have identified in Chapter 2, chances are you will not know how they prefer to receive information. Research suggests that they may prefer visual, aural (i.e., auditory), kinesthetic, or written sources.[10] To effectively reach your audience, you will want to tailor your delivery so that each of these preferences is acknowledged.[11]

AURAL

Consider incorporating lectures & discussions.

Those that prefer auditory inputs may benefit from the opportunity to talk about their ideas.

VISUAL

Consider incorporating maps, diagrams, charts, or graphs.

Those that prefer visual inputs may benefit from the opportunity to color code information or by drawing representations of ideas.

READ/WRITE

Consider incorporating thoughtful labels & headings.

Those that prefer read/write preferences may appreciate accompanying handouts or the opportunity to write notes.

KINESTHETIC

Consider including exercises that engage the senses & are grounded in reality, such as real-life videos, demonstrations, or simulations.

Those with kinesthetic preferences may benefit from having an opportunity to act upon the problem through brainstorming or planning the path forward.

To learn about your own preferences, take the questionnaire at VARK.com.

AUDIENCE PREFERENCES

Research suggests that the general population exhibits lower Visual and Aural preferences and higher Read/write and Kinesthetic scores.[12] However, this may vary based upon the discipline you're speaking to. For example, a room of designers may be more appreciative of visual information, while a corporate management team may prefer written sources.

PRESENTATION STAGES

Many of the story segments discussed in the earlier chapters mirror the journey you'll take your audience on during an in-person presentation. Similar to Launch, you'll want to "Hook" your audience in with a "S"tory at the start of the presentation. You can then use your "S"tory to highlight the problem at hand, emphasizing its stakes. Only after the audience is thoroughly distressed about the issue will you then offer your solution, which is your design. During the Finale, you can either recall your "S"tory by suggesting how your design will address that character's problem or prompt the audience toward an action of their own.

Figure 5.2 - "S"tory segments & the audience's journey during a design presentation

THE HOOK,
THE PROBLEM, & ITS RELEVANCE

The first thirty seconds of a speech are invaluable, and they should be treated as such. Use this time to garner the attention of the audience. Then focus on orientating them and framing the problem by telling them a quick "S"tory, in the form of an **anecdote** or **parable**. Aim for your intro to be a compelling and condensed version of the same story you're about to tell. To connect with your audience, make sure this Story highlights universal truths and speaks to their emotions (see Chapter 3).

If you feel inclined, consider asking audience members to share a similar story of their own. Or ask them questions about your story – just make sure that these questions are not of the right answer/wrong answer variety since it would be counterproductive to have the audience feel as though you are putting them on the spot when you are still trying to establish a relationship with them.

There are several things to consider in your Hook. First, a savvy audience will see through false flattery. So if you appeal only to their self-interest during your Hook, yes they will listen to you, but they might not respect you. So consider how their self-interest coincides with broader societal concerns. Second, how much of your own emotion is appropriate for display? It's often good to tell the audience how you feel about the given topic. Doing so lets them know you care about it, and by extension, you care about them.

Whatever, your approach, know that it's likely that your audience will frame their opinion of your message from very early on.

CONSIDERATIONS FOR THE HOOK

What you do within the first few minutes will either build rapport or damage it. For example, if you ask the audience questions about themselves, and then fail to wait for their answer, the message is that you don't care enough to hear their response. So, don't ask, *how are you?* without pausing and listening to their answer – these seemingly small gestures can go a long way in building rapport.

Consider five methods of building good will early in the presentation:[13]

Establish common ground through shared experiences & goals.	Avoid discussing controversial or distasteful ideas during the first few minutes.
Extend these areas of common ground to a series of ideas that they will agree with, then transfer their agreement to your new information. *Or* Confirm areas of common ground, but then contrast these areas to your new information.	Avoid speaking down to your audience or trying to impress them artificially.
	Use examples that convey your idea and trust your audience to infer the underlining themes.

To engage the audience early on, consider the following tactics:

AURAL
tell a story

VISUAL
show a vivid image that symbolizes the story's values

READ/WRITE
have audience members write a word that symbolizes the story

KINESTHETIC
have audience members share a similar experience

EXPLORING THE PROBLEM

Lead "your audience down into the valley of despair before taking them up the mountainside of hope."[14]

Congratulations – you have garnered your audience's attention. Now it is time to frame the problem using anecdotes, details, facts, and insightful analysis, which can be a balancing act. Speeches are more likely to fail from too much information, than too little.[15] However, if you are presenting a problem that your audience does not yet know about, this stage may take some time. Also, at this stage, it's important to allow your audience the time to actually feel the emotions set forth (let them get anxious, worried, excited, etc.). These emotions can be leveraged to build momentum. To engage the audience during this stage, consider the following tactics:

AURAL
have audience members shout concerns
ask them questions

VISUAL
show images of the problem

READ/WRITE
have audience members write concerns on a note card

KINESTHETIC
have the audience vote on areas of concern by show of hands
role play

THE SOLUTION & ITS BENEFITS

Once you are convinced your audience feels involved in the problem and that they have become properly agitated about it, then they are ready to hear about the solution — which is, of course, your design. Paint them a compelling picture of all the positive aspects made possible by your design, essentially, how the design solves their problem. Consider recalling your initial story and how your protagonist might respond given the new opportunities offered by your design.

If you are in the early stages of design, consider letting the audience help determine aspects of the solution; this will help them feel a sense of ownership. It is important not to judge their solutions — even if they are weak or inappropriate; which may make them feel as though you are personally indicting them; besides, the other audience members will be less likely to share their own ideas for fear of being called out. Instead, validate their input and thank them. You can later offer rationale that will help them see that their solution might not be the most appropriate.

For a controversial issue, consider presenting alternative design solutions, but outline the pros and cons of each, saving the best solution for last. Morgan called this the *Residue Method*,[16] since the audience will accept your position as the "residue" left after all other options have been deemed unsuitable. Sharing options will let the audience know that you have at least considered the alternatives. Consequently, they may be less hostile toward you and your solution. Consider the following tactics to engage the audience:

AURAL	VISUAL
describe the benefits of the solution	include a visual comparison such as before/after images

READ/WRITE	KINESTHETIC
have audience members label drawings with thoughts and/or concerns	have audience members label drawings by actively moving about or placing sticky notes

QUESTION & ANSWERS

Questions during a design presentation can come at nearly any time. Being asked a question (especially when you are mid-presentation) can be a nerve-wracking experience. Yet, questions mean that the audience feels invested in your presentation – or at the very least, they are listening to you.

An important, but often underestimated facet of Q&A is actively listening to the question. Many of us are not the best listeners – it's not our fault exactly; we may already be working through potential responses in our head, and society has trained us to view silence as apathy. However, we risk missing the nuance of the question, and the audience may see us as uncaring.

To improve your listening, when you are asked a question, listen to the person speaking with your entire body. This means keeping your body and mind still, as you would when someone was telling you something of extreme importance. Chances are you will find yourself leaning forward, or nodding your head. These seemingly subtle gestures send a powerful message. Always repeat the question so that the rest of the audience can hear it, and so that you can confirm that you understand what is being asked. If you do not understand the question completely, consider restating it, and asking if your version is correct.

The way you answer questions makes a statement as well. Avoid a judgmental stance; this can make for an awkward and tense environment. Instead, aim to clarify and empathize with the questioner. Many politicians are masters at this. When they start an answer, they try to connect with the person by stating the prevailing emotion. For example, "*I understand this change might make you a little worried...*" or "*I respect your concern...*"

However, your answers should be somewhat brief. What may start as a powerful response can quickly falter amongst unorganized muttering. Also, think about those in the room who aren't actually verbalizing their questions. They may be shy, or feel uncomfortable sharing their concerns. You may even run out of time. Remember that these individuals may be strong advocates, so be sure that they have a way to follow up with you. You can leave out note cards for questions or leave your contact information on the screen. Let the entire audience know that you want to hear from them and that you are accessible.

Q&A can be stressful, but if you treat it as an opportunity to clarify and highlight your ideas, it can be very productive.

THE FINISH

> "Where you win or lose the hearts, the energy, and the commitment of the audience."[17]

You owe it to your ideas to finish your presentation strongly. If you have built up your audience's fervor about the problem and provided evidence of how your idea will resolve it, the final step is to prime audience members to take action. Skilled politicians are masters at energizing their crowds at the end of their remarks, and designers can do the same.

You may be tempted to recap your message. Doing so might aid recall, but the risk is losing momentum and the audience's attention. Lengthy summaries are passive, boring, and likely unnecessary, especially if you've already provided a memorable performance.

Instead, consider asking the audience to take an action by providing two types of prompts. The first prompt should be a relatively easy action that can be completed inside the room. This prompt should lead the audience into a second one that urges them to do something beyond the presentation itself. To determine what these should be, think back to your goals. Are there commitments you would like the audience to make, or goals you would like to have them outline? Perhaps, you simply want them to share your message with others. In early design, your goals may be quite different than in later stages.

With some creative thinking and simple props, goal-orientated audience engagement can be done with any sized group. Whatever your goals, frame your closing remarks as a call to action.

AURAL
repeat memorable phrases or ask rhetorical questions

recall your initial story

VISUAL
end with a vivid visual

READ/WRITE
have the audience label drawings/images

KINESTHETIC
prompt a friendly competition

ask the audience to pledge to do something

ENDING WITH AUDIENCE QUESTIONS?

While it might be tempting to close with a Q&A session, Morgan advised that is not the strongest way to conclude a presentation.[18] Chances are you have witnessed some of the pitfalls of Q&A yourself – the mass exodus of people at the start of Q&A, or the inattention and chatter of those who remain. The reason – the questions are not in line with their interests.

Ending with questions can be counterproductive.

On the other hand, those with questions might not continue to follow along until they receive answers. To curtail these issues, Morgan suggested to instead break up the Q&A within the presentation itself.[19] However, doing so can be difficult since you don't want to reveal too much and it may muddle up your presentation flow – or your train of thought. So consider retaining the notion of a dedicated Q&A session; just include several of these throughout the presentation. If these sessions go on too long or take you in a new direction, that's okay. You can either follow the lead of the audience, knowing that you have struck a chord. Or you can find a way to move back to the issue at hand, but in doing so acknowledge that their concerns warrant a later discussion.

Also, give thought to what questions might be asked in advance, and how to answer unpredictable questions without revealing too much ahead of schedule. If their question will be addressed later in the presentation, plan a response letting them know that their question was so good that you'll be addressing it shortly.

Q&A during the actual presentation does take a bit of an iron stomach. You'll be giving away some control, but doing so will let the audience feel as though they are participants in your presentation instead of merely bystanders. Plus, having answers in hand will keep audience members from dwelling on any areas that were unclear or unresolved, and chances are that in a design presentation, impromptu questions are going to happen anyway.

Consider offering multiple opportunities for questions & answers.

AUDIENCE ENGAGEMENT IN DESIGN PRESENTATIONS

Your audience may not always like your ideas, but the last thing you want to do is set up a standoff. So try to avoid approaching the meeting as if you know all of the answers. No one knows their organization, or their needs better than they do (even if they don't yet see the problem you're addressing), so an arrogant attitude may cause unnecessary conflict. Instead, remember to enlist them to work with you so that they will feel more invested in the problem. Pre-discussion surveys, raise of hands, small group discussions – there are many ways to involve your audience in the presentation. These things are important to do since audience members are less likely to refute ideas that they feel are of their own making.

ALIGN YOUR DELIVERY TO YOUR MESSAGE

You may have an exceptional design, but how you deliver your message will likely influence your audience's response to the design itself. Linguist Deborah Tannen suggested that every utterance functions on two levels: communicating ideas and negotiating relationships.[20] The audience will read a great deal from your linguistic style, which Tannen defined as a person's directness or indirectness, their pacing and pausing, as well as their use of words, humor, stories, figures of speech, questions, and pleas. Together, these form a set of culturally learned signals that are the basis of how we share and understand messages. These signals can be hard to negotiate (especially if you are considered an outsider), but the good news is that you have been practicing your whole life to both send and receive signals.

WORD CHOICE

Word choice, or diction, is an important tool in audience engagement. When speaking, aim to be conversational, but not vague. To avoid ambiguity, use precise language and eliminate empty words such as extraneous adjectives and qualifiers. **Qualifiers** and **hedging** will make you seem unsure and less confident. This includes any anxiety-induced filler words, such as *um, like,* and *so*. If you might be guilty of employing fillers, it's best to get diagnosed early. Deliver your speech to a trusted ally and have them drop scraps of paper each time they hear a filler. One or three might be fine, but a forest on the floor is a recipe for disaster. To avoid using fillers, slow your pace, know your content, and rehearse.

Since your goal is not to confuse your audience, also avoid **jargon** (page 62). If you must use an unfamiliar word, be sure to define it for the audience. The best kind of definition is an extensional one, where you simply point to the referenced object and say what it is. Another way to define an unfamiliar word when speaking is to compare it to similar or opposite terms. Also, explore the connotative meaning of your words as they may have different meanings to different people.

Colorful language (not of the expletive-filled variety) can be very engaging. Look for ways to evoke useful metaphors, and artfully repeat a few keywords or phrases for added resonance.

Your words will carry meaning and potency – choose them wisely.

> To avoid filler words, slow your pace, know your content, and rehearse.

TIMING & REPETITION

Aim to speak with *"brevity, simplicity, and integrity."*[21]

Boredom is the enemy of persuasion, so consider how to deliver your messages in brief, but complete thoughts. If your speech is longer than 20 minutes, plan to break it into 15–20 minute sections. After each section include a short activity or Q&A session. This will help retain attention and reactivate your audience should their attention be waning.

While short messages are powerful, repetition can do wonders to sway an audience. In fact, Morgan described this as the "single most important linguistic device of speechmaking."[22] Consider structuring your content so that you reinforce important ideas by repeating them. For instance, you can recall the beginning at the end of the speech, refer to the initial story several times during the presentation, or call upon a bold phrase multiple times. These types of repetition can help the audience keep up, make sense of the material, and remember your message.

ALIGN YOUR DELIVERY STYLE TO YOUR MESSAGE

"People make the mistake of focusing too much on the content of their argument and not enough on how they deliver that message."[23]

To give your audience a clear, visionary, and memorable message consider these 3 C's: Clarity, or speaking to be understood, Conviction, which is speaking to be believed, and Charisma, or speaking with passion.

CLARITY
Speak to be understood.

Your idea will have little appeal if it is not understood, so consider how your delivery might add clarity to your message.

When speaking, your voice is an inherent component of clarity. Morgan observed that good voices have two qualities: presence and resonance.[24] Presence is the quality that causes your voice to be heard and understood, as well as being clear and compelling. It is accomplished by projecting your voice so that the sounds are not held in your throat. Resonance is the quality that makes your voice sound rich, deep, and pleasant, which is accomplished through steady breathing. To master both, slow your speaking pace and be mindful of your breathing.

CONVICTION
Speak to be believed.

Your ideas deserve your conviction, and speaking from a strong stance will magnify your message. Audiences can be confused if, when you are trying to make a point, you sound instead as though you are asking a question. To speak with conviction, Morgan suggested speaking with an **authoritative arc**.[25] Think of this as the opposite of asking a question. In a question, your **pitch**, or the highness or lowness of your voice, typically raises at the end of the sentence. In contrast, in an authoritative arc, the pitch raises in the middle, and lowers at the end of the sentence. This simple difference makes it sound as though you are speaking with greater confidence.

Research suggests that young people often raise their pitch at the end of a sentence – even if it's not a question.[26] If this may be a problem for you, listen to the great orators to hear how they emphasize key points, then practice a few phrases each day.

CHARISMA
Speak with passion.

"You can never affect others if you yourself are not affected by the idea."[27]
Great speakers have charisma, which is essentially having the capacity to channel their passion about a topic into their delivery. Essentially, charisma is the opposite of galloping flatly through your words.

To put your passion on display, master the pause, which can do wonders to focus the audience's attention. Employ a pause after you have made a key point. Also, consider the variety in your voice. Inflection makes your voice sound interesting, and it helps to emphasize key points. Humor can also add to your charisma, especially since we tend to bond with those who can make us laugh (see page 61). However, humor is not requirement for charisma; if you are not naturally inclined to be funny, don't force an awkward laugh by trying out a few one-liners on the stage.

Do however, aim to match your level of enthusiasm to your audience's ability to receive it.[28] To do so, you'll need a strong and accurate sense of your audience's state of mind coupled with the ability to modify your tone accordingly.

CRUTCHES THAT CAN CRIPPLE CHARISMA

Some common speaking tools can actually undermine our charisma; these include our notes, podium, and even our slide deck.

NOTES

A memorized speech can make for a robotic delivery. At the same time, reading from a script verbatim can be even worse. And barring the opportunity to use a teleprompter (which is rare in design presentations), it will be up to you to find the right balance between knowing your content and managing your connection with the audience. For some, it is enough to have headings on slides to trigger their talking points, while others will feel more confident having written notes on a single card. Whatever method you choose, be sure to practice your delivery using the same tools that you'll have in the final presentation.

PODIUM

Placing the podium between you and your audience is like building a wall between you and them. Being trapped behind a podium can leave you missing out on opportunities for connection.[29] Aim to move beyond the podium.

Proxemics

Proxemics is the amount of personal space that people feel is necessary to put between themselves and others. Understanding proxemics can improve your delivery. Research suggests there are four zones within which behavior and relationships differ: public, social, personal, and intimate.[30]

INTIMATE SPACE <1.5ft/46cm
PERSONAL SPACE 1.5–2.5ft/1m
SOCIAL SPACE 7–12ft/2–3.5m
PUBLIC SPACE +25ft/7.5m

Figure 5.3
Zones of personal space

In ancient Greece, most speeches were delivered at a public distance; hence, grand gestures were required. Remember though that, today, the expectation has shifted toward a more personal experience. Thanks to TV, we want to see the "tight shot" of the speaker's face. To give your audience this experience, aim to close the gap between you and them at crucial junctures. When you emphasize a point, move toward the audience. To keep the entire room engaged, Morgan suggested that, for larger rooms, a speaker should mentally split the room into four quadrants.[31]

Plan to make eye contact with a few individuals from each of the four quadrants. Move toward audience members in the front two quadrants, and make eye contact with those in the back. Also, be sure to pause after important points, so the audience has time to wrap their minds around what you just said. Move away from them only when you are finished making the key point; this will help the audience feel as though each of them is getting your time.

If you have a smaller group, you won't need the quadrants, but again, make it seem as though everyone is getting some of your time.

Figure 5.4
Mentally dividing a room into quadrants can make audience engagement more manageable

SLIDES

If you choose to use them, slide decks can be a valuable asset in a design presentation. Slides allow those at a distance to see what you're presenting and they help to organize your talking points. Yet, they do pose a few fundamental risks.

When you present via slides, you essentially force your audience to split their attention between you and what's on the screen.[32] You won't want them to do this for long periods, so it's important that your slides require little reading. Your slides may also tempt you into talking to them rather than to your audience, meaning that your body faces the screen and not toward your audience. This can make you seem unprepared and uncomfortable. Third, a slide show may cause unnecessary and distracting movements, either because you feel the need to gesture to a slide or you have to walk back and forth to a computer to advance slides. This kind of movement does little to cut the distance between you and your audience, nor does it support your message. Instead, invest in a wireless remote, which will allow you to jockey slides without being tethered to a lectern.

These strategies can help you conceptualize slides that support,rather than distract from your message.

ALIGN YOUR BODY TO YOUR MESSAGE

If our words fail to align with our nonverbal signals, our credibility suffers. At its best, our body language helps us to appear genuine, authentic, and passionate about the needs of the audience. At its worst, our body language can send a message saying that we're disinterested, lifeless, or uncomfortable. Consequently, it is important to be aware of your body language so that you can modify any gestures that fail to conform to your message.

FACIAL EXPRESSIONS

We decode a great deal of information based on the faces of others and some expressions send fairly universal signals – both positive and negative.[33] The most prominent positive expressions are the smile and the head nod. Research suggests smiling makes us appear more attractive, while a vertical head nod shows affirmation and agreement. Other positive facial expressions include raised eyebrows and wide-open eyes. These suggest that you're receptive and interested, in turn, making the audience more likely to be attentive.

Negative facial expressions are generally the opposite of positive ones. We have all seen them – the frown, shaking head, downward slanting eyebrows, and narrowed eyes. Since the goal is to foster a positive relationship with the audience, most negative expressions should be avoided. However, at times, they can be used to convey the significance of the problem at hand. To avoid being seen as a cynical person, or one who is scornful of the audience, use your negative expressions sparingly.

POSTURE

Audiences often make up their minds about a speaker very quickly. The only way they can construct such quick judgments is to evaluate speakers visually. Since our posture can be seen from far away, it sends strong signals about us and our message. A slumping posture conveys low energy, whereas heads up, back straight is a confident, intellectual stance, and chest out suggests that you are receptive to the audience.[34] Since these are powerful cues, aim to be conscious of your posture whenever you are speaking to an audience.

GESTURES

Our hands are another source of information, though many of us are perplexed as to what to do with them while we talk.[35] Too much movement can be distracting, while too little can make us seem stiff. When deciding what to do with your hands, the first thing to think about is making sure you are not portraying a defensive or combative stance. To avoid these signals, avoid placing your hands over your groin, or crossing your arms for extended periods of time. These gestures might leave the audience thinking you are either aloof, ready to do battle – or need to use the restroom. Instead, open up to the audience, shoulders wide, palms showing. This builds trust and rapport.

Your movements should embrace the audience but be used somewhat sparingly. When in doubt, leave your arms at your side and bring them up when you are making a point. Try to avoid touching your face, hair, and head – Morgan referred to this as "nervous grooming."[36] These gestures can also be seen as flirtatious – not appropriate in business and academic settings.

NOISE

To persuade your audience, you will need to amplify your message and reduce any sources of **noise** that might distract from it.[37] There are two types of noise, internal and external. Internal noise factors stem from within the audience member (i.e., what they are thinking or perceiving).[38] These types of noises are often the result of the audience member's bias, their misinterpretation of the message, or any personal distractions. The best way to minimize internal noise is to maintain the audience's attention.

External factors, on the other hand, come from the surrounding environment. The impact of external noise factors depends on several considerations: the intensity of the issue (i.e., volume, sightlines, etc.), its contrast against the surrounding environment, its novelty, and if it occurs multiple times. Minimize these factors, and your audience can more easily focus on your message.

Should an unfortunate incident occur – the mic is screeching, sounds are coming from the room next door, or you have tripped over your own feet – simply acknowledge the issue (so the audience doesn't dwell on it), then move on. They'll likely sympathize with you and offer forgiveness. Chances are they too have had to deal with similar problems.

Figure 5.5
Types of noise

FINDING YOUR CONFIDENCE

The good news is you're presenting to human beings, not malicious alien-creatures. Each person in the room has faced their own struggles, problems, and concerns. Essentially, they are just people, and they are in the room because they believe you have something important to say. Secondly, almost everyone gets nervous before a big presentation; it's only natural. The key is to put your anxiousness to good use. Your goal should be to eliminate any potential causes of anxiety through preparation and rehearsal. Any remaining jitters are then aimed at animating your delivery.

PREPARATION

A common cause for speaker anxiety is fear that you won't know all the answers. The best solution for this is to simply do your homework. Know as much as you can about the topic, your audience, and the context of your presentation. Consider the following:

QUESTIONS TO ASK ABOUT YOUR AUDIENCE
All of your background work should be done (see Chapter 2).

What are the expectations for this presentation?

Will the audience have just eaten or be hungry, tired or wide-awake?

QUESTIONS TO ASK ABOUT YOUR PRESENTATION
When is it?
Daytime and evening presentations will have different atmospheres.

Where is it?
Will the presentation be in a small or large room?

What kind of occasion is it (i.e., formal, informal, academic, etc.)?
This will inform your manner of dress and word choice.

Who was the speaker before you (if any)?
This will help you determine if the audience will be enthusiastic or listless ahead of your presentation.

REHEARSING

"More speeches fail from lack of rehearsal than any other single problem."[39]
Winging it may have seemingly worked for you before, but considering that our memories tend to protect us from embarrassment, you may be remembering your presentation in a better light than your audience. Even if you were truly successful without practice, who is to say that would happen again?

Many of us put off rehearsal for one of two reasons; we either feel like we don't have the time or rehearsing reminds us of why we're nervous in the first place. When determining whether or not to rehearse, assess your priorities; what tasks are more important than a strong presentation? For the procrastinators, the more you put off rehearsing, the more stressful of a proposition it will become.

Aim to rehearse at least three times before a presentation – four if you are lucky enough to do a dress rehearsal. Not only will each rehearsal tighten and refine your presentation, but each allows you to focus on specific areas.

1. Tone & Timing
2. Tools & Transitions
3. Bringing it all together
4. The dress rehearsal

REHEARSAL #1 TONE & TIMING

When your tone supports your message, the results are powerful. For this reason, one rehearsal should be dedicated to harnessing your emotional tone and managing your timing. Your emotions will be embodied in your expressiveness, countenance, gestures, and motions. These cues are especially critical in your opening remarks since they prime the audience for your message.

To maximize your emotional range, in this rehearsal, consider exaggerating your expressions. While your final presentation will not be so exuberant, this exercise will help trigger your muscle memories when you are actually in front of your audience. However, you needn't rehearse your gestures in detail, since doing so can actually make you seem insincere. Instead, aim to channel your passion for the topic into your delivery so that your gestures naturally convey your intent.[40]

> **Babbling Rehearsal**
> Speech Coach Nick Morgan prompts his clients to do an exercise he calls Babbling Rehearsal.[41] During a Babbling Rehearsal, the speaker is essentially mumbling their presentation, providing the audience with only nonsense phrases. However, they deliver these phrases in a way that conveys their emotions. So while the audience is not privy to the speaker's words, they can see their expressiveness. The key is to understand if the audience can interpret the speaker's emotions without having the benefit of their words.

REHEARSAL #2 TOOLS & TRANSITIONS

Your presentation tools can certainly support your message, but poorly managed tools can just as easily distract from it. In this rehearsal, attend to any tools you may wish to incorporate into your presentation such as slideshows, notes, models, etc. The goal is to be competent and confident with your tools.

The second aspect of this rehearsal is practicing how you will lead your audience from one train of thought to the next, in other words, your transitions. Poorly planned transitions, such as items being shown too early or too late, will seem unprofessional. Focusing on your transitions will help ensure that you are delivering the audience neatly from one point to the next.

> **GROUP PRESENTATIONS**
> If you are presenting as part of a group, insist that you rehearse with the entire group. Rehearsal will help your team to avoid redundancy, forgotten elements, or awkward moments such as members talking over each other, or gazing at each other wondering, *who was supposed to talk about this?* These types of issues make it seem as though your team is unprepared or is incohesive, either of which can cause your entire team's credibility to suffer.

REHEARSAL #3 BRINGING IT ALL TOGETHER

The goal of the third rehearsal is to bring all aspects of the presentation together. This will build your overall confidence ahead of your final delivery. Aim to mimic the final production as closely as possible. Then reflect on this rehearsal to fine-tune your delivery.

DRESS REHEARSAL, THE GOLD STANDARD

Dress rehearsals are a beautiful thing. They allow you to test your delivery in the actual environment of your final presentation. If you have the opportunity to do a dress rehearsal, do it.

Start by exploring the room. Walk around it, sit where the audience will sit – don't forget about the back row. Explore any potential sources of distraction; will doors be slamming, lights glaring, etc.? Then view the room from where you will be speaking, standing there until you feel comfortable. If possible, give your entire presentation, and have a trusted ally sit in the back row. This will help you determine if everyone will be able to see and hear you clearly. When delivering your presentation, practice your movements and even try out a few vantage points for making eye contact with the audience. Channel your emotions into this delivery and mimic as much as you can about the actual performance. The goal is to eliminate as many potential stressors as possible – tweak lighting, do a sound check, cue up any visuals – these are things you do not want to worry about when it's finally showtime. If your hosts have set the room up in a way that tethers you to the podium, see if that can be changed. Often there are lapel or wireless handheld mics, and remotes that will allow you to step away from the lectern.

In the unfortunate event that the final room location is unknown or is unavailable, try to find a similar environment, or at least imagine the space as accurately as possible when you rehearse.

Following a dress rehearsal, assess any areas needing minor refinement. This likely won't change your content or its structure, but adjustments can help to sharpen your final presentation.

REHEARSALS THAT DON'T COUNT

"A speech is never real until you give it."[42]

Sometimes we trick ourselves into thinking we have rehearsed, but in reality, we haven't. This is a disservice to ourselves, our ideas, and our audience. Sorry, but the following "rehearsals" don't count:

FIGURE 5.6
Eyes off the screen when rehearsing

SITTING IN FRONT OF YOUR COMPUTER

Chances are you will not be facing your slides during your final presentation, so rehearsing while sitting in front of them does little to help ensure that you are familiar with the content and can manage transitions effectively. Nor will it help you test your strategies for audience engagement.

IN YOUR HEAD

Nice try, but a rehearsal doesn't count until someone can hear what you say – preferably someone other than yourself.

A "QUICK RUN THROUGH"

Hashing out a presentation on the way to the presentation itself is rarely effective. If you fail to deliver your message at the same length and with the same detail as your final presentation, you have not fully prepared.

The point is not to settle for second-rate rehearsals. If a presentation is worth giving, it's worth doing so knowing that you are prepared.

COPING STRATEGIES

A little bit of nervousness is normal – and can even help animate your delivery. However, too much anxiety can cripple your performance. If you're still feeling anxious (despite ample preparation), consider the following coping strategies:

GET TO KNOW YOUR AUDIENCE

If you get to know your audience in advance, you might find that they are not as scary as you have imagined. If you can, mingle with them at functions and exchange a bit of small talk before your presentation. This will give you a few friendly faces in the audience, and you can make eye contact with them during your presentation. Remember, they are just people too, and they share many of the same challenges, goals, and aspirations as you.

MENTAL IMAGERY

Positive mental imagery can help build your confidence ahead of a big presentation. Take a few moments to picture yourself giving a brilliant presentation. Make these images as vivid as possible by imagining the room, the audience's reaction, and your sense of certainty. Remember these images when you're feeling nervous.

RELAXATION

Remember, the worst case scenario probably isn't all that bad — so relax. Chances are you will not face the same penalties as the ancient Greeks. Moreover, minor missteps are forgiven. In fact, they can make you seem more human to your audience. Expecting perfection will only cause undue anxiety, and your performance shouldn't be a measure of your self-worth. With this in mind, it's likely that you are more anxious than you need to be.

JUST BEFORE THE PRESENTATION

Use the minutes before your presentation to get you into the right mindset. Listen to music that aligns with your intended tone and perform simple acts to help channel your energy. For instance, if you want to be energetic, try jumping a few times (just make sure your clothing and hair don't get tousled). If you're aiming for a relaxed tone, try some breathing or stretching exercises. Either way, smile beforehand; research suggests that smiling activates happy emotions.[43]

Just before your name is called, take a few deep breaths. Remember that you have prepared, and the audience is likely rooting for you. When your name is called, stride in confidently with your head held high. Shake hands with the person who introduced you (if there was one). Then, look at the audience and pause before you speak. This pause will help direct their attention, calm your nerves, and keep you from talking too fast.

At showtime, have some fun.

REALIGN YOURSELF TO YOUR AUDIENCE

Remember, as a designer; there are times when you will need to convince others of the merits of your design. In other words, you will need to *sell* someone on your idea. To make the sale, you must have their trust, and trust is a product of the relationship you have built with your audience. If you have a longstanding relationship – wonderful, this will make your job of persuading audience members far easier.

If you have just met the audience, you will need to assess their level of trust based on their feedback. Since it is unlikely that they will be booing or cheering, you may need to rely on real-time nonverbal cues to understand how they are receiving your message.[44]

What is their emotional and intellectual state?
Are they leaning forward in their chairs, or sitting back passively?

Am I building rapport?
Are they responding to my wit and jokes with smiles and laughter?

Do they agree with what I'm saying?
Are their heads nodding in agreement or shaking?
Are they imitating my gestures?

Is the audience ready to hear my idea?

NOT READY TO HEAR YOUR IDEA	READY TO HEAR YOUR IDEA
looking away	making eye contact
arms crossed	arms relaxed
leaning back or slumping	leaning forward or sitting up straight
legs crossed away from you	legs crossed toward you

SPECIAL PRESENTATION TYPES

Not all presentation environments are the same, and some involve special objectives and circumstances.

JOB INTERVIEWS

If you haven't already had a job interview, you will some day. Most interviews couple high stakes with high stress, but think of an interview as merely a catalyst for a conversation. Keep in mind two objectives for this conversation. The first is to create a bond with the interviewer (so that they like you), and the second is to highlight your potential (so that they want to work with you).

Often, this means an interview for a design job is more about your potential than your previous work, so tailor your discussion to their needs. If sharing a portfolio, orchestrate it to align with the position at hand. If you are feeling comfortable (or brave), start the interview by asking them what they want to know about you, then find evidence in your portfolio that speaks to these attributes.

Always research the employer and have some questions prepared for them. Failure to do so can make you seem uninterested, or unprepared. Aim to make your body language align with theirs; remember, this shows that you are interested. Adopt the same general posture, and be sure to smile.

In sum, you want to make the interviewer's life easier by helping them see why you are so great. So don't do anything to distract them from seeing that.

VIDEO CONFERENCING

While video conferencing provides an excellent opportunity to connect with others who may be far away, video conferencing tools don't always measure up to our expectations. Cameras and lighting can be of poor quality; signal strength can be weak, any of which can throw you off your game.

However, there are a few things you can do to improve the audience's perceptions of you. Do make eye contact with the webcam, but don't feel the need to stare at it. Try putting a picture of a family pet next to the camera (but don't block it). This friendly face will keep you looking and smiling at the camera without gawking at it. Also, be expressive and share your passions. Give short, simple, and conversational responses. Responses that include "now where was I" can be distracting, so being concise will help you to reestablish the conversation should you and your other party get disconnected.

Remember though, that those on the other side of the screen will likely understand some of the negative nuances associated with video conferencing.

> TIPS FOR VIDEO CONFERENCING
> - Check your equipment and settings in advance.
> - Look at the camera.
> - Try to sit in an environment with good lighting.
> - Ensure that you have a reliable internet connection.
> - Know when the microphone is and is not on mute.

LEARNING FROM THE GREATS

You can learn a great deal by watching the greats.
Examine the delivery tactics of the following:

Winston Churchill, 1940; *We Shall Fight on the Beaches*
 Significance: *rally cry evoking universal truths through pride of country and stoicism*

Cory Booker, 2010; Pitzer College commencement speech
 Significance: *integration of personal stories & humor*

Bill Gates, 2009, *Mosquitos, Malaria & Education.* TED Talk
 Significance: *integration of vivid, memorable props*

Steve Jobs, 2005; *How to Live Before You Die.* Stanford commencement
 Significance: *personal, reflective messaging*

Michelle Obama, 2016; speech to the Democratic National Convention
 Significance: *personal, empowering messaging with a call to action*

Ronald Reagan, 1986; address following the Challenger disaster
 Significance: *expression of shared grief*

Eva Zeisel, 2001, *The Playful Search for Beauty.* TED Talk
 Significance: *conveying ethos through a personal story*

SUMMARY

While designers do not face the same high stakes as defendants in the courts of ancient Greece, design presentations still require planning of both intent and execution. Designers seeking to persuade their audiences of the merits of their idea should consider how first to elicit the attention of their audience using "S"tory, and then share its relevance to the problem at hand. This understanding comes from providing the audience with a personalized experience. To do so, aim for an alignment between yourself, your audience, and your message.

Aligning these three aspects is done through careful crafting of both the content and its delivery.

Content Presentation content should acknowledge the audience's preferences for aural, visual, read/write, and kinesthetic forms of information throughout the presentation. The hook is an invaluable opportunity to appeal to the audience through their emotions, and compelling presentations allow the audience time to revel or wallow in their feelings before providing a solution. A long summary at the end of a presentation can squander your momentum. Instead, use the finish as a call to action, prompting the audience to act both within the room and beyond it.

Delivery Remember that how you say something is often as important as what you are saying.

So consider how to best harness delivery strategies of:
- clarity, *speaking to be understood,*
- conviction, *speaking to be believed,* and
- charisma, *speaking with passion.*

Preparation
There's no way around it, important presentations will require preparation. Your planning should involve knowledge of the topic, the audience, and the contexts of the presentation, as well as at least three rehearsals. Coping strategies such as positive mental imagery, familiar faces, and relaxation can help to reduce any remaining anxiety.

In the end, remember that you are speaking to a group of people with whom you likely have many things in common. After all, they would not be attending your presentation if they did not think you had something important to say.

TERMS

anecdote	hedging	pitch
authoritative arc	jargon	qualifiers
channel	noise	receiver
elevator pitch	parable	sender

APPLICATION 5.0

Use your statements from Chapter 4 for the following:

1 Recall the talking points developed in Chapter 4.

Consider strategies that acknowledge the audience's various preferences for receiving information.

The Hook
Goal: To garner attention

AURAL
VISUAL
KINESTHETIC
READ/WRITE

Exploration of the Problem
Goal: To illustrate the relevance & magnitude of the problem

AURAL
VISUAL
KINESTHETIC
READ/WRITE

Sharing the Solution & Its Benefits
Goal: To highlight how your design will resolve the problem

AURAL
VISUAL
KINESTHETIC
READ/WRITE

The Finish
Goal: To prompt action within and beyond the room

AURAL
VISUAL
KINESTHETIC
READ/WRITE

2 Rehearse your entire presentation with a peer for Tone & Timing. Have them track how many times you use filler words by dropping a scrap of paper each time they hear you use one. (Note: this rehearsal does not yet include visuals.)

3 Adjust and refine your presentation based on your audience's comments and your own experience.

4 Rehearse your entire presentation with a peer for Tools & Transitions. This time, keep track of each time you would prefer to have a visual to reinforce your ideas. The goal is only to create those visuals that would benefit your message.

5 Adjust and refine your presentation based on your audience's comments and your own experience.

The third rehearsal will occur following Chapter 8.

OBJECTIVES

- Gain a broad understanding surrounding the role of visual communication in design
- Be able to apply design elements and principles to a graphic composition
- Understand how to develop visual messages to persuade and aid comprehension
- Be able to conceptualize a personal brand
- Connect this knowledge to future presentations

Photo with permission from Anna Osborne

6

VISUAL STORYTELLING

This chapter centers on the use of visual communication.

Following a promotion, Lee was tasked with designing her company's annual report, which is shared each year with prospective clients and investors. These reports were always narrative-based, using only a few scattered images to illustrate business metrics. Lee sensed that their previous reports read as shortsighted snapshots since they failed to capture what investors loved most about the company, namely, how their business decisions reflected their values.

Hoping to leverage some untapped potential and emphasize their company's broader vision, Lee set out to design a different kind of report – one that would rely on integrated visuals to convey information.

INTRODUCTION

We acquire more information through our eyes than from all of our other senses combined.[1] So it may not be surprising that the last 10% of effort allocated to a project can often serve as the initial basis of a viewer's evaluation. That is to say, the visual packaging surrounding an idea can influence impressions about the design itself. Once these impressions are set, they can be difficult to alter. While designers are adept at producing sketches, illustrations, and renderings, presenting intangible ideas can prove more difficult. Moreover, conveying ideas without getting in the way of design itself can be difficult. The question becomes how the visual package can align with and support the idea, providing the audience with a clear and compelling message.

This chapter will explore this connection through decisions on images, type, and layout.

IS A PICTURE WORTH A THOUSAND WORDS?

Once your storyboard and talking points are developed, it's time to generate the props to support your story. Since our brains are wired for visual information, these props can be extremely important. In fact, the human brain contains approximately 20 billion neurons dedicated to analyzing visual information.[2] This gives our brains a remarkable capacity to process images. Studies suggest that due to their vividness, distinctiveness, and our ability to see the entire visual at once, visual messages hold several advantages over their word-only counterparts, especially in terms of garnering attention, influencing emotions, and aiding in recall and comprehension. To capitalize on these advantages, however, thoughtful planning is required, with consideration given to Vitruvian aspects of: **attractiveness, soundness,** and **utility**.[3]

Figure 6.0
The ancient Roman architect Vitruvius theorized that designs should exhibit three principles: *venustas, firmitas, & utilitas*.[4] Design scholars continue to use this framework to evaluate a design's success[5]

utilitas
utility
usefulness & function

firmitas
soundness
quality & reliability

venustas
attractiveness
novelty & appeal

ATTRACTION & PERSUASION

Designers can learn a great deal from advertisers. Each day, they vie for our attention (and dollars) using distinct and sometimes eye-popping visual appeals. Since these images can be both vivid and quite different from one another, their novelty can be used to entice an audience to consider their proposals.[6] Recent research in consumer thinking suggests that graphic ads can more easily capture consumers' attention,[7] and to enable greater levels of issue-relevant thinking.[8] These insights suggest that we are more inclined to think about a product longer (and maybe purchase it) if we can see it rather than just read about it. The danger, however, lies in providing an audience with too much of a good thing – effectively overwhelming or desensitizing them to the message at hand.

While we are awed by dazzling product imagery, we also encounter a range of other types of images each day, from empowered professionals and aspiring athletes to starving children and mistreated pets. In effect – we are almost constantly manipulated via visual messages. These images are used to stimulate an "immediate visceral understanding,"[9] such that our gut reactions evoke a range of emotions like sadness, guilt, confidence, or joy. These emotions can leave a strong impression and vivid imprint, influencing our beliefs,[10] often without our even recognizing that our beliefs have changed. This manipulation is frequent but not inherently bad since it is often done for very valid and altruistic purposes. For instance, public service announcements compel us to give or strive for self-improvement, while news outlets rely on visuals to express the significance of world events. Understanding the persuasive potential of imagery can help designers leverage these same messaging tactics.

LEVERAGING THE FIRST IMPRESSION

Right or wrong – our first impressions are often both potent and long-lasting. In his book, *The Design of Everyday Things,* Donald Normal described the visceral effect of our perceptions, causing us to either feel attracted to or repulsed by what we see.[11] This effect can be especially potent in visual communications since it is thought that our immediate exposure to visual information trumps the slower processes of our rationale thinking.[12] As a case in point, while our money may be better spent on future expenses, we might still go out and buy those expensive shoes that we just saw in the store window. We are drawn in by what we see.

Similarly, designers might be able to secure sustained buy-in for an idea based on first impressions. These initial thoughts may even withstand potential scheduling challenges and budgetary constraints – problems that may very well occur later in the design process. While many of these reactions are based on subjective perceptions, some knowledge of human cognition and the design elements and principles can lead to more effective strategies.

FOR FURTHER READING

The Design of Everyday Things by Donald Norman

RECALL & COMPREHENSION

Along with persuasive sway, evidence suggests that visuals trigger memories and aid information recall. In fact, one study found that when shown a series of many images, viewers had the capacity to remember which images they had seen before with 90% accuracy – even four days later.[13] This effect has become known as **picture superiority effect**,[14] and it can be elevated further by pairing images with corresponding text.[15] Researchers have suggested that such word/image pairings activate both verbal and non-verbal neural pathways,[16] engaging more of our brain, consequently increasing the chances that we will retain the information in our long-term memory.

There are also several ways that visuals aid comprehension. First, they are thought to present information in a concise and focused manner, thus helping viewers to attend to particular aspects of a message.[17] Images can also provide an organizational structure, allowing viewers to navigate information with greater ease.[18] Finally, word/image pairings are thought to help viewers understand complex ideas through **scaffolding** – where words build on images, and images on words, thus reinforcing understanding.

In addition to focusing on aesthetics and viewer emotions, picture superiority can be leveraged through the use of:[19]

Relevant visuals to represent concrete objects.	Visual analogies which relate new ideas to familiar content.
Two or more images shown in association to reinforce the message.	An uncluttered composition that reinforces a clear hierarchy of information.
Images paired with words.	

AUTHOR'S NOTES 6 E's of Information Engagement

While design scholars have long lamented a lack of research utilization by designers, few have explored or proposed strategies to improve communication between researchers and those in design practice. I have come to believe that this disconnect is stunting progress in many design fields since research studies that remain unknown or unacknowledged by designers stand little chance of influencing their design decisions for the better. As I transitioned from practice to academia, I felt compelled to address this impasse by studying how design practitioners approach and process research findings.

My research included Likert-type tests, heat maps, open-ended responses, and interview questions, from which themes emerged regarding which tactics designers considered to be both effective and engaging.[20] I have come to call these the 6 E's of Information Engagement.

Empathize — Understand your audience

Emphasize — Highlight key information

Explanatory Images — Use images when possible

Embrace Color — Use color to code & highlight information

'Enformation' Clusters — Distribute information with headings

Established Organization — Plan for viewer navigation

E-MPATHY

Whether your audience is composed of eight-year-olds or executives, time and attention are likely short in supply.

Consider what your audience already knows, and plan to highlight what is important to them. Once you learn what they care about, you can use imagery that aligns with these interests. For instance, those moved by pathos appeals would likely be swayed by images conveying emotion.

E-MPHASIZE

Call out key information both visually and verbally. Aim for this information to be relatable and tangible.

Use statistics sparingly, but poignantly. When stats are used, give them in smaller, more approachable terms and use descriptive labels, so viewers can "picture" those involved in the statistics. For example, eight of ten girls will sound more convincing – and palpable than 80% of female children.

E-XPLANATORY IMAGES

When appropriate, show vivid imagery, but be sure that it is clear, supportive of your message, and in no way distracting or overwhelming.

Never insert images "just to fill space." Chances are images selected under this pretense will have little to do with your intended message.

"E-NFORMATION" CHUNKING

Too much of anything can be overwhelming. Educational psychologists use the term "chunking" to describe the parsing of information into more manageable chunks, like how we might say phone numbers in short strings of 3 or 4 numbers.

If your information is dense, consider parsing it out, similar to how the 6 E's were provided on this page spread.

E-MBRACE COLOR

Color can be used to trigger an emotional response or aid comprehension.

Consider how and when to use color to elicit favorable opinions, thread information together, or draw distinctions.

E-STABLISHED ORGANIZATION

Some aspects of compositional constancy will allow viewers to interpret information and distinguish differences with greater ease.[21]

Strive for an established organization when possible. In print work, this means creating only a handful of page layouts and limiting the number of colors and fonts used. However, exact duplicates can feel static, so determine what should change and why.

EXERCISE 6.0 ENGAGEMENT TACTICS

Using a pair of facing pages in your favorite design publication, consider the following:

Empathize
How does the content align with the magazine's audience?
For instance, how might this information pique their interest or speak to their needs?

Emphasize
How does the composition emphasize important information?
Have the document's designers used headings, captions, large graphic text, or diagrams?

Explanatory Images
What images are used and how do they support the message?

Embrace Color
What colors are used, and how do they support the message?
What emotions do the colors evoke (excitement, calming, etc.)?
Have the document's designers used color-coding tactics?

"Enformation" Clusters
Is the information parsed out into "chunks" such as paragraphs or insets?
How is this done?

Established Organization
Flip through a few other pages in the same issue.
Are there any similarities, such as a comparable use of margins or placement of objects?

VISUAL THINKING STRATEGIES

Since imagery is so vital to design storytelling, selecting and creating the right story *"props"* can make the difference between which ideas are embraced and which are rejected. While there is no single right or wrong way to go about creating imagery, four tasks can help conceptualize images that are attractive, sound, and useful.[22] We'll refer to these tasks as Scanning, Understanding, Imagining, and Developing.

Figure 6.2
Visual thinking tasks

Scanning	Understanding	Imagining	Developing
What's out there?	What does it mean?	How can it be represented?	How can it be shared?

SCANNING & UNDERSTANDING

We are constantly in scanning and understanding modes. In fact, our eyes help us make sense of the world around us by scanning it constantly. While we rarely notice it, they are in near constant motion, allowing us to track a range of details and six million different colors.[23] We rely on these processes for our learning, understanding, and survival. Consider the scenario below:

Would you stay and play or run away?

Imagine you are walking down the street and see a dog running toward you. While you're a dog lover, you still need to determine whether this dog is friend or foe, so your brain directs your attention toward features and patterns that are most meaningful.[24] In this case, you look at the dog's posture and facial expression. This dog has its ears back and teeth showing.

Your decision happens in less than a second from seeing the dog – eye to brain, brain to feet – any longer might be dangerous.

When conceptualizing visual story props, think of the big picture first and foremost. Author and consultant, Daniel Roam suggested that to begin, we actually should back away, reflect, and see everything – all at once.[25] Stepping back can admittedly be difficult to do, especially when facing a lot of information, tight deadlines, and packed schedules. However, spending even a few minutes "scanning" to see the richness of the issue at hand can make a big difference in how you move forward. For instance, ask yourself, what were your original goals? And, how did your design decisions satisfy those intentions? If you're working with information, laying it all out is the first step to determining what to include and how to represent these ideas.

Figure 6.3
Note cards are a fast way to see and reorganize ideas

If Scanning helps us see the big picture, Understanding helps us to make sense of it. This is when we decide what information warrants our time. We determine this by filtering these inputs, or cues for relevancy. We then categorize and cluster them so that we can identify patterns, commonalities, and differences, essentially, asking ourselves, what is important?

SENSORY VS. ARBITRARY CUES

Many of our interpretations (and those of our audience) are informed by our prior knowledge, environments, and cultural backgrounds. **Arbitrary cues** depend on these types of learned understanding. For example, a child who cannot read would not know to avoid the chemicals under the sink based upon a written label alone. Arbitrary symbols only work if the person knows enough about them to accurately interpret their meaning. Arbitrary symbols can also be interpreted differently from culture to culture.

On the other hand, **sensory cues** rely on our senses and intuition; thus, very little learning is necessary. The toddler from above might be frightened by the skull and crossbones symbol on the label, thus slamming the cabinet door. Sensory symbols tend to be more consistent across cultures, individuals, and time since they rely on universal truths to convey meaning.[26]

Determining which to use is largely a function of your audience's understanding and background. Since people can interpret arbitrary cues quite differently from one person to the next, sensory cues may be more appropriate for a diverse audience.

Arbitrary Symbol

Sensory Symbol

Figure 6.4
A child might not know how to read the arbitrary signal at the top, but they may be frightened enough to avoid the dangerous activity by the sensory symbol below it

COMPOSITIONAL CUES

Alongside sensory and arbitrary cues, **compositional cues** such as placement, form, and color help us make meaning from what we see:[27]

PROXIMITY

We assume that objects close together are related.

SHAPE

We notice differences in shape and believe the unique forms are more important.

COLOR

We notice differences in color and assume groupings are based on these differences.

SHADE

We detect different shades and use that information to delineate information.

Figure 6.5
Composition cues can help a viewer navigate information

107

IMAGINING

Imagining tasks allows us to explore potential ways to convey ideas. These representations can be thought of as signs since they signal information to the audience. When exploring your ideas, consider whether the audience has seen similar information before and whether any metaphors might support their understanding.[28] An important frame of reference in this process is the study of **semiotics**, which can be briefly explained by how meaning is made from signs, which are categorized as either icons, indexes, or symbols based on their likeness to the object they represent.[29]

Figure 6.6
Semiotics can explain how viewers might interpret visual representations

ICON	INDEX	SYMBOL
physically depicts the object it represents **Sensory Cue**	shows evidence of the object it represents **Somewhat Arbitrary Cue**	has an arbitrary relationship to the object it represents **Arbitrary Cue**

DEVELOPING

Once your content has been determined, it's important to consider the specifics of how it will be represented – with icons, indexes, or symbols, and with concrete or abstract representations. Think of these representations as answers to the questions of *who, what, when, how much, where,* and *how.*[30]

WHO?
Individuals or groups can be represented by portraits.

WHAT?
Tangible objects and some ideas can be represented with icons.

WHEN?
Time and order can be represented with timelines.

HOW MUCH?
How much something costs can be presented on a table.

WHERE?
Where something occurs can be represented on a map.

HOW?
How something occurs can be represented with a flow chart.

Figure 6.7
Visual representations can be thought of as answers to questions

REPRESENTATION STYLES

In his book *Exercises in Visual Thinking*, Ralph Wileman offered a taxonomy (classification system), highlighting a range of ways an object can be represented.[31] In Wileman's system, objects can be presented through pictorial symbols (the most realistic representation), graphic symbols (icons or outlines of the object), or verbal symbols (written words).

[pen photo]	three-dimensional representation or model		
[pen photo]	picture	pictorial symbols	Concrete
[pen outline]	illustration		
[pen silhouette]	icon	graphic symbols	Ways to Represent Objects
[tapered line]	conceptual icon		
[thick line]	abstract icon		
writing instrument	definition or description	verbal symbols	Abstract
pen	label or noun		

Figure 6.8 Representation tactics

EXERCISE 6.1 REPRESENTATION TACTICS

Create a series of representations similar to the one above for both an object and a verb of your choice. Then discuss your representations with a peer to determine what method would be most appropriate for your typical audience.

109

Media

There is an innate relationship between representation tactics and the media in which they will be shared. Below is an overview of potential media options that designers can leverage in their presentations.

SCREEN-BASED PRESENTATIONS

Screen-based presentations typically coincide with a verbal presentation, meaning that the audience is receiving information from two sources – thus inciting a battle between looking at the screen and listening to the presenter. In this scenario the speaker dictates how content is offered and when. Since the audience have little choice in the matter, they can easily grow bored or overwhelmed. Arbitrary symbols can aggravate this effect since they take longer for viewers to process. This is why presentation slides should avoid long written passages.

Appropriate symbols: high Sensory, low Arbitrary

PRINT MEDIA

Print media is essentially any paper-based format, such as books, brochures, posters (or boards) and magazines. When you flip through a book or magazine, or approach presentation boards, you can see the entire page at once, which means that as a viewer, you get to determine how to scan the content – where to look and when.

Since viewers can determine their speed, both arbitrary and sensory symbols can be used. However, designers working in this media need to consider how to guide their viewers' eyes through content.

Appropriate symbols: Sensory or Arbitrary

PHYSICAL MODELS

A physical model is a prototype or miniaturized version of the final design outcome. Since they replicate features of the actual design and offer something for viewers to touch and feel, physical models have an inherent appeal to our senses.

Appropriate symbols: high Sensory

INTERACTIVE MEDIA

Interactive media such as apps, social media, and websites appeal to our innate desire to engage with content by altering it, and focusing on or filtering out content. While opinions are mixed regarding the long-term effect of these sources on our capacity to process information, their growing use will likely change audience expectations for design presentations.

Appropriate symbols: high Sensory

VIDEOS

By engaging sight and sound, videos provide a multi-sensory experience, and they are becoming more widespread in design communications. Videos typically follow a linear format, wherein the video's producer dictates the sequence and pacing of the content. This means that there is little time for viewers to process information, so symbols need to be easy to recognize and interpret.

Appropriate symbols: high Sensory

ORGANIZING GRAPHIC REAL ESTATE

Regardless of media, even the best of story props will be missed or misinterpreted if they reside in a poorly planned composition. So it's important to carefully organize the space surrounding your representations.

ORGANIZING GRAPHIC REAL ESTATE

All media face real or implied graphic boundaries. Within these limits, you'll need to maximize your opportunities to sway the audience. Consider the extents of your composition as graphic real estate, and similar to locating a building on a city lot, the location of your graphic elements such as images and text can have favorable or detrimental effects. As such, designers need to be mindful of borders, sightlines, and open spaces. Lacking this consideration can make even the best story props look sloppy and ill-considered, which can leave your audience bored, confused, and generally off message – and frankly, make you look bad. So, to make your stories come alive, consider employing principles of visual hierarchy.

VISUAL HIERARCHY

Lacking cues that suggest importance, viewers may wander aimlessly through content. Visual hierarchy can influence what viewers see first as well as the order in which their eyes travel from one element to the next.

To plan your visual hierarchy, first determine what is most significant and place it accordingly. Consider natural reading preferences, which eye scanning studies suggest follow a pattern corresponding to the letters F or Z in left-to-right reading countries.[32] Think of newspaper layouts where items aimed at piquing interest, like headings or compelling images, are placed at the top of the page, above the fold. To keep the viewer moving forward, you'll also want to place a stimulating object near the end of the sequence, thus pulling the eyes toward it.

Figure 6.9
Readers in most Western cultures typically scan information in F- or Z-like patterns

TOOLS OF EMPHASIS

An important consideration in visual hierarchy is understanding how to emphasize the elements you feel are most important. Consider the images below; the left composition is scattered with no clear focus, while the right iteration makes use of alignment, **negative space**, and scale to create a sense of visual hierarchy.

Figure 6.10
The left composition fails to lead the eye, while the right arrangement incorporates tools of emphasis like alignment, negative space, and scale to prioritize information

111

GRID

Creating an implied grid can help you leverage the tools of emphasis by providing an innate structure to your composition. This structure helps to keep the final composition balanced and intentional. The Golden Ratio and the Rule of Thirds can be used to compose your grid.

Fibonacci Sequence & the Golden Ratio

Figure 6.11 Implied grids can be used to organize a graphic composition

Many grids are based on the Fibonacci sequence, where a square's size is the sum of the two preceding it,

e.g., *1+1 =2, 2+3=5, 3+5=8...*

When each number on the Fibonacci sequence is divided by the previous, the result is roughly the Greek number phi, which forms the Golden Ratio.

1 : 1.618

Rule of Thirds

Rule of Thirds is often used by professional photographers when composing a dynamic shot.

Objects are placed 1/3 away from either edge instead of in the center.

Grid Elements

Grids are composed of a few basic elements: column lines are vertical, flow lines are horizontal, and margins mark borders.

With these elements in mind, you can also create your own grid by adopting uniform spacing or creating a new grid to follow your predetermined rules.

Figure 6.12 Grid lines can be regularly or irregularly spaced

columns
margins
flow lines

ALIGNMENT

Your content can be anchored to your grids by aligning it to either a column or flow line. Alignment provides organization, which makes the composition appear more intentional and aids viewers in navigating the information.

FLUSH LEFT

Pro
Safe choice for legibility.

Con
Can be seen as conservative.

Figure 6.13
Alignment strategies

Which of these alignment strategies works best for the given information?

CENTER

Pro
Having content anchored down the center is great for odd shapes.

Con
Its symmetry can make it seem dull.
Its two ragged edges make this tactic unsuitable for long bodies of text.

FLUSH RIGHT

Pro
Less common & more provocative.

Con
Its ragged edge at the left makes it unsuitable for long bodies of text in left-to-right reading countries.

EXERCISE 6.2 UNDERLINING ORGANIZATION

To leverage implied grids, it's best to start by studying how they are used in design communications. Consider the following:

Make copies of 2–3 pages from different design magazines.

Over these copies, mark lines indicating implied grids and determine if objects are positioned along this grid via flush left, center, or flush right alignment.

Would you make any changes to this underlining strategy?

NEGATIVE SPACE

Negative space sounds, well. . . negative, and some designers hesitate to use it. However, negative space, or if you prefer, white space (though not always white), is an area of relief around an important object. Negative space sets off forms through contrast and gives viewers' eyes a place to rest so that they can, in turn, focus on the actual content. It's a fundamental tool of emphasis since it helps viewers to categorize and cluster information. What negative space is not, however, is *left over* space. Effective negative space is intentional. Larger areas of negative space help to reduce the perception of clutter. Also, negative space in the center of a layout can be disorientating for viewers, so avoid trapping it away from the edges of a composition.

The following images are alternative layouts for the right side of an earlier page spread. Consider which iteration most effectively integrates negative space.

Figure 6.14
Trapped negative space does little to declutter the page

Figure 6.15
Too little negative space can leave viewers feeling overwhelmed

Figure 6.16
Larger areas of negative space at the edges of the page give viewers some respite

AVOIDING NOISE

Noise in graphic design is essentially visual clutter, which distracts an audience from the message. To avoid visual noise, consider the following:

AIM TO:

Use proximity to show relationships.
Related items or those that are to be compared should be adjacent.

Use implied grids to place content.
Grid lines can be used to anchor your content, providing balance.

Create a cohesive visual presentation.
Use only a few select fonts, forms, and graphic treatments.

Create a simple composition.
Every element on the page should reinforce your design story.

AVOID:

Heavy borders.
They tend to pull the eyes away from content.

Overlapping images.
The tension at the area of overlap can draw attention away from the content itself.

Unnecessary graphic elements.
Gradients, watermarks, and embellishments can distract viewers from your message.

Placing large & dark elements at the top of the page.
This causes the composition to feel top-heavy and out of balance.

TESTING YOUR COMPOSITION

To test your visual hierarchy, have someone close their eyes then quickly reopen them in front of your composition. Ask them what they noticed first. If their response doesn't align with your intent, consider reemphasizing your message and deemphasizing whatever drew their attention.

TYPOLOGY

Cave paintings and hieroglyphs seem to indicate that our earliest ancestors were predominately visual communicators. However, as human language grew in sophistication, and literacy rates increased, so too did our ancestors' preference for word-based communication. This meant visuals were somewhat marginalized, with images added to text to: provide embellishment, represent, organize or clarify content, or aid reader recall.[33]

However, strategies such as data visualization, information graphics, and annotated pictures/tables are becoming more prevalent.[34] These strategies give designers the ability to more fully capitalize on the inherent advantages of visual communication by placing information in a visual context. Being able to see the information allows viewers to rapidly interpret it by noticing patterns, recognizing problems, and even identifying potential solutions. While such representations vary in aesthetic character, they seek to integrate words with imagery, thus offering a more cohesive explanation of information.

When designing your visual story props, consider the relationship between text and images. Ask yourself the following:

> Are images within text or text within images?
> Which is more prominent?
> Which is developed first?

Which of the following strategies would be most effective?

TEXT FIRST[35]
Images are added to bodies of text to either:

Embellish
Goal: to add decoration

Organize
Goal: to cluster and differentiate content with charts & diagrams

Represent
Goal: to make content more tangible with concrete images

Aid Recall
Goal: to help the audience remember content by targeting multiple neural pathways

IMAGES FIRST
Text is added to images to either:

Clarify
Goal: to reduce ambiguity with labels & captions

Organize/Clarify
Goal: to cluster and differentiate content with headings & insets

Elaborate
Goal: to expand on information with descriptions

Aid Recall
Goal: to help the audience remember content by targeting multiple neural pathways

EXERCISE 6.3 WORD TO IMAGE RELATIONSHIPS

To explore the relationship between text and images, locate 7–10 samples of design communication from websites and magazines.

Which of the strategies from above do they use?

Are these relationships effective for garnering attention & aiding comprehension?

PSYCHOLOGY OF TYPE

Type can play an influential role when telling design stories. In her book *Visual Design Solutions,* Connie Malamed suggested that typefaces "provide subtle meaning beyond the design itself,"[36] meaning that type can convey particular tones, moods, and attitudes to viewers. In fact, studies on the rhetorical perceptions of typography suggest that fonts are often characterized as either e*legant, direct,* or *friendly.*[37]

This means that the type you choose should reflect the content of your message by eliciting the desired emotions. When selecting fonts, consider your audience and how they might interpret the character of the text. Aim to see your selected fonts through their eyes. — body copy

A typeface is a family of fonts — pull out text

TYPE TERMS

You'll need to ensure that any **font**, or family of characters you choose is legible at the distance the audience will be from your work. So consider both your font and text size by viewing them as your audience will, using the same media and at the same distance.

Type love

- **Ascender** -- part of a letter extending above the mean line
- **Cap Line** -- upper boundary
- **Mean Line** -- upper boundary of most lowercase letters
- **Base Line** -- where letters sit
- **Descender** -- part of a lowercase letter extending below the baseline
- **Glyph** -- an individual letter or symbol

Tracking
space between strings of letters

Kerning
space between individual letters

Leading
space between lines of text

Leading refers to the space between lines of text

117

FONTS

It's best to use to use only a few fonts or typefaces. Aim to limit font changes only to draw distinctions. For instance, you may want to distinguish copy text from display type. **Copy** text forms the overall narrative (think paragraphs), while **display type** is reserved for headings and text with emphasis. Since headings are aimed at calling attention, their fonts can be more distinctive. See font categories below:

FONT CATEGORY	EXAMPLES	BEST USES
serif	Times New Roman Garamond ENGRAVES	printed media
san serif	Century Gothic Arial Franklin Gothic	headings digital media
script	edwardian palace	distinct headings only
decorative	eras demi letter gothic Bradley Hand	distinct headings only
(Dingbats)	Wingdings 1 Wingdings 2 Wingdings 3	for symbols

9 pt
10 pt
11 pt
12 pt
14 pt
18 pt
24 pt

Figure 6.17 Test your font sizes at the distance that they'll be viewed

FONT CONSIDERATIONS

It's important to understand how large a font will appear in real life. Fonts should rarely be smaller than 10pt, and slightly larger fonts work better for older audiences.

If you are moving files between Macs and PCs, look for **open type** fonts. Emphasis can be added with *italics,* **boldface**, or by using pullout text, but be careful not to overuse these tactics as they can dilute your message if used too frequently. All caps text should only be used for headings and short labels or phrases; avoid it for paragraphs.

OBTAINING FONTS

If you desire to use fonts other than what's already installed on your computer, they can be downloaded from reputable websites. Also, font recognition websites allow designers to identify fonts they have seen while they're on the go by uploading photos of signs, flyers, and posters.

FONT SOURCES

Font Downloads
DaFont
Font Squirrel
Typekit

Font Recognition
What the Font
Font Squirrel

COLOR

Color is one of the most versatile, but demanding tools in the design storyteller's toolkit. Thoughtful applications of color can work to gain an audience's attention, evoke their emotions, signify meanings, and be used to code information. For some, however, colors can be hard to distinguish, and our perceptions of color can be somewhat complex and nuanced. Color perceptions vary, depending on our respective cultures, histories, and preferences.[38] For example, brides in Western cultures wear white to signify their purity, and red in Eastern cultures to promote their luck.

Complicating a designer's decisions on color is the fact that a color's surroundings can alter its appearance. Nearby lighting conditions and adjacent colors can have surprisingly dramatic influences on a color. To avoid surprises, designers should consider the environments where their selected colors will be viewed, and how viewers might react to them.

Figure 6.18
A color's surroundings can influence its appearance.

PSYCHOLOGY OF COLOR

Color's influence on human behavior is known as color psychology. While there is too much research on color to cover everything in this text, some general guidelines bear mentioning.

COLOR PERCEPTIONS

Bright colors are associated with "showiness"[39] and excitement.[40]

Neutral colors are considered understated and elegant.[41]

Dark colors evoke a sense of strength, or boldness.[42]

Reds, yellows, and oranges are considered dominant, stimulating colors, so they often appear more prominent in a composition.[43]

Greens and blues are considered calming and appear recessive in a composition.[44]

Colors are commonly thought to embody certain attributes. Consider some common color connotations.

COMMON COLOR CONNOTATIONS[45,46]

BLUE-trust, security, stability
RED-exciting, stimulating
BROWN-ruggedness

YELLOW-playful, confident
GREEN-growth, nature (sustainable)
BLACK-luxury, elegance

EXERCISE 6.4 COLOR CONNOTATIONS

To understand how colors perceptions are leveraged in brand messaging, locate 2–3 websites from companies or organizations you consider to embody each of the following attributes: *trusted, sustainable, & confident*.

Compare their brand's colors against the common color connotations listed above.

Do your findings support the connotations?

CHOOSING A COLOR PALETTE

Color palettes are sets of colors used in a design. It's best to keep these sets small since too many colors can cause viewer fatigue and confusion. At the same time, a dull palette can leave viewers uninterested. To avert fatigue, but secure viewer interest, it's best to pair brightly saturated colors with neutrals such as grey, white, black, tan, or navy.

Established palette frameworks can aid color selection.

Figure 6.19 Palette frameworks

Analogous Palettes
three adjacent colors on the color wheel, such as reds and oranges

Complementary Palettes
colors that are opposite each other on the color wheel, such as red and green

Split Complementary Palettes
include colors opposite each other on the color wheel, but are modified by including an adjacent color such as red, orange & green

Monochromatic Palettes
use shades of the same color, which can be sophisticated, but dull

Palette Resources
Online tools can help identify palette options:

Adobe Color	ColorExplorer.com	Design Seeds
COPASO	MudCube	TinEye Labs

USING COLOR

Usability refers to the way in which color can be understood, and used.[47] To enhance color usability, consider the following:

WHEN USING COLOR

Use color consistently.
The same colors should be used on the same types of content.

Use color to aid visual hierarchy.
Bright and deeply saturated colors will be noticed first.[48]

Use culturally appropriate colors.
When working with unfamiliar cultures, do advance research.

Use a limited color set.
Aim to use no more than seven colors.[49]

When selecting colors, also consider those with color vision deficiencies, which is about 8% of the population.[50] A commonly held misconception is that colorblind individuals see in black, white, and grey only. However, they are more likely to be unable to perceive differences between colors, most commonly between red and green.

RESOURCES FOR UNDERSTANDING COLORBLINDNESS

Coblis	Color Blind Check app	Vischeck
Contrast-A		

CONTRAST

An important aspect of color is contrast, which basically means difference, and we are wired to notice it.[51] As such, contrast can be a powerful tool for directing eyes toward important information, but, in order to work, contrast needs to be clearly different. In fact, it is recommended that one use a 3:1 luminance contrast ratio between a pattern and its background and 10:1 between text and background.[52] That means text should be 10 times darker (or lighter) than its background. Inverted text (light text on a dark background) should be avoided for longer narratives.[53] You can check your contrast levels at *Checkmycolours.com*.

COLOR MANAGEMENT

There are a few technical terms and issues that should be noted in color management. For one, screens and printers do not speak the exact same language; ergo, each has its own color mode. **CMYK** corresponds to commercial print work (e.g., Cyan, Magenta, Yellow, Key for Black) — think of toner colors. **RGB** is used for on-screen viewing (e.g., Red, Green, Blue). Additionally, Pantone® is a proprietary color management system that can be used to match 1,867 specific colors. Failure to understand these systems may cause your work to appear different from what you expected. So be sure to view your work in advance on the medium in which you will be sharing it.

Figure 6.20
Inverted text is more difficult to read, especially if there is relatively little contrast

BRINGING IT ALL TOGETHER
Wirtten | Spoken | Visual

The best visual packages work hand-in-hand with your other communication channels (i.e., written summaries & verbal presentations).

So, consider the context of your presentation carefully. Will you be there to explain the content? Or, will your content need to stand alone, such that viewers will need to derive meaning from the words and graphics alone?

Figure 6.21
Communication channels are interrelated

To align your communication channels, determine:

> The appropriate quantity of labels (written + visual)
> Standalone documents will likely require more **contextual labeling**.
>
> How might you gesture toward the content? (verbal + visual and written)
> How to incorporate **speaker triggers** without forcing the audience to read at length? (verbal + visual)

SLIDE DECKS

Designers often give screen-based presentations, and while there is nothing inherently wrong with the software used to produce slide decks, design storytellers should be wary of relying on their templates. Apart from some kitschy backgrounds, these templates tempt designers to force their content into formats not befitting their goals. This can cause a disconnect between the verbal, written, and visual communication channels. For instance, a slide that contains too much text compels the audience into either listening to the presenter or reading the content. Perhaps even worse, is that speakers may inadvertently start reading from the slides themselves.

Consider the following two slides, which both convey the same content.

Which is more effective?

Figure 6.22
Avoid forcing content into a template

Produced Using a Template
Bulleted lists force the audience to read instead of listening, while the image featured fails to represent all three areas of content equally.

Produced by Creating Image First
Integrated graphics incorporate less labeling so the speaker needs to be very familiar with the content and provide explanations for each area.

SLIDE DECKS
Methods for Integrating Content

Storytellers keep their audiences on the edge of their seats by sharing information on a "need to know basis." Design storytellers can leverage this suspense by incorporating tactics of progressive disclosure in their slide decks. This means that rather than including extended prose and lengthy bulleted lists, information is instead parsed out onto separate slides.

Figure 6.23
The top slide introduces the subtopic, and primes the audience for an impending comparison. However, only the first part of the information is discussed in detail.

The bottom slide elaborates on the second part of the information. The previously shown process is now grayed out, which allows viewers to recall it without dwelling on it.

ORIENTATING THE AUDIENCE

Audiences like to have a sense of how the presentation is unfolding. This includes how far they have come, how much is left to go, and what the current topic is. However, this doesn't mean that you have to go over this information explicitly — doing so might be boring. Instead, orientate your audience by incorporating a visual table of contents (such as metaphorical binder tabs) or purposeful transition from one sub-theme to the next, like chapters intros in a book.

Figure 6.24
The top slide introduces the current sub-topic in the order of the presentation, while the content itself suggests what topics will be discussed in subsequent slides.

The bottom slide acts an introduction for a sub-theme. For greater effect, the slide can be reused at the beginning of each sub-theme by changing the number and title.

123

SLIDE COMPOSITION

To avoid overwhelming audiences, compose each slide so that it contains just enough content to maintain interest, and trigger your talking points.

Figure 6.25
Consider how much content to place on each slide

POSTER PRESENTATIONS

Some presentations are given from posters or larger boards. Since all information is visible at once, the presenter has less control over what viewers see and when, making visual hierarchy especially critical.

Figure 6.26
Examine the use of implied grids, alignment, and negative space in both the top & bottom poster presentations

ESTABLISHING A BRAND IDENTITY

A personal brand is your face to the world. It's a cohesive expression of you and your values through various components including logos, fonts, colors, graphic composition, and image styles. A successful **brand identity** should allow one to identify your work, even without seeing the entire package.

BRAND IDENTITY TOOL KIT

A complete brand identity is comprised of a number of markers that range across communication channels.

visual message — colors, logos, fonts graphic compositions, & image treatments

written message — mission statement key phrases, slogans, & mantras

verbal message — gestures & energy levels verbal expressions

STORYTELLING IN PRACTICE

How do stories drive the vision of a brand?

In the re-branding of our practice, we found, through research, that our clients and other stakeholders were as interested in the experience as the end-product or the design itself. This led us to the conclusion that our marketing focus should be on our emphasis of the stakeholder experience, not the design. There was less interest in our credentials than the importance of solid relationships.

So the story we tell is one of starting out as a traditional firm, focused on design and documentation, enjoying several decades of success and stability, though not growing. More recently, we found ourselves competing on the basis of project images, work we had done for other clients. Increasingly, this beauty-contest approach was subject to opinion and very difficult to manage. We came to the conclusion that most of our competitors were as capable as we were and that the real distinction was the people. What made us different and better was how our team engaged, not only our clients, but the contractors, engineers, consultants, public agencies, and other project partners.

Playing this back to existing and new clients, we've quickly recognized that a better conversation or exchange was taking place and that this would be our point of distinction and competitive advantage. It also put us in a leadership role, seen as partner in the project, not relegated to design and documentation as a service. This has changed our business.

Eric Ibsen is the chief design officer for Forge. Eric provides design & marketing leadership in a mid-size architectural firm. His emphasis is on the importance & value of quality design.

LOGOS

Even the tiniest of images can tell a story. A recognizable logo makes an impression, helping an audience identify with the given person (or company) and get a sense of their values. The key to designing a logo is making it simple and clear while still representing your message through either explicit or subtle maneuvers.

Consider making your logos in a vector-based program so that they can be scaled up without losing quality. Also, since these images may be used in multiple formats, it's a good idea to keep them crisp with high contrast, so that they look good in print and on-screen.

> **LOGO CONSIDERATIONS**
>
> Limit the number of colors used.
> Ensure that it is legible in black & white since it may be copied.
> Confirm that size and proportions allow for its use across media.

Letter Mark
uses monogram or initials
substitutes for longer words

Icon Mark
uses an identifiable icon
helps to build recognition

Abstract Icon Mark
uses an abstract icon
implies a deeper meaning

Emblem
an encased symbol
such as a badge or seal
historical references

Combination Mark
pairs art with text
versatile and recognizable

Word Mark
full name or work
works well for memorable names

Figure 6.27
The type of logo used depends on the messaging goals and available content

EXERCISE 6.5 EVALUATING LOGOS

On a separate sheet of paper, list the messages you think each of the above logos convey. Then exchange your assessments with someone else.
Were your evaluations similar or different?
Then find 2–3 design firm logos & list the messages you believe their logos send.
List successful & unsuccessful attributes of each.

EXERCISE 6.5 CREATING A LOGO

An important aspect of telling your story is branding it with a logo. This logo can be used on multiple items such as your resume, letterhead, presentation introductions, and even on social media. This exercise will help you generate and refine ideas for this simple, yet invaluable representation of your personal story.

1 Find 10 professional identity logos (either from individuals or design firms). Analyze them for:

Novelness
 Does the logo have a unique character & style?
 Does the logo look like another, or share similarities with another image?

Clarity
 What does the logo say about the creator?
 Does the logo convey a set of values?

Simplicity
 Is the logo distilled to its simplest elements?
 Can anything be removed from the logo without losing message?

Reproducibility
 Does the logo have scalability (can it be made larger & smaller)?
 Would it be legible if copied in black and white?

Share your analysis with a peer and discuss if they feel the same way about the logos.

2 Using the themes from the Point of View Exercise in Chapter 3, determine what values you want your logo to convey. For example, if you want it to speak to your high energy, then a potent logo with highly saturated colors would likely work well. On the other hand, if you want to convey sophistication, a logo with intentional negative space would be effective.

3 Based on the values you have identified, generate a series of 10–12 quick sketches. Using the table above, obtain feedback on your sketches from at least 5 other people. Try to gain feedback from both individuals that are close to your work and those that are less familiar with your ideas.

4 Based on the feedback, eliminate half of the options and refine the other half. At this point, it might be valuable to produce these iterations digitally. Then, get feedback from 3 new individuals based on the factors in the table above.

5 Based on that round of feedback, develop 3 iterations to a more final stage, including final colors, and fonts. Print these iterations at various scales on at least 3 different printers.

6 Seek feedback on your final 3 printed iterations. Then, determine which iteration most successfully conveys your values.

CREATING YOUR VISUALS

There are many ways to create your visual story props. You can use your own sketches, which can be digitized. There are also many resources for the production of digital graphics. If you are producing work digitally, consider whether you want **vector**-based graphics, which can be scaled without losing quality, or **raster**-based, which allow for fine color calibration. See Chapters 7 & 8 for a list of software options and resources.

SUMMARY

We acquire a great deal of information through our eyes. Consequently, visual messages play a vital role in design storytelling. Imagery allows designers to attract attention and persuade their audience, then help that audience to both understand and recall the message. To create visuals for a design story, aim to first Scan the information you have, then seek to Understand it by determining what it means and what is important. Imagine the possibilities with signaling tactics such as icons, indexes, and symbols. Finally, develop the content, by exploring frameworks and representation tactics, which can range from abstract to realistic representations.

Often, your graphics can be enhanced by integrating labels and the typeface you select should be legible and support your intended tone. It's best to limit your fonts to one for copy and another for headings.

Color is a versatile tool, but consideration needs to be made as to how it's perceived and how best to manage it for your media.

For your visual messages to be successful, they need to be placed within compositions that consider visual hierarchy and tools of emphasis. Regardless of media (slide show, board presentation, etc.), thoughtful planning can help your visual messages reinforce your design story.

FOR CONSIDERATION

ADAPTING THE MESSAGE TO THE MEDIA

Considering that design stories can be told with paper-based, on-screen, physical, and interactive props, evaluate how your story would need to adapt to each.

TERMS

attractiveness \| soundness \| utility	glyph	raster
arbitrary cues	kerning	RGB
brand identity	leading	semiotics
body copy	negative space	sensory cues
compositional cues	noise	speaker triggers
copy	open type	tracking
contextual labeling	picture superiority effect	typeface
CMYK	pull out text	vector

APPLICATION 6.0

Recall your ideas from Chapter 5 and start to sketch ideas for your upcoming presentation. Remember to keep your goals in mind as well as how to make each representation clear, vivid, and memorable. Consider the following:

1 The Hook

Goal: To garner attention by appealing to the audience's emotions

Are you conveying information that explains who, what, when, how much, where, or how?

What representation method would work best, abstract or concrete?

Are these depictions aimed at appealing to emotional or intellectual interests?

Sketch a few ideas based on your talking points.
These will be refined in Chapters 7 & 8.

Exploration of the Problem

Goal: To illustrate the relevance & magnitude of the problem

Are you conveying information that explains who, what, when, how much, where, or how?

What representation method would work best, abstract or concrete?

Are these depictions aimed at appealing to emotional or intellectual interests?

Sketch a few ideas based on your talking points.
These will be refined in Chapters 7 & 8.

Sharing the Solution & Its Benefits

Goal: To highlight how your design will resolve the problem at hand

Are you conveying information that explains who, what, when, how much, where, or how?

What representation method would work best, abstract or concrete?

Are these depictions aimed at appealing to emotional or intellectual interests?

Sketch a few ideas based on your talking points.
These will be refined in Chapters 7 & 8.

The Finish

Goal: To prompt action within and beyond the room

Are you conveying information that explains who, what, when, how much, where, or how?

What representation method would work best, abstract or concrete?

Are these depictions aimed at appealing to emotional or intellectual interests?

Sketch a few ideas based on your talking points.
These will be refined in Chapters 7 & 8.

OBJECTIVES

- Be able to identify and analyze various methods for communicating information
- Understand how to succinctly summarize information & findings
- Construct visual representations of processes, information, and criteria
- Connect this knowledge to future presentations

STORYTELLING WITH INFORMATION

This chapter will focus on story for sharing information.

Maggie was a talented student who had artfully composed a portfolio showcasing outstanding designs, though on the day of her internship interview, she was nervous and had slept very little the night before. When her name was called, she walked in, smiled, and shook each interviewer's hand. After she sat, the first interviewer commented ...

> *"We were impressed by your skills, and we'd like to know more about how you arrived at your design."*

Being nervous, she drew a blank and stumbled through a response. The interviewers quietly started to question her thought process and her communication skills. A simple diagram of her process may have not only outlined her key decisions but also trigger her memory, prompting an engaging discussion about her unique approach.

INTRODUCTION

Designers make hundreds, if not thousands, of decisions during any given project. Since many of these decisions have lasting impacts, potential employers and clients alike increasingly want to know more about them. As such, it is critical for designers to negotiate information en masse, to communicate aspects of the problem at hand, and their process for resolving it. Visual messages can be a powerful asset in this process as they distill complex information, helping the audience to see the nuances surrounding a problem without being buried in it.

This chapter will explore how diagrams can aid in design storytelling by highlighting a designer's unique process, their resulting findings, and information about the project itself. These story props not only work to build a designer's credibility but also to ensure a shared understanding of the project's goals.

THE SIGNIFICANCE OF INFORMATION DELIVERY

We all live busy lives – school, jobs, and activities fill our time. Your audiences will be no different. They may be running a company and dealing with a myriad of business matters involving employees, shareholders, and colleagues, or they may be responding to the conflicting opinions of their constituents as they battle to make their own deadlines. Consequently, their capacity for editing, highlighting, grouping, categorizing, cataloging, and a number of other tasks necessary for comprehension is limited, and our opportunities to share valuable information in design meetings, quite brief. So designers must work quickly to garner attention and succinctly distill valuable information that supports the design story.

> Give "the viewer the greatest number of ideas in the shortest time with the least ink in the smallest space."[1]

THE ROLE OF VISUAL MESSAGES

While there is no empirical research supporting the adage that a picture is worth a thousand words, the ubiquity of this phrase demonstrates the potential of visual messages for balancing economy with insight through illustrated relationships. Yet, they present unique challenges concerning how much information to display and how to do so. The key is to eliminate clutter and present information clearly and cleanly. Acclaimed educator and author Edward Tufte noted that graphic excellence in information design "gives to the viewer the greatest number of ideas in the shortest time with the least ink in the smallest space."[1] This can only be done after proper consideration of the audience and the evidence at hand. What is needed to build a case for the audience change you are seeking?

APPROACHING INFORMATION

Each person approaches content differently, and it is hard to predict with reasonable accuracy how an audience will interpret information. This is due in part to our preferences, environment, and our conditioning. One fundamental difference is that some of us are more apt to use mental shortcuts, also known as **heuristics**, for the quickest path to comprehension, (especially when we are pressed for time).[2] Others, however, prefer to take a more exhaustive approach to gaining understanding by reviewing the entirety of an information source.[3] This means the amount of evidence necessary to build a plausible case may vary based upon your audience's preferences.

HOW WE APPROACH & CONVEY INFORMATION

Research has suggested that differences in how we approach information might also stem from our gender, age, and cultural background.

Studies have found that, even as babies, boys and girls view information differently.[4] As we grow, our conditioning often intensifies these differences. Boys are often taught to be competitive and girls to be social.[5] Consequently, men and women may respond differently to content.

Even if we may not care to admit it, our age can impact how we interpret and react to information.[6] Each generation has grown up amongst a different set of world events which influence how they view the world around them.[7] In practical terms, younger generations have used technology from a very early age, while those with older eyes may benefit from larger labels and greater color contrast.

Our cultural background also influences how we process information. Mannerisms, childrearing practices, and educational systems vary, which can have practical implications for designers. For instance, Europeans are accustomed to green exit signs, while in the U.S., red exit signs are most common.[8] Bear in mind, however, that there are exceptions to every rule, and designers need to consider the specifics of their audience when designing information for them.

Exit sign in London.

Exit sign in Florida.

Figure 7.0
Even relatively similar cultures can have different approaches to information design.
top photo by Lisa Waxman, Ph.D.

Feeling overwhelmed by the many differences in how we process information? Scholars have offered useful strategies for developing information graphics.

STRATEGIES OF INFORMATION DESIGN

Simplicity
For a viewer to understand information, they must first be able to find it. This means that depictions should be void of unnecessary information, in other words, clutter. Tufte referred to this as design efficiency.[9]

The bottom map begins to eliminate unnecessary labels and simplifies the background.

Figure 7.1
Remove unnecessary information to support legibility

133

STRATEGIES OF INFORMATION DESIGN

Provide the capacity to compare
Some information can be grasped on its own, while other evidence is best understood when shown in context. This is known as micro and macro reading. Tufte defined micro reading as individual stories about the data,[10] whereas macro reading is scanning information for patterns.

Macro reading
Collectively, these lines represents ridership on a city's mass transit system.

Micro reading
This line indicates ridership aboard one bus line.

Figure 7.2
Arrange content to allow for comparison

Figure 7.3
In the image below, the timeline and the responses align, thus showing when responses were collected

Integrating evidence
Stratify and layer information so that is identifiable.[11]

Allow for credible comparisons
Variation should stem only from the information itself, while accuracy in scale allows viewers to recognize magnitude and relationships. Below, the size of the circle indicates the number of responses about a topic.

Data relationships
Lines can be used to link information and arrows to denote causal relationships.

134

MEDIA FOR SHARING INFORMATION

When presenting information, it is important to consider the potential opportunities and inherent challenges of various media.

SCREEN-BASED PRESENTATIONS

Screen-based presentations generally follow a linear structure, wherein the speaker dictates the speed at which information is seen. Considerations for screen-based presentations include alignment between visual cues and talking points, as well as maintaining viewer attention.

PRINT MEDIA

In these media, viewers can scan information at their own pace. However, since the entirety of information is viewable on the page at any given time, viewers can be overwhelmed with too much of it. That means that designers working in print formats need to consider how much information to place on a page, and what cues such as color-coding and seriation (i.e., numbering) could be offered to help viewers navigate the content.

ENVIRONMENTAL INFORMATION DESIGN

Environmental information design includes large-scale installations like signs, advertisements, and exhibitions. Due to the physicality of these environments, designers need to determine the appropriate scale for users, and consider the suitability of a more complete sensory experience by engaging sight, sound, hearing, and touch.

INTERACTIVE MEDIA

What distinguishes **interactive media** like apps, websites, and augmented reality experiences from other sources is the element of choice. Interactive sources allow viewers to *scan through* and *dip into* information, which means that they can choose both the pace of their viewing and what they see. For this to happen effectively, however, designers working in interactive formats need to study the flow of their information and then provide intuitive navigation cues, such as tabs, hyperlinks, and buttons, so that viewers do not miss out on valuable information.

VIDEOS

While videos provide a multi-sensory experience, they can be a tricky media for sharing information since the video's producer dictates both the orchestration and timing of content. As such, any information presented with a video needs to be easy to comprehend within the given time constraints.

REPRESENTATION TACTICS IN DESIGN ANALYSIS

Information can reveal a powerful message, but only if we can unearth the right evidence to tell the story.

Design analysis is crucial to ensuring that the �»▸▸problem is being solved, by addressing the ▸▸▸concerns. Analysis tasks vary and largely depend on the project at hand as well as the skills and motivations of the designer. Such tasks include examining similar environments through precedent studies, speaking with project stakeholders via interviews and focus groups, or recording the behaviors and actions of project stakeholders. The findings from this process can be a very potent communication tool, especially when shared with the client before commencing design work. Doing so will help to engender a mutual understanding about the project, and add to your credibility.

TYPES OF INFORMATION

Designers will often arrive at different types of information, or **data** when analyzing a design problem. This information can include **quantitative data**, which stems from numerical figures, like population size or percentages. Data may also be **qualitative**, where findings are described in narratives such as interview transcripts, written feedback, or observation notes. Chances are, designers will call upon both sources to form an accurate definition of the project.

DIAGRAMMING DESIGN ANALYSIS

Diagrams can be a simple but potent tool for communicating findings, since they can answer the following questions:

Figure 7.4 Ways to document design analysis

WHEN?
Research Process
timelines and charts

WHEN?
Trends Over Time
timelines and charts

HOW MUCH?
Magnitude
numerical values

WHERE?
Location
maps or plans

WHO?
Stakeholder Criteria
user needs & desires

WHAT?
Design Criteria
design constraints or goals

WHO?
Organizational Information
groups & relationships

HOW?
Suggestions
ideas and next steps

PROCESS DIAGRAMS

We encounter depictions of ▢▢▢▢▢▢ every day; timelines and schedules illustrate a series of steps or the timing of an event. Since life and the design process aren't always a linear process, diagrams can also include feedback showing how one may return to previous steps as new information becomes known, or as changes occur. Process diagrams can also have a second layer of information that may summarize what was learned or uncovered during each step. Consider the following case study:

Case Study

A design team is collecting information about a company's staff before beginning a redesign of their corporate headquarters. As part of their pre-design services, the team undertook a multifaceted process to improve their understanding of underlying issues. During this process, they distributed surveys to employees, conducted interviews with representatives from each department, and observed workers' behaviors. They then analyzed this information and arrived at design criteria and suggestions for the new space. They could illustrate their process in several ways, as seen below:

Bar Chart

SURVEY of user perceptions → INTERVIEWS with stakeholders → OBSERVATION of user behaviors → ANALYSIS of data → GUIDELINES to inform design

Line Chart

SURVEY of user perceptions • INTERVIEWS with stakeholders • OBSERVATION of user behaviors • ANALYSIS of data • GUIDELINES to inform design

Process Doughnut

1 SURVEY of user perceptions — 2 INTERVIEWS with stakeholders — 3 OBSERVATION of user behaviors — 4 ANALYSIS of data — 5 GUIDELINES to inform design

Modified Gannt

SURVEY of user perceptions | INTERVIEWS with stakeholders | OBSERVATION of user behaviors | ANALYSIS of data | GUIDELINES to inform design

Figure 7.5 - Use process diagrams for steps or methods

EXERCISE 7.0 PROCESS DIAGRAMS

Sketch 2–3 ideas representing other ways to convey the steps outlined in the case study above.

DATA OF MAGNITUDE

Data of magnitude show relationships between value, size, or quantities of information. This information is often given in either percentages, if reporting a portion of a whole, or quantities, if revealing the actual number of responses. Refer to the case study below:

Case Study
Recall that the design team began their analysis by issuing a survey to employees. This survey asked 200 workers about their current workspace and their thoughts on its strengths and weaknesses. One question revealed that 52% of employees felt their current space hindered their required work activities; 33% felt it somewhat hindered their work; 10% felt their current workspace somewhat supported their work; while 5% indicated their current workspace supported their work. These percentages indicate magnitude, so it's important to accurately illustrate the relative size of the value to help viewers perceive relationships between the given quantities.

Percentage-Based
showing portion of the whole

Pie chart
Should only be used for percentages

Cloud
Clouds can be arranged to emphasize various values

numbers are reported in percentages

Quantity-Based
showing actual counts

Bar
Familiar technique but can vary graphically

Stacked Bar
Valuable when space is limited

Figure 7.6
Use magnitude diagrams when sharing percentages or quantities
(See Diagrams Appendix for more iterations)

STAKEHOLDER CRITERIA

Stakeholder diagrams describe the characteristics of those involved in a project, which can include demographic variables like age and gender, or qualitative characteristics such as work titles, preferences, likes or dislikes, and how they spend their time. Even if the client already has a general sense of this information, it is often important for designers to document these variables to confirm understanding.

Case Study Con't.
Following the interview process, the design team found that employees of the company spent their time doing one of four things: collaborating, performing focus work, learning new tasks, or socializing with their colleagues. They were also able to determine the approximate percentages of time spent doing each. This describes two layers of information – what the tasks were, and the relative time allocation to each. These layers of information can be represented in various ways:

Pyramid
Depicts magnitude & hierarchy

Radar
Can be used to highlight specific aspects of information

Metaphor
Can graphically represent the source of information

Figure 7.7
Use stakeholder diagrams when conveying information about people
(See Diagrams Appendix for more iterations)

139

ORGANIZATIONAL INFORMATION

Another way to document project stakeholders is to note their relative presence in an organization, civic group, or community. These types of diagrams depict organizational hierarchy, and relationships between different groups can be indicated with lines and adjacencies.

Case Study Con't.
The design team also interviewed department leaders and wanted to show an organizational chart reflecting these individuals' positions and their relative location within the company. Below shows an option for doing so:

Figure 7.8
Use organizational diagrams when portraying relationships between groups of people

LOCATION

Location diagrams, such as maps and plans, can display position, place, proximity, and spatial relationships. These diagrams can represent macro environments (such as the entire planet), down to small-scale scenes, such as a floor or individual workstation.

Case Study Con't.
Following their surveys and interviews, our fearless design team observed the current office for a week, watching how people worked, who they worked with, and what tools they used. They found that employees collaborated in some surprising locations. Below are a few ways to illustrate their findings:

2-Dimensional

3-Dimensional

Figure 7.9
Use location diagrams when portraying locations & spatial relationships

TRENDS

Designers often encounter **longitudinal** trends, or patterns over time, such as monthly sales throughout a fiscal year, or hotel occupancy during peak travel season. These types of diagrams often have two axes, one for the information and the other for the time period. However, they do not have to follow a traditional X-, Y-axis diagram format.

Case Study Con't.
The design team also wanted to portray how many staff members were in the office during a typical business day. Several options include:

Bar or Line Chart
Familiar techniques

Scatter
Circles size correlates with quantity

Radar
Displays information in 360°

Figure 7.10
Use trends diagram when displaying information over time

EXERCISE 7.1 FINDINGS DIAGRAMS

Sketch 2–3 ideas representing other ways to convey the findings outlined in the case study above.

DESIGN CRITERIA

Design criteria outline any goals and requirements deemed necessary for the project's success. Such items can include desired features, essential items, best practices, or even things to avoid. Communicating this information via diagrams can help establish mutual understanding and confirm project particulars before moving forward.

Case Study Con't.
Using their findings from surveys, interviews, and observations, the design team is ready to formulate design criteria to highlight how each of the major spaces should accommodate its users.

Mind Map
Can show the relationships between ideas

Drawing Overlays
Can begin to tie goals to locations

new focus work zone

reconfigured collaboration zone

Ribbon
Can be used to show category & subcategory or cause & effect

Figure 7.11
Use design criteria diagrams to show goals or requirements

142

SUGGESTIONS

The goal of design analysis is to provide suggestions for the new space or determine next steps in future research. This information is likely to be the most important to the client and, depending on their level of expertise, it can be communicated using abstract or concrete symbols.

Case Study Con't.
From the information collected during their research, the team prepared several key suggestions for the new design. They feel their insights will be important in moving forward and they can illustrate them in several ways:

Image Overlay
An image of an existing design can be a useful reference

facilitate **collaboration**
collaboration zones in close proximity

provide for **focus**
reduce distractions with acoustical separation

Drawing Reference
A drawing can be appropriate if a similar diagram was shown earlier

reconfigure for focus work
- mitigate distractions
- provide access to tech.

enhance collaboration within work zones
- provide ample work surfaces
- maintain proximity & sightlines
- affirm team identity

Figure 7.12
Use suggestions diagrams for showing the path forward

EXERCISE 7.2 SUGGESTIONS DIAGRAMS

Sketch 2–3 ideas representing other ways to convey the suggestions outlined in the case study above.

DIAGRAM CONSIDERATIONS

When determining how to construct a diagram, consider the following:

1 What should viewers notice first?

Recall that visual hierarchy can provide cues as to where the viewer should begin in a composition. And these tactics apply within diagrams as well.

Text

The visual hierarchy of text can be influenced by the character of the font, and the color of the text.

Smaller text is considered less important; larger text is often read first.

Text should be in close proximity to the relevant information.

Negative space around a text can give it more prominence.

Images

Negative space around an image can give it more prominence.

Larger and more saturated images will often be noticed first.

2 How should viewers progress through the information?

After the viewer initially engages with an information source, they need to determine their sequence for navigating the information quickly. In some instances, text can guide a more structured and linear approach, or it may be best to provide options for the viewer. Research has shown that viewers prefer a combination of both approaches (known as guided exploration), which allows viewers to choose their paths within a more structured system.[12]

Headings, grouping, and numbers can guide a viewer's navigation of the diagram.

linear approach (left)

guided exploration (right)

3 What do they need to remember?

Unfortunately, *everything* cannot be the answer to this question. It is important to acknowledge that, despite a designer's best efforts, viewers are not likely to remember everything, so they will need to determine what the important "takeaways" are and highlight them accordingly. See Chapter 6 for tools of emphasis.

EXERCISE 7.3 EVALUATING INFORMATION DESIGN

Review trade publications, blogs, and websites to find 5–7 informative diagrams.

Analyze these diagrams per the three questions from above.

Then discuss your assessment with a peer.

DIAGRAM ANNOTATION STRATEGIES

Words serve to support the comprehension of visual information. Well-placed labels, headings, and descriptions can reduce ambiguity and clarify meaning. Even short headings can mean the difference between confusion and understanding. Some research has suggested that integrative visuals (i.e., those relying on both images and text) are more engaging than messages using text or illustrations alone.[13] However, studies also have suggested an inverse relationship between the number of words in a message and the reader's enjoyment in viewing it.[14] As such, the appropriate use and integration of text components are important for both viewer perceptions and comprehension.

When determining how to annotate your diagrams, consider the following:

How the information will be shared.
Diagrams that will be accompanied by a verbal presentation will require less annotation.

The complexity of the content.
Complicated data sets like **multivariate** analyses (having three or more inputs), will likely require more annotation.

The background knowledge of the audience.
If the content is familiar or they have seen similar diagrams in the past, the diagrams may require less annotation.

DIAGRAM CREATION STRATEGIES

Ideally, creating diagrams won't require a significant investment of time. In fact, creating diagrams can be as simple as a quick, but thoughtful annotated sketch. However, some planning can direct your efforts and save you some time. Start broad by determining content and overall form before adding details like navigational cues and annotation. Software programs and websites can also make the process quick and easy.

DRAWINGS AIDES

There are numerous tools and programs to help you generate diagrams digitally.

Sketching
Adobe Illustrator Draw
Autodesk Sketchbook
Paper by Fiftythree
Tayasui Sketches

Photo Manipulation
Adobe Ideas
Adobe Photoshop Touch
FX Photo Studio
Layers
Vector Snap

Chart/Icon Builders
Easel.ly
Flowdia
Graphia
Icona

Map Generation
Carto
iSpatial
Mapbox
Mango

Data Display
Diagramo
Grafio
Grapholite
Microsoft Visio

Photo Collage
Photomontage
Pic Collage
Photomontager

TESTING DIAGRAMS

Even the most beautiful depictions of information will be unsuccessful if they fail to build understanding. With this in mind, it's critical to test the clarity of your depictions. It's especially important to understand how information will be approached and interpreted if you will not be there to explain it.

To avoid confusion or misunderstandings, review your work with others. Find reviewers with a similar level of expertise to those in your audience. During their evaluations, avoid explaining the information; let the diagrams do the talking and then ask reviewers to describe their understanding of the information. Should their interpretations be inaccurate or questions arise during their viewing, the diagrams should be revised, and additional annotation may be needed.

SUMMARY

Informed design choices are increasingly important in all design fields. Conducting design analysis and sharing subsequent findings both establishes a mutual understanding of project parameters and helps build credibility. However, this is no small undertaking since designers often have little time to construct representations and share information, and since meaning-making is such a multifaceted process, influenced by an audience member's biology, environment, and conditioning.

To overcome some of these issues, information design scholars have suggested that visual representations remain free of unnecessary information and ornamentation, while still providing viewers with enough information to make credible comparisons and see relationships for themselves. To do so, designers may opt to create diagrams that focus the viewer's attention on specific issues, such as the designer's process, the magnitude of their findings, criteria about the project and its stakeholders, organizational or locational information, longitudinal trends, and, ultimately, suggestions for moving forward.

When creating diagrams, designers should consider where viewers should begin in the information, how they will then navigate the content, and what they need to later recall about it. There are cues to aid viewers in this process including compositional tactics such as visual hierarchy, placement, and negative space, as well as the inclusion of objects like numbers, lines, and arrows, and text-based annotation including labels, headings, and descriptions.

Yet, even the most beautiful representations of information fail if viewers fail to understand them. Designers need to test their representations by reviewing them with others. What lies at stake is not only the accuracy of the viewers' interpretations, but also the credibility of the designer, and, at times, the future of the project itself.

FOR CONSIDERATION

Start your own reference library of diagrams by clipping examples or posting them to digital boards.

Then sort your collection by their underlining principles (the type of content, organization, structure, tone, etc.).

When working on your own projects, reference these underlining principles as a starting point for creating your own story props.

TERMS

data
interactive media
heuristics

longitudinal
multivariate

qualitative data
quantitative data

APPLICATION 7.0

To enhance the Exploration of the Problem portion of your presentation, consider the following:

1 Explore your content. Identify 2–3 findings or insights that informed crucial decisions. Consider how your audience would benefit from knowing about this information and how this knowledge might encourage the audience change you are seeking.

2 Determine which diagrams might best represent this information, either process, magnitude, criteria, organizational, locational, or suggestions diagrams.

3 Review the information design strategies listed earlier in the chapter, along with any diagrams you have been saving.
With these strategies in mind, conceptualize 2–3 ways of representing the selected information.

4 Generate your ideas through sketching or by creating diagrams digitally.

5 For each iteration, establish where viewers should begin, how they should navigate the content, and what they will need to remember about it.

6 Determine what cues will help viewers navigate the content.
Test several methods of integrating navigational cues into each diagram. The goal is to produce 2–3 versions of each.

7 To understand how others might approach and interpret these diagrams, review them with others without providing verbal explanations of the information.

8 Ask your reviewers to explain their interpretations of the information.
If these explanations are inaccurate or they have questions about the information, revise the diagrams, adding additional cues or annotation to reduce ambiguity.

9 Test your refined diagrams to ensure they are clear and align with your presentation talking points.

Practically Speaking

The diagrams in this chapter were created in Adobe Illustrator.

OBJECTIVES

- Gain a broad understanding of methods to communicate design ideas
- Be able to identify appropriate communication methods for various audience groups
- Be able to identify appropriate communication methods for various design stages

Image by Emily Swerdloff

STORYTELLING WITH IDEAS

This chapter will focus on story for sharing ideas.

The big day.

Annie had it scheduled on her calendar for months. It was the day she would finally present her capstone project. Now, the big day was just a few short weeks away.

While her classmates tackled their drawings at seemingly breakneck speed, Annie wanted to reflect on her work and her audience before deciding on how to tackle her final package. In doing so, she thought it might save her time in the long run and make for a more meaningful presentation.

INTRODUCTION

While design outcomes are real-world creations – full of dimensionality and nuance, designers tend to communicate the intent of their ideas – at least initially, via paper and screens, which leaves some wrestling with how best to document, communicate, and ultimately celebrate their designs. To aid in this process, designers can use props to share their solution and convey its benefits. That said, there are many manners in which to share design ideas – each presenting their own challenges and opportunities. This chapter will explore these tactics, including outcome diagrams, various drawings types, and some multi-modal strategies that can be used as props in telling a compelling design story.

EXPRESSING IDEAS

Idea in head – pen in hand, was the traditional path toward design expression. While this route remains both relevant and valuable, today, there are many props that designers can use to inspire, orientate, and build their audience's understanding.

What is included in a design story and the manner in which it is done (i.e., the character and tone of the imagery) are largely functions of a number of considerations:

Quantity of Elements
How many props should be included?

Level of audience:	
expertise	*How much do they already know?*
interest	*How much do they care?*
expectations	*What do they expect?*
time available	*How much time is available for viewing & comprehension?*
Your goals for:	
audience feedback	*What elements do you want/need feedback on?*
The project's level of:	
completion	*How much is already known about the project?*
complexity	*How many components of the project should be included?*

Character of Elements
What is the best media & level of development for those props?

Level of audience:	
expertise	*What will they be able to understand?*
interest	*What elements pique interest?*
expectations	*What do they expect?*
Your goals for:	
audience feedback	*Are you seeking formative feedback or final approval?*
time management	*How much time do you have to produce elements?*
The project's level of:	
completion	*How much is already known about the project?*
complexity	*How many aspects about the project should be included?*

Following these decisions, aim to be consistent with these characteristics, since the audience may incorrectly infer that characteristic changes imply a change in the design.

QUANTITY CONSIDERATIONS

All designers face constraints of time and budget. The key is to maximize our opportunities when telling our stories, so each image needs to have a purpose. A few powerful images will likely be more effective than many mediocre ones. So prioritize your efforts — remember to refer to your goals and your knowledge of the audience when determining what props you will need to tell your design story.

CHARACTER CONSIDERATIONS

Since the fate of a project can rest upon a client's interpretation of design illustrations, the persuasive sway of various media types should bear consideration. In other words, what subliminal messages do sketches, hybrid drawings, or photo-realistic representations convey to viewers?

AUTHOR'S NOTES The Influence of Rendering Style

To investigate this, I conducted a study that explored the responses of both interior designers and proxy clients to images of the same design — the only difference being the style of the rendering itself.[1]

The results revealed that experts and non-experts evaluate architectural renderings differently. The client group was more inclined to value the most realistic rendering higher. This might be due to their having less design expertise, making it more difficult for them to "imagine" design outcomes from seemingly vague imagery. However, realistic images can cause misunderstandings, especially in the early stages of design.

hand-drawn sketch

One design leader who participated in the study noted how competition renderings for a recent project essentially *locked in* design decisions in the client's mind before their team was able to explore and finalize options. This experience led him to conclude that it was critical to align the design progress with the fidelity of the renderings. For example, schematic sketches should be used in early design meetings, thus allowing the designer to maintain some flexibility (and time) for specific design considerations. So, unless your design is nearly complete or you desire specific feedback, it may be best to represent ideas abstractly. On the other hand, in a competition scenario where the goal might be to awe the decision makers, advanced realism might make for a memorable experience.

hybrid rendering

While designers might prefer to use familiar tools or those thought to make a visual significant impact, it's best to examine your goals before choosing which rendering style to use for a presentation. Is the goal to provide conceptual or informative depictions?

	Conceptual Low fidelity	Informative High fidelity
Use when there is	little need for realism	greater need for realism
Consider for	preliminary sharing & idea development	later stages of a design
Examples	sketches, study models, & mock ups	computer renderings, animations, final models, & prototypes

photorealistic rendering

Figure 8.0
The images (above), which were used in the study, suggest that an image's rendering characteristics can convey subliminal messages

151

DESIGN OUTCOMES DIAGRAMS

Outcomes diagrams can be a quick way to focus on a particular aspect of the design. When creating diagrams, consider what idea you're aiming to depict, then focus solely on what is needed to represent this idea. Avoid including unnecessary information so that the viewer can concentrate on your message.

When information is potentially confusing or complicated, consider framing the diagram around a metaphor, which can make seemingly unfamiliar information more understandable.

Figure 8.1
Outcomes diagrams can focus viewers' attention toward a specific aspect of the design

Parti Diagram
Conveys spatial relationships

Location Diagram
Pinpoints a location or destination

Form Diagram
Represents specific forms

Figure Diagram
Depicts baseline information

Wayfinding Diagram
Depicts a system of tools that are intended to help occupants navigate a space

DIAGRAMMING TOOLS & TECHNIQUES

Outcomes diagrams are great for highlighting a specific issue in the design, and they take little time to create. Creating an outcomes diagram can be as simple as sketching a few forms to serve as abstract representations of ideas, or they can be created in robust software programs. Either way, the best diagrams are clear, simple, and focused.

There are many ways to create a diagram, including:

Manual Drawings

Traditional sketching is a timeless tool for conveying information. If this is your method of choice, consider how to digitize your sketch outcomes so that you can include them in presentations. Some tools to consider include:

Pen & paper digitized with a scanner Watercolor digitzed with scanner

Tablet Apps

Tablet Apps are a great way to bring the fluidity of hand drawn images into digital formats. Some tools to consider include:

Sketching Apps
Adobe Illustrator Draw
Autodesk Sketchbook
Moleskin Tablet
Paper by Fiftythree
Tayasui Sketches

Chart/Icon Builders
Flowdia
Graphia
Icona

Computer Software/Websites

Software programs can be a powerful tool for graphic production.
Some tools to consider include:

Drawing & Symbols
Adobe Illustrator
Corel Draw
Dingbats font

Flow Charts
Diagramo
Microsoft Visio

Icons/Vector Art
Flat Icon
Illustrio
Icon Finder
Noun Project

EXERCISE 8.0 OUTCOMES DIAGRAMS

Find 10–12 design diagrams from websites, apps, or magazines in your field.

Analyze each diagram for clarity, simplicity, and focus on the message.
Discuss your findings with a peer.

CONCEPTUAL IMAGERY

Conceptual drawings are often used early in the design process. They are frequently more evocative and imaginative than subsequent imagery and can be generated via hand sketches, collaging, and hybrid images.

Figure 8.2 Conceptual images can take on a range of styles

Mixed Media
Can be used to depict soft, delicate forms.

Product Sketches and Renderings
Photo by Emily Swerdloff.

Collage
A photomontage can represent multiple ideas or focus viewer attention.

Evocative Rendering
Conceptual renderings can portray visionary ideas.

CONCEPTUAL IMAGERY TOOLS & TECHNIQUES

You can use conceptual imagery when you want to inspire an audience but don't want to yet burden them with the constraints of reality. An important consideration for conceptual imagery is tone. Should the tone be futuristic, awe-inspiring, galvanizing, etc? This decision can say a lot about your design.

Consider your tone when selecting your media. While many of the same tools can be used in both conceptual drawing and diagrams, it may be useful to consider a wider range of tools that may allow for more nuance in color and form.

Manual Drawings

A greater range of pen thicknesses may be useful, allowing for shading and shadow. Some tools to consider include:

Copic Multiliner SP
Faber Castell pens
Prismacolor Premier Illustration Markers
Rapidograph pens

Sakura Pigma Micron
Staedtler Pigment Liner
Uni Pin Fineliner

Tablet Apps

Tablet apps can be an excellent way to bring the fluidity of your hand into digital formats. Some tools to consider include:

Sketching Apps
Adobe Illustrator Draw
Autodesk Sketchbook
Moleskin Tablet
Paper by Fiftythree
Tayasui Sketches

Photo Manipulation
Adobe Ideas
Adobe Photoshop Touch
FX Photo Studio
Layers
Vector Snap

Photo Collage
Photomontage
Pic Collage
Photomontager

Chart/Icon Builders
Easel.ly
Flowdia
Graphia
Icona

Computer Software/Websites

Software programs can be a powerful tool for graphic production. Some tools to consider include:

Adobe Photoshop
Blender
Corel DRAW
Corel Paintshop Pro
GIMP
Krita

Pixlr
PhotoPlus X7
Vectr
Xara Photo & Graphic Designer

Entourage
Howard Models
Immediate Entourage
Skal Gubbar
Textures
Vyonyx

EXERCISE 8.1 CONCEPTUAL DIAGRAMS

Locate 5–7 conceptual design diagrams that are aimed to inspire or galvanize an audience early in the design process.

Analyze each diagram for message clarity.
Discuss your findings with a peer.

ORTHOGRAPHIC DRAWINGS

Orthographic drawings are a series of separate but related views. There is no foreshortening in orthographic views so that they can be drawn to an accurate scale. Orthographic drawings often illustrate more technical aspects about a design.

Figure 8.3
Showing orthographic views simultaneously can help viewers understand spatial relationships

Front Elevation
side view

Side Elevation
side view

Plan
top down view

Section
slice through view

ORTHOGRAPHIC TOOLS & TECHNIQUES

Orthographic drawings can be produced via manual drafting or computer software.

Manual Drawings

Since orthographic views are drawn to an accurate scale, they are drafted using either a T-square and triangle or parallel bars. Typical methods of doing so include using graphite pencils on vellum paper, or ink and mylar.

T-Square & Triangle
T-Squares are the least expensive way to produce parallel lines.

Parallel Bars
Parallel bars are fixed to a drafting table.

Pencils
On the HB graphite pencil scale, higher numbers represent harder cores. The harder the pencil's core, the lighter its markings on the paper.

9H is typically the hardest pencil; HB is midway; and 9B is a soft lead that leaves dark, black marks on the page.

Pens
There are many fine technical pens available in a range of price points. If you are producing multiple drawings, consider purchasing pens with a series of tip sizes, anywhere from .003mm to 1.4mm.

If you plan to keep your pens for a while, consider buying refillable versions.

Line Weights

Since there is no foreshortening (and little shade and shadow) in orthographic drawings, line weights are critical to legibility. There are a few universally accepted conventions for both manual and digital drawings:

Section Lines
The heaviest lines, which are used where objects are being cut.

Object Lines
Show prominent forms such as furniture or buttons on product.

Profile Lines
The second heaviest lines, are used to show the edges of important forms.

Detail Lines
The lightest lines, which are used to indicate materiality or texture.

Digital Drawings

Today, there are many software programs available to create orthographic drawings. The earliest software programs were fashioned after traditional 2D orthographic drafting techniques using layers to distinguish line types and line weights. More recently developed tools, however, model elements digitally on the computer. Orthographic views can then be captured from these models by rotating around them on screen. The most recent software programs even make use of algorithms to create parametric, or flexible forms that respond to various inputs.

MODELING

While the role of physical models has shifted given new technologies, models remain an important tool for studying design decisions and for communicating design intent.

For industrial and fashion designers working with true-to-life scales, physical prototypes provide an invaluable tool to test form and function. At the same time, for designers and architects working in the built environment — where full-scale prototyping remains largely unfeasible — physical models continue to be a vital tool to illustrate macro relationships between forms and objects.

Figure 8.4
Physical models can be used to both study the design & share it with others

Parti models, study models, concept models, and **maquettes** can be built at a reduced size to depict large-scale projects.

Form models and **prototypes** can be built at full scale to test form & function.
Photo courtesy of Emily Swerdloff.

MEANS OF MAKING
When determining how to make the model, first reflect on the desired form and consider whether it would be constructed most easily through additive, subtractive, or cast-in-place model-making methods.

Additive Making	Subtractive Making	Cast-in-place Making
components are added to represent forms.	areas are carved away until only the desired form remains.	a hardening agent is poured into a negative form.

Whatever method you choose, be sure to protect your lungs and extremities during model building. Ensure proper ventilation and use respiratory masks when sanding and painting. Also, aim to cut with high-quality equipment and fresh blades, and only do so when you are rested and alert.

Figure 8.5
Methods of model making

MODELING TOOLS & TECHNIQUES
Important considerations in model building include access to materials and tools.

Material
When selecting materials, consider whether the goal is to convey materiality or to emphasize form. For materiality, use materials that mimic final selections. If the emphasis is on form, select materials that are uniform and nondescript.

Nondescript model materials include:

museum board	plaster	wire
bass or balsa wood	acrylic	thread
chip board	epoxy	rods
masonite	plywood	putty or filler

Tools
Depending on your construction method (i.e., additive, subtractive, or cast-in-place), different tools may be necessary. Before starting, consider the need for and access to the following:

Measuring
digital & laser capturing devices

Cutting
X-acto blades with sharp edges
laser cutter
router (manual or CNC)
band saw
rotary tools

Adhering or Forming
3D printer
cast-in-place forms
straight pins
quick-set glue or 2-part epoxy

Finalizing
putty
sander/sandpaper
appropriate paints

MODEL AS STORYTELLING PROP

One of the biggest mistakes a designer can make is putting enormous effort into crafting their story props and then failing to leverage them in the presentation. If you choose to build a physical model, be sure to place the model in a location where your audience can see it. However, keep in mind that whenever the model is visible, your audience will likely be looking at it, even if you're not, so, consider revealing the model at a predetermined time. Not only will this help focus the audience's attention, but doing so can add a bit of mystery, drama, and charisma to your presentation.

When you are discussing the model, gesture towards it. You may need to hold it up or project it on-screen. Also, consider building the model in a way that maximizes your storytelling opportunities by adding interactive features such as removable layers, and building it at scales that make it easy to use, view, or manipulate. Keep in mind that unless the model is encased, the audience will likely want to pick it up, so craft the model accordingly.

When your presentation is over, expect the audience to draw closer so that they can view the model from different angles. Finally, remember that your final rehearsal should include all of your props, this will help you become comfortable with using them, thus making your model building efforts worthwhile.

VIRTUAL MODELING

The frontiers of design communication are both vast and changing. At the time of this printing, tools such as holograms and technologies that capture gestural movements and provide multi-sensory experiences are being developed. The path forward is hard to predict, but some technologies are already being integrated into design storytelling, and bear explanation.

Thanks to new user-friendly software programs and less expensive hardware, digital models are growing in popularity. Such models can be shared via virtual and augmented reality experiences. While each method presents limitations, they offer newfound potential to bring design stories to life.

AUGMENTED REALITY (AR)

AR is the enhancement of an existing environment by superimposing new information over it. These augmented scenes are made visible as a response to a **marker**, or with GPS coordinates.

Some retail stores are already using augmented reality to show their products within existing environments.

Figure 8.6 Augmented reality (top) & virtual reality (bottom) provide new opportunities for design storytelling

VIRTUAL REALITY (VR)

VR can be thought of as a total immersion within a virtual environment. To view this environment, users wear a **steroscopic** headset and sometimes use hand-held devices for **haptic** feedback. Inexpensive headsets make use of a mobile phone and allow the user to view a design from many angles, while high-end sets allow for locomotion, or movement within a virtual space.

THREE-DIMENSIONAL DRAWINGS

Three-dimensional drawings give viewers a sense of spatial relationships. These drawings can be created with **parallel projection**, where there is no foreshortening of distant objects, such as in Isometrics and Axonometrics, or by making use of a vanishing point(s), such as in perspective drawings, which allows viewers to perceive depth, thus giving a realistic view.

PROJECTED DRAWINGS

Figure 8.7
3-Dimensional drawings give viewers a sense of spatial relationships

Isometrics Drawings
All three sides are visible & share equal emphasis.

30°

Elevation Obliques
Give more emphasis to a vertical face; all vertical lines are vertical & parallel lines remain parallel.

90°
elevation scale

Plan Obliques
Give more emphasis to the plan view or horizontal plane.

45° or 60°

161

PERSPECTIVES

There are several types of perspectives you may opt to use based on your goals and desired viewing angle. Consider where the "viewer" is located relative to the objects featured.

Figure 8.8 Perspectives can have either one, two, or three vanishing points

vanishing point

1-Point Perspectives
Are easy to construct but their symmetry can be dull.

2 vanishing points

2-point Perspectives
Are the most widely used since they are thought to depict a more natural, asymmetrical view.

3 vanishing points

3-point Perspectives
Are typically reserved for tall objects and buildings where foreshadowing in three dimensions is helpful.

OTHER THREE-DIMENSIONAL VIEWS

Section perspectives, **section obliques**, and **exploded views** can also serve as useful props in telling design stories.

Section Perspective

Section Oblique

Figure 8.9
Section perspectives & exploded views show design components

Exploded View

DRAWINGS AIDES

There are numerous tools to help create 3-Dimensional Drawings.

Manual
Compose It Grids
Gridvu Drawing Tool
John Pike Perspective Machine
Perspective Grids Underlays

Hybrid
(programs/apps with grid underlays)
Adobe Photoshop Sketch
Illustrator Underlay
Gridvu
Procreate

Digital
3Ds Max
Autodesk 123D
Form Z
Inventor
Maya
Optitex
Revit
Rhino

Sculptris
SketchUp
Solidworks

163

RENDERING

Rendering adds a great deal of dimensionality to your design depictions. A rendered image gives viewers a sense of color, light, material, and texture. Entire volumes have been written on how to generate inspired design renderings. Below is an overview of rendering considerations:

Focus
Use color and saturation for emphasis; aim to focus viewers' eyes on the center of the image, not its edges.

Realism
Align the level of detail and realism with your project's stage of development

Media
Select media that aligns with the audience's interest and your skills & ability.

Consistency
Aim for a consistent rendering style throughout the design presentation; the audience will infer that style changes are indicative of design changes.

RENDERING TOOLS

There are numerous tools to help you render a perspective drawing:

Manual

Dry Media	Wet Media
Color Pencils (Prisma Color)	Markers (Prisma Color, AD, or Copic)
Pastels (Rembrandt)	Water Color

PAPER

Select paper based on media, tooth (graininess), color, & weight:

Dry Media Options

Tracing Paper
translucent, inexpensive, expect marker bleed

Bond Paper-copy paper; opaque, inexpensive

Toned Paper
high tooth & high contrast, available in a range of colors

Bristol Paper
dense paper with a relatively smooth finish

Vellum-translucent

Ingres Paper
textured paper, available in a range of colors, great for pastels

Wet Media Options

Marker Paper
translucent, no marker bleed

Mylar
translucent paper with smooth plastic film, best for ink drawings

Water Color Paper
translucent paper, comes in multiple finishes

DRAWINGS AIDES

There are numerous tools and programs to help with rendering.

Hybrid
Stylus with Sketching Apps
Photoshop Filters

Digital
Indigo Renderer
Lumion
Maxwell
Mental Ray
Octane Renderer
VRay

FOUR-DIMENSIONAL DEPICTIONS

The fourth dimension is time, and technological advances now allow designers to represent their designs over a duration. Designers have long benefited from before and after images as well as sequential depictions that illustrate how a design is assembled. Today, there are many opportunities to showcase how a design responds to various inputs and constraints. For instance, architects and interior designers can generate daylight studies, illustrating daylighting patterns over the course of a day, week, month, or year. Or, using RFID (Radio-Frequency Identification) devices and the internet of things, design researchers can track and display the locations of building occupants, highlighting patterns of use. Similarly, industrial designers might show force animations depicting how a product can withstand user demands. At the same time, fashion designers might show how a garment responds to the movement of its wearer.

GIFs, Graphic Interchange formats, are compressed image files that allow for short animations. GIFs are often the format of choice for websites and blogs that feature quick, looping animations. Software plug-ins enable the study of various inputs which can then be shared with project stakeholders. Additionally, many designers are now creating videos and animations, which are discussed in Chapter 9.

As a design storyteller, it will be imperative to keep abreast of new technology — both within design and from other fields. With a bit of vision and thoughtful planning, these tools can provide the vivid props your story needs to make for a memorable and persuasive audience experience. The key is to keep the story focused on the message at-hand.

Figure 8.10
Daylight studies can show light patterns over a period of time

SUMMARY

The "props" designers use to convey their ideas are essential components of any design story since they can inspire, orientate, and build audience understanding. To determine the quality and quantity of your props, consider your goals, your audience's characteristics, and the project's stage of development. To avoid miscommunication, aim to align the fidelity of your design's representations to your stage in the project (i.e., early stages would likely utilize more schematic representations, while later stages may benefit from added realism).

There are a variety of props that you may opt to include in your story:

Diagrams
convey specific points.

3-Dimensional Drawings
illustrate spatial relationships & realism.

Conceptual Images
inspire & evoke abstract thinking.

Physical Models
depict spatial relationships.

Orthographic Drawings
depict technical information & scale.

4-Dimensional Depictions
illustrate a design over of time.

Today, designers can create these representations using a range of manual, hybrid, and digital tools. While it is important to stay abreast of new communication technologies, the key is to keep the goals and the audience in mind when determining what to create and how to do it.

FOR CONSIDERATION

"Have a big idea and/or unifying concept and clearly communicate that at the outset of your presentation. If you have a goal, state that to keep your audience on track. Present your concepts in a sensible order to support your efforts to communicate, persuade or gain approvals. And don't rely on the quality of your visuals to make up for a weak idea. Great images of a poor design won't last."

Eric Ibsen,
chief design officer for Forge

TERMS

- additive making
- augmented reality
- cast-in-place making
- concept model
- dry media
- exploded view
- form model
- GIFs
- haptic
- isometric
- maquette
- marker
- orthographic views
- parallel projection
- parti model
- prototype
- section oblique
- section perspective
- stereoscopic
- study model
- subtractive making
- virtual reality
- wet media

APPLICATION 8.0

To enhance the Sharing the Solution portion of your presentation, consider the following:

1 Reflect on your audience and your design. To determine the quantity of your visual messages, identify 2–3 of the most compelling benefits for your audience. Consider how best to frame these benefits for your audience (See Chapter 2) and how knowledge of these benefits might encourage the audience change you are seeking.

2 Based on your stage in the project, your goals, and the characteristics of your audience determine which representations methods (drawing type & level of fidelity) would best convey these benefits.

3 Similar to Chapter 7, for each iteration, establish where viewers should begin, how they should navigate the content, and what they will need to remember about it.

4 Determine what cues will help viewers to do this. Test several methods of integrating navigational cues into your depictions. The goal is to produce 2–3 versions of each.

5 Quickly sketch out your ideas and discuss them with a trusted peer prior to beginning any final iterations.

6 Based on your reviewer's feedback, generate your ideas by whichever means you feel most appropriate; aim to create 2-3 iterations for each.

7 To understand how others might approach and interpret these depictions, review them with several people without providing verbal explanations.

8 Ask your reviewers to explain their responses to the images. If these explanations do not align with your goals, revise your work accordingly.

Rehearsal

9 If you are not generating a video for your presentation, rehearse your presentation once more in front of an audience using your entire visual package.

10 Adjust and refine your presentation and your visual messages based on your audience's comments and your own experience.

OBJECTIVES

- Gain a broad understanding of time-based media, including video and motion graphics
- Analyze the appropriateness of time-based media for design storytelling
- Understand a typical work flow for time-based media
- Gain a broad understanding of video and motion graphic tools and terms
- Outline a presentation using time-based media
- Develop a broad understanding of audio terms and techniques
- Conceptualize and construct a video presentation

STORYTELLING WITH VIDEO

This chapter will focus on the use of video and motion graphics in design presentations.

Ethan's firm would soon be interviewing for a wayfinding project at a large hospital. Ethan learned first-hand how important wayfinding is to anxious patients – and their partners. His son was born six weeks premature just a few months earlier. Having no opportunity to visit the hospital in advance, he had felt bewildered as he and his partner hurried toward the maternity ward.

Back at work, Ethan was confident in his firm's capabilities, but firm leaders were unsure if they would even win the project. Their company was smaller than their competitors, and they had never worked on such a high-profile project. After discussing their predicament in a staff meeting, Ethan nervously shared his story. Together, they decided that a video filmed in first-person recounting Ethan's experience would not only be memorable, but it would illustrate their passion for the project.

INTRODUCTION

Video is an enticing communication platform for designers. Unlike any other media, videos have the power to garner attention and convey the emotionality of a moment. At the same time, new technologies have made it increasingly easier for the average viewer to see, share, and even create their own videos. These videos can be viewed from all over the world, and at any time of day.

Acknowledging this potential, the media analysis company, comSCORE Inc., named the rise of short-form videos and the demand for the skills needed to create them as one of the ten trends that defined 2015.[1] While videos are seemingly easy to produce, the work that goes into their production is often grossly underestimated, and since videos send so many vivid messages (both intended and unintended) they require extra consideration.

THE ROLE OF VIDEO IN DESIGN

Some design fields have long been entrenched in video, having collaborated on television and multimedia campaigns for decades. Others are relatively new to the media. Interior design and architectural firms are just beginning to use video to share firm news, research, and ideas, highlight key projects, and recruit talent.[2]

Given the decreasing cost of video equipment, smaller firms and freelance designers can also include videos as a part of a larger communication and marketing strategy. However, videos aren't created solely for external communications. There is evidence to suggest that videos created by job candidates could enhance their prospects of being granted an interview.

THE ROLE OF VIDEO IN HIRING

Not only can firms create videos, but evidence suggests that job candidates may benefit from doing so as well. In one study on viewer perceptions, seven of eight designers in hiring positions felt that design candidate videos would give an applicant an edge in making hiring decisions. They suggested such videos could:

1. Offer a novel approach for highlighting a candidate.
2. Confirm a candidate's speaking ability.
3. Feature a candidate's video production skills.
4. Provide a means to showcase a candidate via voice and music choice.
5. Provide an added dimension to traditional application materials.[3]

COMPARISON OF STRATEGIES

Videos can be an appealing, but not always appropriate, communication vehicle for designers. Since video production can be a time-intensive proposition, designers should consider how best to incorporate videos into their communication strategies.

STRATEGIES FOR COMMUNICATING DESIGN IDEAS

Static, no presenter

Deliverables are shared without a verbal presentation.
Example: online portfolio or design competition exhibition
Short videos may be embedded into the document.

*Static, with presenter

Deliverables are shared alongside a verbal presentation.
Example: project critique, job interview, or jury panel
Short videos may be embedded into a slide deck.

Time-based (video)

Deliverables are shared via short-form, scripted videos.
Example: video RFPs or candidate marketing videos

*Note: this can include in-person or video conference calls.

COMPARISON COMMUNICATION STRATEGIES

Those opting to create videos should understand their differences from other communication tactics.

	Static no presenter	Static with presenter	Time-based (video)
captive vs. voluntary audience	**voluntary** *Audience members are free to exit the presentation area.*	**captive** *Social etiquette discourages the audience from leaving.*	**voluntary** *Viewers are free to stop the video.*
attention & timing	**audience-dependent** *The viewer determines how long to view the material.*	**audience-influenced** *The audience can change the pace by asking questions or providing non-verbal cues.*	**producer-dependent** *The video producer dictates timing and influences the viewer's attention through visual & auditory cues.*
potential for rapport between audience & presenter	**none**	**high**	**low**
level of exchange between audience and presenter	**none**	**high** *Questions are asked & answered.*	**little to none** *However, non-linear formats can provide audience choice and the potential to post messages to provide feedback.*
level of reach — the potential to share information with a broad audience over time and geographic range	**moderate**	**low**	**high** *(if online)*
other considerations	How the audience will navigate information	How the speaker will best support the information	The optimum level of information to curtail boredom and over-stimulation

EXERCISE 9.0 ADAPTING MESSAGE TO MEDIA (VIDEO)

Review the chart above and compare it to your last presentation.
If you were to incorporate a video, how might your approach change?
List 3–4 of the most important changes.

WORKFLOW OF VIDEO PRODUCTION

It is important to understand the tasks involved in producing a persuasive video because it is often more work than expected, and changes made late in the process are often more costly and time-consuming. This workflow can be generalized into stages of **Pre-production** (planning), **Production** (creating), and **Post-production** (refining).

Figure 9.0
Video production workflow

PRE-PRODUCTION
PLANNING

➡ PRODUCTION
CREATING

➡ POST-PRODUCTION
REFINING

Planning in pre-production can save a great deal of time & expense.

OVERVIEW OF PRE-PRODUCTION

Thoughtful preparation during pre-production can save a great deal of time and expense later on.

Tasks in this stage should include:

Audience Analysis & Segmentation
Determining audience characteristics
(See Chapter 2)

Logline
Determining the essence of the message
(See Chapters 2 & 3)

Tone Check
Planning for the viewers' emotional journey
(See Chapters 2 & 3)

Storyboarding
Determining the video's structure

Script Writing
Determining what will be said

Scouting Shots and/or Outlining Assets
Determining each filming location
Testing sound and lighting levels in filming locations
Selecting props
Inviting **talent** (actors or narrators)
 and/or
Developing initial concepts for graphics

PRE-PRODUCTION
AUDIENCE ANALYSIS & SEGMENTATION

When dealing with a specific audience, video producers must first consider who their audience is and how best to engage them. Recall the Audience Characteristics table in Chapter 2, and revisit your goals. Is the intent to inspire a movement, evoke an emotion, or provide information? Keep these goals in mind as you determine logline and tone – the two most critical decisions in pre-production.

LOGLINE

A **logline** can be thought of as a one or two sentence synopsis of your story. But, more importantly, these short statements convey the premise of your message. A logline serves as an anchor for all future decisions – both large and small, from those on story and cinematography to music selection and prop placement – all subsequent decisions will support your logline.

Though they're important, loglines can be difficult to conceptualize. Since the goal is to be brief but powerful, start by considering how you might deliver your message via a bumper sticker. Think back to the themes unearthed in Chapter 3, then place the protagonist within the theme (remember this protagonist doesn't need to be a person). Do, however, suggest their goal, the conflict, and the stakes. Finally, incorporate one or two well-placed adjectives to give some emotional insight, but avoid providing too much information. The most powerful loglines are memorable, not comprehensive.

EXAMPLE LOGLINES

From humble beginnings came an extraordinary design mind.
We sense that our hero triumphed over challenges.

This is the story of a tiny device making a huge difference.
The contrast between "tiny" & "huge" piques interest.

TONE CHECK

How should the audience feel during the video, and after?
Should they feel hopeful for the future, or spurred into action?
The answer to these questions will help determine what tone the video should take. **Tone** can be characterized as the overall "feel" of the video, and it's imperative to align the tone to your audience, yourself, and your message. A lighthearted, humorous tone would be grossly inappropriate in recounting the plight of refugees, and a fast-paced video, dripping with pop culture references, is unlikely to appeal to retirees. When determining tone, consider which persuasive appeal would sway your audience, convey your values, and highlight any universal truths that may align your message with the audience.

Remember that sometimes the audience has to feel the gravity of a problem to appreciate the solution. This means that the tone may change. A video that starts in a dark place can end on a high note. Such a change is reflected in the video's music, pacing, and the expressions of those being featured.

EXAMPLE TONES

provocative	awe-inspiring	empowering	tragic
endearing	uplifting	stoic	light-hearted

THE ROLE OF TONE IN VARIOUS VIDEO TYPES

The desired tone of the video will likely influence how it is produced. Stories steeped in pathos (i.e., emotional appeal) may be best communicated via **live-action** footage, which can authentically depict human emotions. Yet, the success of a live-action video hinges on finding the best talent and filming locations.

On the other hand, stories that are light-hearted or have little need for realism may be well-suited for **motion graphics**. Since they make use of graphic assets generated specifically for the video, motion graphic teams also have greater control over aesthetics. However, animation can be time-intensive, and computer-generated special effects can be difficult to produce. So, consider your goals, equipment access, and skills when determining how to produce your video.

QUESTIONS TO CONSIDER WHEN SELECTING VIDEO TYPES

When choosing between live-action and motion graphics, consider the following:

	Live-Action	Motion Graphic
Tone	Would real people most authentically convey the desired emotional tone? / Is human expressiveness a priority?	Is there a specific visual style that would best represent the desired tone? / How much control is needed/desired?
Equipment	Do you have access to a video camera, mic, & editing software?	Do you have access to a vector-based graphic program & compositing software?
Knowledge	Are you familiar with photography & camera settings?	Are you familiar with key framing?
Asset Acquisition	Do you have willing, able, and relevant participants to act as your talent?	Do you (or others) have the ability to make high quality graphics to support your tone & message?
Access	Do you have access to the necessary scene locations? / Do you have access to appropriate props?	

STORYBOARDING FOR VIDEO

Storyboarding is the process of deciding how the logline and tone should be communicated.

A well-crafted storyboard has two primary functions:

 1) aiding project development, and

 2) serving as a record of the decisions made.

A storyboard outlines the overall sequence of the video – including what is both seen and heard at all critical junctures. Storyboards are also used to help plan for shot locations, talent needs, and graphic elements.

SEQUENCE

One of the most fundamental decisions made during the storyboarding process is the arrangement of the story. Video storyboard sequences often fall into one of two general categories: linear and nonlinear.

Linear Sequence

Videos following a **linear sequence** are likely to be familiar to viewers. A predetermined order shapes the story, and while it may make use of flashbacks, or foreshadowing elements, each audience member will view the same plot unfolding.

Linear Storyboard
The plot is predetermined.

Figure 9.1
A linear video sequence follows a predetermined order

Non-linear Sequence

Videos making use of a **non-linear sequence** can be likened to the *Choose Your Own Story* formats found in some children's books. Not to be confused with non-linear editing, non-linear sequences allow the viewer to choose their own path during critical junctures in the story. Storyboards for these types of videos are often represented by flowcharts that outline the options available to viewers. While nonlinear stories may allow for more engagement with the audience, they can become confusing, and producers of these videos will likely need to develop more material to cover the available options.

Non-Linear Storyboard
The audience decides how the plot will unfold.

Figure 9.2
A non-linear video sequence allows the audience to chose their path

175

SCRIPT WRITING

Writing a script is different from writing a paper or book. This is because dialogue is conversational, using colloquial words, phrases, and contractions – essentially, everyday language. Viewers typically expect an alignment between what they hear and what they see, so timing matters. Long-winded dialogue can cause imagery to linger on screen, while a series of short, bursts of lines might seem rushed. So consider the rhythm and cadence of the words being used against the imagery that will be shown. Know how much time it takes for lines to be spoken aloud at a reasonable rate of conversation, including time for pauses and inflection. Be sure to indicate pauses and unspoken action in the script so that they're not overlooked.

Time	Audio	Video
00:02	I wake up everyday thinking about people, {pause} how they live their lives, how they spend their time, and the products that make their lives better.	Live footage of the designer talking to the crowd.
00:08	{Musical score fades in}	Cut to shot of the crowd listening and gaining interest.

Figure 9.3
The script above indicates timing and has unspoken elements in italics

When a script calls for multiple people to have a speaking role, professionals almost always do a **table read.** Not only does a table read force everyone to practice their lines, but it also helps those involved to understand their responsibilities and gain a sense of the overall timing of the story. During a table read, anyone with dialogue reads their lines aloud with the same inflection and cadence as they would during filming. If a script calls for yelling . . . they yell; if they are to cry . . . they cry. Everyone involved also pauses for any non-verbal action to take place.

You might find that some will stick closely to the script while others will start **ad-libbing,** and give unprepared remarks. In either case, it is important for everyone to seem natural, at ease, and on message.

Figure 9.4
A table read can help finalize the script & timing

SCOUTING LOCATIONS

If your video will feature any live-action footage, determining when and where to film should be done early in the planning process. Consider the following:

> When scouting locations, look for places and spaces that will help elevate your story and what is happening in the scene.
> -Annette Tulley

GETTING PERMISSION

Apart from very public spaces such as open parks, you will likely need to obtain permission to film in most locations. This process may take some time, or you might even get denied, so plan on getting permission early. You'll also need to get consent from anyone that will have a recognizable likeness on the video – whether speaking or not.

It is best to have these agreements in writing and signed. Also be sure to save them in the event of any issues. On the consent forms, include information as to how you intend to use the video and what it is about.

MAXIMIZING NATURAL SETTINGS

Proper lighting can take a scene from dull to inspiring. Outdoor photographers have long credited the golden hour as the optimal time to shoot. The **golden hour** is roughly the first hour after sunrise and the last hour before sunset. During those times, the sun is low in the sky, casting a soft, diffused light. However, it can be difficult to shoot footage during such short time spans since the sun's angle will quickly change. For that reason, it is important to visit a site at the same time of day you plan on filming and during the same time of year. A location will feel very different at 6 pm in January than at 6 pm in June.

Also, when filming longer scenes outdoors, you may need to visit the site at the same time of day on consecutive days, so plan accordingly.

MAINTAINING CONSISTENCY

A distracted viewer is not an engaged viewer, so avoid potential distractions by eliminating seemingly small, but unplanned changes. These can include any number of things, such as people wearing different clothing or accessories, changing hands on a clock, or props that have moved.

To avoid the potential for distractions, think about variables such as weather, noise, and people-related factors like uninvited passersby or awkward gawkers.

MAXIMIZING THE VIDEO'S LIFESPAN

Ever wonder why some videos feel tired?
Hairstyles and clothing can quickly date a video, as can indicators of time. So to extend the shelf life of a video, ask talent to dress in a timeless manner, and try to avoid having time-sensitive objects in scenes such as calendars or date-specific signs.

FILMING EQUIPMENT

A basic filming kit should include equipment to capture audio and video, steady the camera, and light the scene. Today, this equipment is much less costly than several years ago. In fact, some independent films, such as *And Uneasy Lies the Mind,* have been filmed entirely on smartphones. However, there are advantages to using upgraded equipment. Consider the following:

FILMING EQUIPMENT

	$	$$	$$$
Video Capture	Smartphone or other portable recording device *Limited settings* *Little memory* *New recording apps*	SLR single lens reflex camera *Ability to change aperture, shutter speed, & ISO settings* *Expandable memory*	Multiple cameras such as: Mirrorless cameras with lens kit *(combines SLR functions with small size)* or Professional camcorder *Ability to change aperture, shutter speeds, & ISO settings* *Expandable memory* *Multiple cameras allow for cutting between scenes*
Audio Capture	Smartphone in a quiet room with little distance away from the speaker *Some mics can be used with smart phones.*	**Lavalier mic** A small mic that can be clipped to a speaker *Allows for audio capture close to the source with minimal impact on the scene*	**Shotgun mic** on a boom A directional mic attached to a long pole *Allows for audio capture close to the source with no visible impact on the scene*
Lighting	Natural daylight and inexpensive lights on clamps *Allows for some light movement*	3 clamp lights and riser stands to allow for more flexibility *Ability to move light*	Photographers light kit that includes stands and collapsible soft-boxes to diffuse light *Ability to move and diffuse light*
Tripod	Shoulder mount or extended arms	54" with pan *Allows for relatively stable side-to-side rotation*	60" with fluid head *Allows for relatively stable side-to-side & up/down rotation*

178

OTHER FILMING EQUIPMENT

After gathering the essentials, other useful filming equipment includes:

HEADPHONES
Headphones allow the videographer to listen to audio as it is recorded.

COLOR FILTERS & GELS
Color filters slide over the camera lens to correct for color issues or provide visual effects.

GREEN SCREEN
While not always green, these solid color backgrounds allow for footage to be superimposed over another by isolating a color and making it transparent.

JIB ARM
A jib arm is a camera mount that allows the camera to move up and down smoothly and reach high angles.

— rotating arm
camera

CINEVATE SLIDER
A cinevate slider is a mount that allows a camera to move from side to side.

camera
— rollers

> If you have a small budget, there are DIY ways to make camera mounts, or check to see if equipment can be rented or borrowed.

DOLLY
Dollies are wheeled carts that allows for camera movement.

camera
wheel(s)

DRONES
Drones with camera mounts allow for aerial shots.

BATTERIES & MEMORY
On the day of filming, be sure to bring extra batteries and memory storage.

CAMERA DISTANCE

The distance that the camera is away from the action (i.e., person or objects of interest) can impact how the audience perceives the message. For example, long shots can be used to give context, setting the stage for a story, while an extreme close-up can provide artistic detail and highlight facial expressions.

When filming people, allow for headroom & a natural eye height.

Medium shots
show some detail, such as a person from the waist up.

Close-up shots
include details, like showing a person's head and shoulders.

Long shots
show entire objects or people.

Extreme close-up
an object (or person's face) fills the composition

Wide angles
are often used in landscapes or opening shots.

Figure 9.5
The camera's distance from the action can change how viewers perceive the message

180

CAMERA SETTINGS

Your camera's settings (i.e., shutter speed, iso, and aperture) can make a big difference to the look and feel of your footage. For an overview of these settings, see the **Photography Terms Appendix.**

Your camera lenses can also impact your photos. If you are using a camera with a removable lens, consider experimenting with different focal lengths. For instance, macro lenses work well for close-up photos, whereas telephoto lenses allow you to photograph from a distance, and wide angle lens allow you to capture more of a scene. In general, the smaller the focal length number, the wider the angle.

LENS FOCAL LENGTH

18mm	wide angle	landscapes, skylines
35–70mm	normal	streetscapes
70–135mm	medium telephoto	portraits
200+	telephoto	sports, wildlife, distant subjects

SCENE COMPOSITION/FRAME

A scene's composition, or frame, can send messages as well. Professionals often use the Rule of Thirds to compose dynamic frames, which means that subjects are not positioned in the center of the frame but one-third from the right or left side of the screen.

Figure 9.6
Placing the subject 1/3 from the edge is often considered more dynamic than centering it

Leading lines can draw the eye toward the action, and bigger items will receive more attention.

Figure 9.7
Leading lines can be positioned in the composition to lead viewers' eyes toward the action

CAMERA ANGLE

Camera angles can imply importance, stature, or imbalance. For instance, sharp angles add drama. Regarding camera height, a low positioned camera can make those on screen appear more significant or imposing, while an aerial shot can provide an overview.

Figure 9.8
Camera heights can impact viewers' perceptions

imposing subject | scene overview

CAMERA POSITION

When positioning the camera, aim to stay in front of subjects. Moving behind them flips the scene, this is not only disorientating, but it causes signs and text objects to appear backward.

flips the scene
text would be backward

sharp angle Subject sharp angle

Figure 9.9
Avoid backward text by limiting camera positions to a 180° range in front of the subjects

Potential Camera Location(s)

CAMERA ORIENTATION

At the time of this writing, the aspect ratio on most screens is either 4:3 (4 units of width, for every 3 units of height) or 16:9 (1920x1080 pixels). Practically speaking, this means that screens are typically wider than they are long. So when filming with a smartphone, hold it horizontally.

Figure 9.10
If filming with a smartphone, hold it horizontally to match the orientation of most screens

NO YES!

CHANGING CAMERA POSITION

Moving the camera during filming can add visual interest. However, this should be done with great care so as not to distract or overwhelm the audience.

Zoom

Avoid jarring movements and instability by using camera mounts that allow very slow and steady gestures.

moving toward the action

Figure 9.11
There are multiple ways that the camera can move during filming

Pan

side to side

Tilt

up & down

Dolly/Tracking

subject

camera moves to follow action.

Crane

subject

camera follows the action from above.

CHANGES TO TIME

The speed of a video clip can also impact how the audience perceives the message. Slow motion adds drama (but requires more light), while fast-paced footage conveys a sense of urgency. Some cameras will allow you to film in "slowmo" or time lapse modes, or you can speed up or slow down clips with the time remapping settings available in most video editing software programs.

slow motion for added drama

fast-paced for urgency

Figure 9.12
The pace of the video can convey meaning

PREPPING TALENT

If the video will feature on-screen talent, it is important to prepare them prior to filming. Interviewees won't do a table read, but there are steps a producer should take to maximize filming outcomes. After all, it's in the best interest of everyone to have talent appearing comfortable and confident while on camera.

PREPARING FOR AN INTERVIEW

Establish your location. Be sure to visit all sites in advance so that you can review camera, lighting, and sound conditions. This will ensure that you have packed the right equipment. If possible, plan to have two cameras for filming, which will give you more options while editing, and serve as a backup in the event one camera fails to record.

Depending on your comfort level, you may want to instruct talent on appropriate attire.

Establish general goals (i.e., what they will be talking about). You may want to do this by sharing a few talking points. A phone conversation is best so that you will have a sense of their vocal patterns (i.e., are they soft-spoken; do they speak in a monotone manner, or are they fast in delivery?).

Obtain a signed consent form, as well as the spelling of their name and official title. While this can be done later, it is much easier to do this prior to filming. Plus, having them provide this information themselves will reduce your chances of getting it wrong.

> Prepping the talent in advance can make filming more productive & pleasurable for everyone.

FILMING AN INTERVIEW

Many people don't like to be on camera, so it helps to set a relaxed tone. Telling a story or joke can help put them at ease.

Explain that your voice will not be recorded, so they will need to restate the given questions as part of their answers.

Start with a few easy questions to help them warm them up.

If they are agreeable, ask them to provide both short and long answers to questions; this will give you more options when editing.

If they provide an inaccurate answer, correcting them can be awkward. Instead, try asking the question differently.

Listen for how you can edit what they are saying. If the person gives a long-winded answer, it may be that you want to incorporate only a portion of their response.

At the end of the session, simply ask them if there is anything else they would like to share, which may provide some interesting insights.

If you have not already done so, be sure to obtain a signed consent form, as well as the correct spelling of their name, and official title (if any).

Be sure to thank them for their time and keep them posted on the video's progress.

PRODUCTION

After what seems like a lifetime of planning, the video will be ready for production, which involves generating and compiling **assets** like video footage or artwork.

PRODUCTION TASKS

Tasks in this stage should include:

Recording Clips or Developing Footage

This includes both primary footage and **b-roll,** or background footage

Reshooting

Obtaining footage again (if necessary)

Recording Voice-overs

Recording speaking parts used for narration

Locating Musical Score

Obtaining royalty-free music

Locating Stock Footage or Graphics

Obtaining royalty-free video footage and graphics

> **Royalty-free does not refer to price, but to the right to use material without paying royalties or license fees.**

TECHNICAL ISSUES OF FILMING

Prior to filming, there are several camera settings to consider:

FILE TYPE

Videos are often filmed using .AVI, .MP4, or .MOV formats. AVI files are universally accepted but are typically large files. Apple Quick Time is needed to play .MOV files, while .MP4 files are universally accepted but within a relatively small file size.

See the **Video File Types Appendix** for more information.

FRAME RATE

Frame rate, or fps, is the number of frames your video shows per second. The more frames per second, the smoother the footage, but the difference becomes negligible with reasonably high frame rates. Over the years, there have been several standards for frame rates. Most Hollywood films are 24fps; in the US and Japan, television is broadcast at 29.97 (rounded up 30 frames per second), though many other countries use a frame rate of 25fps and newer technologies have allowed frame rates of 60fps. The most important thing is to be consistent with your footage so that all clips are filmed with the same frame rate.

RESOLUTION/SIZE

Be sure to film at the highest possible resolution quality for your camera. Most cameras have resolution presets which may be labeled as high quality, or as 1920x1080, 720 (for standard – quality), or 480 (for low – quality). These numbers refer to the output size. Higher numbers denote higher – quality footage – and larger file sizes. Footage shot at 720p or, worse yet, 480i, will be of low quality on bigger screens. The "p" and "i" refer to how the file is scanned (or drawn on screen). Progressive scanning "p" updates the entire frame at once, whereas interlaced "i" files update portions of the frames. Practically speaking, progressive scanning reduces the "flickering" effect one may see as a video is played.

You may have seen an odd coding when filming, such as:

What is this odd language?

1080p/30

The image is 1080 pixels high.

It is progressively scanned.

Its frame rate is 30fps (29.97, to be exact).

COMPRESSION

Video files are going to be large. To save room, they are often compressed using a codec. While this is a complex topic, the essence is this: big files are compressed into small files and then decompressed using an algorithm; this can be done through either:

Lossless Compression
compresses videos but retains fidelity (i.e., video quality).

Lossy Compression
removes information during compression that can never be restored, thus slightly compromises the quality.

Many editing programs include compression settings. At the time of this writing, the most common is H.264, which is lossy, but the resulting .MP4 video file is relatively small, making it easy to upload online. MP4 file types are often considered the industry standard file format. See the **Video File Types Appendix** for more information.

LIGHTING

Lighting can be used to add drama or general appeal to any scene. As discussed earlier, it is important to recognize the variables that come with natural lighting. For indoor scenes, artificial lighting might be needed to supplement ambient illumination levels. However, your camera flash produces a relatively harsh light, so consider obtaining a few portable lights. You can either opt to mount these lights on floor stands or an overhead beam.

TYPES OF LIGHTING

When selecting light fixtures, consider your illumination goals, either to supplement light levels or to add focus and drama. If the aim is to boost overall light levels, it will be important to avoid washing out the scene with harsh light. Generally speaking, the broader the light source, the softer its glow. In diffuse light, rays are traveling in multiple directions, producing a more even glow overall. To achieve this effect, place a relatively inexpensive softbox over the light fixture. Specular lights, also known as spotlights, can add focus to the subject by providing a more intense light. These lights produce a tight beam with hard shadows. The lamps, or light bulbs you use can impact the look of the scene as well.

LAMP TYPES

Incandescent
Pros Inexpensive up front, dimmable, good color
Cons Short life, inefficient, produces heat

Fluorescent
Efficient, long life, good color
Expensive up front

LED
Pros Long life, efficient, dimmable, small
Cons Somewhat limited colors, expensive up front

Halogen
Efficient, warm light
Expensive up front

Figure 9.13
Overhead lights and those on stands can be used to light a scene

COLOR TEMPERATURE

Another thing to keep in mind is that very few lights produce pure white light. Instead, most have either a bluish or yellow tint. These shifts in tint are due to light's wavelength, known as color temperature, which is measured in degrees Kelvin. The higher the Kelvin number, the bluer the light.

LEDs are growing in popularity due to their small size and energy efficiency. At first, they were avoided for photography, but they now come in both warm (3,000K) and cool types (6,000K), though photographers still use other types of light sources as well.

1,000K	2,500K	5,000K	7,500K	10,000K
WARM LIGHT				**COOL LIGHT**
Candle Flame	Sunrise Sunset	Artificial Lights	Midday Sun	Clear Blue Sky

Figure 9.14
Color temperature

DIRECTION OF LIGHT

The direction at which light strikes a subject can affect how it appears on-screen. As a rule of thumb, lights that shine directly on a subject will cast very short shadows, while lights that graze the subject from the side will produce long directional shadows. A key light is the primary light of the scene, while the fill lights add illumination to dark areas.

Single Fixture Lighting Schemes.

Singular lighting schemes use only one light fixture. While these schemes can create drama, they can be problematic since they cause harsh shadows.

SINGULAR LIGHTING SCHEMES

Figure 9.15 Single light lighting schemes

Front lighting
Lighting the front of the subject can seem harsh due to the absence of shadows on their facial features.

Back lighting
Light from behind the subject can create a romantic or ethereal effect.

Up lighting
Light from a low level can produce moody images.

Top lighting
Light from a high angle can make the subject appear threatening.

Full side light
Lighting the subject's side can provide texture & drama.

188

3-point Lighting Scheme

Most scenes are rarely lit with only one source of light. To balance brightness while minimizing undesirable shadows, most are lit using a three-point lighting system in which lights are placed in three locations.

The key light shines directly on the subject and is often the brightest light. The fill light also shines on the subject, but from a different (often lower) position. Its role is to balance lighting and eliminate harsh shadows. Finally, the back light shines on the subject from behind. Its role is to minimize shadows on a backdrop.

> Having several light sources can help properly illuminate subjects & reduce harsh shadows.

Figure 9.16
A 3-Point lighting scheme can be used to eliminate harsh shadows

EXERCISE 9.1 LIVE-ACTION FILM PLANNING

Thorough planning is critical in video production.

Determine locations for filming (i.e., school, work, home, local businesses, etc.).

Consider any potential issues which may impact filming in these locations.

Consider how you may need to modify these sites to accommodate sound & lighting.

Refer to pages 178-179, and develop a list of necessary items for filming, such as camera and mounts, lighting, mics, etc.

List any camera angles that you would like to use.

Determine which lighting scheme you plan to use for each scene.

SOUND

Poor sound quality can actually alienate viewers faster than a poor picture.[4] That being the case, a camera's built-in mic will rarely suffice. The key is to record desirable sound as close to the source as possible, while eliminating – or at least mitigating – undesirable sounds.

DESIRABLE SOUNDS

In recording high-quality sound – location matters. Aim to record in dead rooms, which are often small, carpeted, and contain furniture or irregularly shaped walls. These soft surfaces work together to absorb, rather than reflect sounds. Dead rooms are especially useful when recording voice-over sessions when someone is heard but not seen. Conversely, live rooms are large and have primarily hard surfaces and reflective finishes, such as stone and concrete. There may be times when recording sound in live spaces is unavoidable. For instance, the backdrop may be important to add context, and the person may need to be visible when speaking. In these scenarios, there are a few strategies that can help minimize potential issues. First, use a directional mic for recording (see Mic Types below), and position the mic as close to the person speaking as possible, without corrupting the shot. However, when placing mics, be mindful of noises that might occur close to the mic itself, such as clothes rustling when the person is moving, or air movement while they are breathing. Finally, to eliminate hollow sounding voices and echoes install sound blankets on vertical surfaces. These will help deaden a live room by dampening the sound. This can be as simple as tacking up moving blankets to any walls that will be out of the frame. Together, these strategies can help you capture the audio you need, in the location you choose.

> When it comes to sound, aim to maximize desirable & minimize undesirable.

UNDESIRABLE SOUNDS

Undesirable sounds are a constant threat when filming. Surrounding noises such as the wind, equipment feedback, coughs, and even the buzz of lights can be audible. To reduce these variables, use a directional mic to target the sound's source. And since every room has some level of sound, aim to record the room while it's seemingly silent. This recording is known as room tone, and these clips can be used to fill gaps between speaking segments.

MICS

To avoid compromising camera angles for sound quality, several mic systems can help to position the mic close to the sound source, while remaining off the screen.

MIC TYPES

Wireless mics use radio waves to transmit sound from a discreetly placed transmitter (on or near the speaker) to the receiver. While wireless mics allow for freedom of movement, they can be unreliable due to feedback issues or poor signal strength.

Directional mics are often placed on a boom, which allows someone to hold the mic just over the speaker (and out of the shot).

Lavalier mics are small enough to clip to the speaker's lapel. While most lavaliers are omni-directional, meaning they pick up sounds from all directions, they are often placed so close to the sound source that ambient noises are rarely recorded.

PRODUCTION OF MOTION GRAPHICS

On their own, graphics can be quite informative, but they become even more potent when paired with the element of motion. The power of motion graphics lies in leveraging the element of change to direct viewers' attention.

To design motion graphics, start by developing a package of graphics. Each individual graphic should relate to all others through shared color palettes, line weights, and positioning. Creating your own artwork will give you the most freedom (See Chapters 6 & 7). However, if you can't do so, select work that you have obtained written permission to use, or have acquired from a royalty-free website. Designers should never infringe upon the intellectual property of designers – ever, period.

After creating the artwork, components are separated onto layers – one layer for each item that will change. These layers can appear in the foreground, mid ground, and background of the composition and each can undergo changes to either scale, position, or opacity. With so many "moving parts," it can be easy to overwhelm viewers, so it is critical to develop cohesive patterns and pacing. The goal is to avoid the appearance of discontinuous elements that bear little relation to the overall video. With this in mind, avoid limiting the video to a series of short sequences flanked by hard transitions, which can start to feel like a string of presentation slides. Instead, consider having prominent elements carry over from one sequence to the next, which, in turn, will also help viewers process the most important pieces of information.

Figure 9.17
In this simple "countdown" motion graphic, the progression of time is suggested by the numbers themselves in addition to the spinning "hand" and growing circles

EXERCISE 9.2 MOTION GRAPHIC PLANNING

Thorough planning is also critical in motion graphics.
Use your storyboard to sketch ideas for artwork.
Consider what elements will be consistent throughout your graphics.
Determine how you can use the element of change to direct viewer attention.
Determine what elements carry from one sequence to the next.

AUDIENCE FACTORS IN MOTION GRAPHICS

To avoid overwhelming (or underwhelming) your audience consider:

Information Quantity

The nature of motion graphics makes comprehensive treatment of information difficult. In other words, too much information can quickly bore an audience or scare them off. The best use of motion graphics in design storytelling is either as a "primer," highlighting specific aspects of information, or as a "teaser" aimed to pique interest. In either approach, consider how to help your audience construct an accurate mental map of the given information. Incorporate factors of visual hierarchy so that the most important elements are most prominent on screen (Chapter 6).

Change

Our eyes our are biologically predisposed to notice a change; this is how we stay safe. But when viewing too many changes, our eyes become overwhelmed. With this in mind, apply changes only to where the viewer should be looking and when. These changes do not have to be complicated to be effective. Simply altering the scale of an item can attract the eye.

Timing

The best motion graphics balance comprehension with visual appeal. A video that moves too slowly is considered boring; too fast, and viewers won't comprehend the message. That said, novice producers of motion graphics tend to rush the timing, since they already know the content and can anticipate where to look and when. A good rule of thumb is that information should be on screen for about twice as long as needed for the producer to read it. Finally, refrain from including long lines of text, since viewers would be pressed to read them.

KEYFRAMING & INBETWEENING

Keyframing is the most common method for adding motion. A **keyframe** marks a starting point and ending point of a change. The time that elapses between keyframes (when the change occurs) is referred to as **inbetweening**.[5] Keyframes can be used to change a layer's scale, position, transparency, and rotation. Movement can either be linear (i.e., a straight line from one position to the next) or curved, which allows easing in and easing out, such as picking up speed or slowing down. Many compositing programs also have a series of effects which can be applied to layers.

Figure 9.18 Key framing is a process of marking starting and ending points

0 seconds
Keyframe to mark start

0.5 seconds
Inbetweening (no keyframe)

1 second
Keyframe to mark peak

1.5 seconds
Inbetweening (no keyframe)

2 seconds
Keyframe to mark bottom

2.5 seconds
Keyframe to mark end

SOFTWARE

To maintain image quality, it is best to use vector-based programs for creating motion graphic artwork. These graphics can then be linked or imported into a compositing program.

Compositing Software
After Effects Autodesk Flame/Smoke
Apple Motion Foundry Nuke

POST-PRODUCTION

Post-production begins after all footage has been recorded and assets developed. During this stage, editors use the storyboard as a guide to arrange footage and refine the story.

POST-PRODUCTION TASKS
Tasks in this stage include:

Viewing & Organizing Clips
Determining which assets to include

Editing Video and Audio
Establishing structure, sequence, and **cuts**

Screening the Video
Playing the video with the goal of receiving feedback

Exporting & Disseminating
Finalizing the video and sharing it with the intended audience

A NOTE ABOUT POST-PRODUCTION & EDITING

Early film editors used to physically cut and splice footage in darkened rooms. Famed editor Walter Murch asserted that from this apparent violence emerged the "soul of the work."[6] He suggested that editing was not an act of simply "putting together" a film, but discovering its path.[7]

In addition to ordering footage, editors must determine the structure, dynamics, timing, and transitions of the story, this involves many decisions, and the process itself requires sharp focus. Good editors can put themselves in the place of their audience, understanding how viewers will perceive everything from the overarching story down to the smallest of details. In other words, good editing manipulates our attention and emotions, so that we feel as though we are participants in the unfolding story. At the same time, editors must practice great restraint. As Murch put it "doing the most with the least," meaning an editor does only what is necessary to engage the audience.[8]

When telling a design story, it's easy to become consumed with editing – spending hours, days, or even weeks refining the story. The results can be stunning, but the process itself unsustainable. To help alleviate your workload, the following pages outline steps for editing design story videos.

EDITING STEPS

Today, many editors use NLEs or non-linear software programs to edit footage. These programs allow them to view and rearrange clips on a timeline without destructing the original clips. The technical aspects of editing can seem daunting, especially since there are many decisions to be made and often no "right" answers exist. But, following a process can make the tasks more manageable and the outcomes more sophisticated.

Review Footage → Organize Footage → Prepare Settings → Import Footage → Mark Ins & Outs → Add to Timeline → Develop Rough Cut → Edit Audio → Add Titles → Fine Cut → Screen → Export → Share

Figure 9.19
Editing tasks

1. **Review all footage, noting desirable and undesirable clips**
Review all of your footage twice, (one for first impressions and a second time with a more critical eye). If you find that you're missing necessary components, you'll need to either reshoot or buy footage. Stock clips can be purchased from a company or artist on websites such as Adobe Stock or Getty Images. If you plan to use stock clips, ensure that these are royalty-free, meaning you aren't required pay royalties to the originating artist; instead you pay the fees in advance. In other words, royalty-free doesn't mean free to download. However, designers should never violate the copyright or intellectual property of another designer or artist, even when faced with a small budget.

Walter Murch suggested editors select a representative set, which entails finding the clips that best capture the tone of your story. Your set can be used as a guide for editing to help ensure you're crafting a cohesive story.

2. **Organize footage**
Sort desirable clips, or intakes, into named folders. Footage that won't be used which (referred to as outtakes) should be archived. Keep these clips organized and accessible. Time spent upfront organizing footage can save time later on because many NLEs link rather than import files. If you move (or even rename) a linked clip on your computer, the program can no longer access it.

DIGITAL EDITING SOFTWARE

NLEs or non-linear editing software programs range from consumer-friendly packages such as iMovie and tablet apps to robust professional programs such as Final Cut Pro and Adobe Premiere Pro. Professional versions add sophistication with settings that allow more nuanced manipulation of sound, color, and transitions. Online sites can help you learn how to use these programs; just consider your knowledge against your deadlines. And before purchasing any software, confirm its compatibility with your computer's operating system.

DIGITAL EDITING HARDWARE

It's best to use a powerful computer for video editing. While cloud-based computing is becoming more common, at the time of this writing, it is not the norm in video editing. A high-quality graphics card will allow for faster playback and video rendering. This is especially important when working with HD footage.

3. Prepare settings for NLE program
 Sequence is the term many programs use to refer to a set of clips that are arranged on a timeline. You can have multiple sequences in a file. Each sequence has settings that define size, aspect ratio, and frame rate. It's best to match the settings of your main footage. Avoid enlarging clips since this reduces picture quality.

4. Import footage takes into NLE
 While it may be tempting to import all clips into the software (regardless of whether or not they will be used), this will be cumbersome and could even corrupt the project file. Import only what you plan to use.

5. Mark ins and outs
 Play each clip (this is also referred to as **scrubbing**) in the program's source monitor. While scrubbing, define which portion of the footage will be included in the sequence by marking an "in point," where the clip will begin, and an "out point" where it will end.

6. Add footage to the timeline
 Add the clip to a layer on the timeline. The relationship from one clip to the next can be marked by either abrupt transitions, known as **cuts,** or with soft transitions, such as in dissolves and fades. Using multiple layers on the timeline allows for the overlapping of footage, which will give you more transition options later on in editing. If footage overlaps, the footage on the highest layer is what is typically seen by viewers.

 A common editing practice is **continuity editing**, which aims to make space and time appear continuous from one scene to the next. Any break in continuity is considered **discontinuity.** Intentional discontinuity can suggest contrast or growing tension. For instance, **jump cuts** purposefully introduce stark discontinuity between shots, (e.g., someone walking followed by a shot of them sitting), while **intercutting** is cutting between two or more events that are occurring at the same time, which can be used to develop two plot lines or ideas at once.

 Unintentional discontinuity, on the other hand, can seem unprofessional and can even be jarring to audiences. To disguise unintended discontinuity, editors use subtle cuts to conceal changes between the clips.

 The pacing of the cuts themselves can move the story. Action sequences may have up to 20 cuts per minute, but dialogue scenes may only have six.[9]

Murch's Rule of Six.[10]

1. Would support the emotion of the

3. Is at an interesting moment.
4. Encourages attention on the right aspects of the story.
5. Respects two-dimensional continuity
 (i.e., does not change the height or position of the subject).
6. Respects three-dimensional continuity
 (i.e., maintains the location of subjects in space (X, Y, Z coordinates)

Murch asserted that the first three rules are more important than the latter, positing that if the first three are satisfied, the audience would be largely unaware of issues in the last three.

7. Develop rough cut

A **rough cut** is the first assembled version of the video. All footage is present and in order, yet subtle refinements such as transitions and titles are not yet complete. Rough cuts are a great tool for getting formative feedback because they allow others to review the overall story and pacing, but you haven't yet invested much time in making fine edits. Ergo, making changes won't be too painful.

8. Edit audio

Most videos are comprised of a combination of voice-over narration, voiced clips (sometimes known as talking heads), and musical scores. Even if these are high-quality audio files, they may still require some editing. For one, you may need to adjust sound levels. In NLE software, you can change an entire clip's audio or just a portion of it with using keyframes. Also, aim for a consistent sound level across clips. Once an appropriate level is determined, adjust all other clips to be at a similar level. Keep in mind though that it's difficult (if not impossible) to increase the volume of a relatively quiet clip. Not only are you raising the volume of the clip's dialogue, but you are inadvertently increasing the level of white noise as well. Hence, you end up with a staticky sounding clip. In addition to volume adjustments, you may need to fade in or fade out tracks with gains and **crossfades.**

Scoring your video is often critical to conveying your desired tone. Well-selected scores are well-paced, following a rhythm similar to the video's footage. The score should also work alongside the other audio components rather than overwhelming them, so make sure that there is enough contrast between background music and dialogue. Music can be purchased from online repositories, and these too should be cleared for copyright and royalty issues.

9. Add titles

There are several types of titles which may be incorporated into your video. **Supers** are superimposed over an image. It's best only to superimpose titles over footage with little movement; this can help eliminate contrast issues between the text and the background footage, as well as reduce the potential to conceal footage inadvertently.

Head credits are at the beginning of the video; a **credit roll** is at the end. Horizontally moving text (often seen at the bottom of cable newscasts) is considered **crawling**, while vertically moving text is considered **scrolling**. **Lower thirds** are often used to show a person's name and title at the bottom of the screen. If you plan on using lower thirds, it is a good idea to plan for this during filming by allowing for some extra space at the bottom of the screen.

Timing is critical. Slow moving titles are dull. At the same time, viewers can get frustrated if they cannot finish reading the text before it disappears. When setting the timing for titles, remember that viewers are often reading the text for the first time, and it may need to run a little slower than you'd initially expect. To improve comprehension, limit text to short lines, and consider making use of progressive disclosure so that viewers have access to what they need, just when they need it. Finally, aim to avoid small and hard-to-read fonts. Together, these strategies will help ensure your viewers comprehend on-screen titles.

10. Develop a Fine Cut

The fine cut is the refined version of the video. This iteration includes titles and all transitions between clips. When determining how to transition between clips, common options include:

TYPES OF TRANSITIONS

A straight cut is a simple transition from one clip to another.

A fade can punctuate a scene by gradually turning into a solid color.

A dissolve serves as a bridge between ideas since one clip dissolves into the other.

There are many types of transitions available. Some feature 3D motion or jarring movements such as wipes, and iris rounds. Keep in mind though that these can distract viewers from the story at hand. Consider refraining from complicated transitions and aim to use only two to three transition types.

11. Screening

Many film directors find it invaluable to have their films screened to small audiences before releasing them. Some choose to do this early in the process, while others prefer to wait until all technical issues are resolved. At whatever point you opt to screen your video, during the screening itself, avoid focusing on the video (chances are you have seen it many times anyway). Instead, watch the reaction of the audience, which can be quite telling. Look to see if they chuckle or tear up when you'd expect and try to catch their facial expressions at critical points.

Be prepared to receive feedback or **notes.** Given a myriad of opinions (some of which may be unclear or conflicting), some feedback may seem harsh. If needed, have someone calibrate comments to filter for only the useful information. Following a poorly received opening for her musical *Movin Out*, Twyla Tharp had her son read newspaper reviews and share only those that provided actionable feedback.[11] Remember that everyone receives negative feedback from time to time, but strive to act upon any trends in the comments. Over time, and with experience, skilled designers can distinguish critiques of work from personal condemnation. Also, consider your own emotional reaction to sharing your work; if you have strong misgivings about screening the video, chances are it's not yet ready.

12. Exporting & Disseminating

Exporting videos was once a complicated process. Today, however, many editing programs have presets designed for specific uses and you can select which website or device you intend to use. Depending on your video's length and target audience, you may choose to disseminate it in multiple ways.

Currently, a popular method is to post videos on online repositories (such as YouTube or Vimeo). These sites allow for videos to be deemed either public or private. Public videos are discoverable by anyone using the site (and on external search engines), whereas a video flagged as private can be accessed only via a unique link. Social media sites are also providing platforms for circulating videos by sharing links or posting clips. You can also opt to share a video during a meeting or even ship physical copies for distribution. The key is to consider how your audience might best approach and access your message.

LESSONS FROM AN EXPERT EDITOR

Famed film editor, Walter Murch observed that good editors should:[12]

Always be aware of both the micro and macro story.
To paraphrase an old adage, while a bricklayer is aware of the importance of each brick, they should not lose sight of the resulting cathedral. So too, an editor should examine details, looking for consistency and quality, but never at the expense of the overall vision for the story.

Feel freed from the creation.
A difficult shot may have been a triumph over adversity, and even beautiful in its own right. However, if it does not support the message or trigger the desired emotions from the audience, it shouldn't "make the cut" into the final video.

Remain aware and look for possibilities.
When editing, there may be unforeseen potential in the footage, which may deviate from your storyboard, but it is important to acknowledge these opportunities. However, use restraint when editing and remember your goals for the audience.

Annette Tully is a marketing consultant & video producer. Annette bridges strategy, creative, and process to produce stories her clients can be proud of, inside their organizations and around the world.

STORYTELLING IN PRACTICE

How do you use video to share a unique point of view?

While working for an architecture and design firm, a design team brought me on board to help them respond to an RFP. They were going after design work to renovate key areas of a football stadium that fans use. So seeing and experiencing these areas from a fan's point of view was critical for us, in addition to hearing what they have to say about those areas and their beloved team. So, with the client's full support, we were given full access to the stadium during the last home game of the season. With one amazing camera person by my side, we spent the entire day talking to fans and filming their activities. These fans are a bit...infamous, with the media choosing to focus more on their fighting spirit. From tailgating to entering the stadium, to experiencing the clubhouse, to being on the actual field itself, we captured the fans' passion, their feelings of community, and the love of their team and the sport. It was amazing. Because we were a team of two (I was writer/director/producer and he was camera/sound/editor), we were able to turn around our 3-minute piece quickly so the design team could use it in the interview for the project. The design team was incredibly talented in their own right and did an amazing job on the proposal and at the interview. But sharing the video in the interview to literally SHOW the client how well our team understood their fans and what they crave in a stadium and sports experience, well, that sealed the deal. The design team won the work!

AUTHOR'S NOTES Time for a Gut Check

Is video the best way to share your story?

Before deciding whether or not to create a video for your design story, you should reflect on the pros and cons of what can be a surprisingly time-consuming endeavor. Both my experience in teaching a class firmly entrenched in video, as well as my research on viewer perceptions of design-orientated videos, has revealed the following:

Pros

Videos hold several storytelling advantages over other media.
For one, the multi-sensory experiences made possible by videos give them an uncanny ability to transport audiences and sway their emotions; this can be an especially potent force when pathos appeals most affect your audience.

Videos provide the ability to connect with others across time and space.
Online videos are viewable from anywhere at any time.

Video can provide a unique platform to highlight sought-after qualities.
When presenting yourself as a candidate for a job or project, evidence suggests reviewers look for soft skills such as character, trustworthiness, grit, and the ability to work well with others. Since these qualities can be difficult to showcase in traditional application materials, video can provide a unique platform to communicate desirable traits.

Cons

Many unintended messages can be sent via video.
Subliminal messages can stem from a video's subtext, such as its settings, context, props, lighting, and sound, to the gestures, voices, and mannerisms of on-screen talent. Or viewers may judge a message by the quality of the video itself. These signals can be difficult to predict, though they may elicit visceral reactions and sometimes snap judgments. This means that designers working in video media have more decisions to make and their decisions can have unintended consequences that may remain unknown since feedback opportunities are rare.

Audiences have short attention spans.
Chances are you won't be dealing with a captive audience — which is good for them, but bad for you; this means you'll need to consider how to gain and maintain their attention.

Video production can be a great deal of work.
⬚⬚⬚⬚⬚⬚⬚⬚⬚⬚⬚⬚⬚⬚⬚⬚⬚⬚⬚⬚⬚⬚⬚⬚⬚ the kind the prompt the audience change you are ⬚⬚⬚⬚⬚⬚⬚re difficult to make. This chapter only provides an overview of the many factors and decisions that go into making a persuasive video. Moreover, if you are going to be on-screen, this takes a bit of tenacity, since you'll likely be hearing and seeing yourself many times when editing. However, your grit may pay off if you can connect with your audience.

EXERCISE 9.3 EVALUATING PRECEDENT VIDEOS IN DESIGN

Design-orientated videos are becoming more commonplace. Today, many designers and firms have their own YouTube or Vimeo channels and post videos on their websites and social media. Watching these videos may help you understand the potential of video for sharing your design stories.

Locate 8–10 online videos produced by professionals in from your design field.

Determine which aspects are successful and unsuccessful, such as pacing, audio, or story structure. List any themes from your evaluation.

Share 2–3 of these videos with others without sharing your assessments. Do they evaluate the videos in the same way?

Retain links to any videos that received favorable evaluations and refer to them when making your own video.

SUMMARY

Video can be an especially powerful means of telling a design story. Their vividness and multi-sensory appeal can be captivating. Moreover, online videos can help designers reach audiences across the world and at any time of day. And evidence suggests that videos are increasingly utilized in design. However, they are often more work than is realized. To create a persuasive video, the designer will need to have a clear idea of who their target audiences is, and how to best reach them; this requires many decisions and technical strategies. However, if mastered, the outcomes can prove invaluable.

The tasks involved in video production can be categorized into three stages: pre-production, production, and post-production.

Pre-Production

Thoughtful planning during pre-production can save time and expense later on. The most important decisions occur early in the process. First, consider the video's logline, or central message – all subsequent decisions will support the logline. Then determine the intended tone, or overall feel for the video. The tone should align the audience to the message. Next, decide if live-action footage or motion graphics will best suit the desired tone. Live action can be more authentic, but you'll have more control over the aesthetics in motion graphics. The video's structure can be either linear or non-linear. Linear is more familiar to viewers, though a non-linear structure adds the element of choice by letting viewers decide how they will navigate through the story. Regardless of your method, it will often take multiple iterations to develop a script that is both conversational and well-paced. If shooting a live-action video, there are many considerations when scouting your locations, such as permissions, lighting, consistency, and tactics to help maximize the video's lifespan. Be sure to determine camera angles as well as strategies for lighting and audio recording prior to filming; this will help to ensure you have packed the right equipment on filming day.

Production

Production involves filming or generating assets. You'll also want to record any necessary voice-overs, obtain music, and secure any other necessary materials. If you are creating motion graphics, consider how to help viewers create an accurate mental map of the information by leveraging tactics of visual hierarchy, change, and timing.

Post-Production

While editing can be a great deal of work, think of it as where the story comes to life since you're deciding on the video's final structure, dynamics, timing, and transitions. Finally, don't be afraid to ask for feedback since it can significantly improve the quality of your design story.

TERMS

- ad-libbing
- assets
- b-roll
- boom
- cinevate slider
- clip

- clips
- compression
- continuity editing
- crawling
- credit roll
- crossfade
- cut(s)
- directional mic
- discontinuity

- dolly
- frame
- framerate
- golden hour
- head credits
- inbetweening
- intercutting
- jib arm
- jump cuts

APPLICATION 9.0

To create a video for your design story, consider the following:

1 Determine your video's logline. Remember to think back to your themes from Chapter 3. Then place your protagonist within the theme by stating their goals, the conflict at hand, as well as the stakes of the issue. Keep the logline brief but powerful.

2 Determine the video's tone, keeping in mind that the tone should align your audience, your values, and to your message.

3 Based on your desired tone, determine if live action or motion graphics would be more appropriate.

4 Determine if your story is best suited for a linear or non-linear story. Based on your decision, craft a video storyboard, noting what the viewer will be seeing and hearing at each critical juncture.

5 Write your script. Bear in mind, that it should be conversational and paced to align with your intended visuals. Be sure to get feedback from others and, if you'll have others speaking on-screen, do a table read.

6 If you're filming live-action shots, determine the best filming locations. Be sure to visit these sites at the same time of day that you will be filming, and take your camera. While there, shoot some footage to uncover any potential issues. Also, determine appropriate camera locations and angles. Note any equipment you'll need for filming day (including props and equipment).

If you're creating motion graphics, generate your artwork using the tactics of visual hierarchy, change, and timing. Use keyframing in a compositing program to add motion.

7 If you plan to score your video, be sure to find an audio file prior to editing. If your video will go on the web, you must seek the appropriate permissions to use it. When in doubt, use royalty-free files.

8 After you have obtained your footage, use the Editing Steps to edit your video.

9 Be sure to screen your video, acknowledging that not all of comments will be positive. However, strive to address any trends in the critiques so that you can improve the video.

key framing	notes	table read
lavalier mic	pre-production	talent
linear sequence	production	timeline
live-action	post-production	tone
logline	rough cut	voiceover
lower thirds	score	
motion graphics	scrolling	
NLEs	scrubbing	
non-linear sequence	supers	

APPENDIX A
PHOTOGRAPHY TERMS

Photographers often refer to three terms they call the Three Pillars of Photography. Understanding these ideas will give you far greater flexibility when generating your own images.

SHUTTER SPEED

Refers to the length of time that a camera's shutter stays open to detect light. This length of time is measured in fractions of a second. Short shutter speeds stop motion, while longer camera speeds blur motion.

Less Light ⟷ More Light

| 1/2000 | 1/1000 | 1/100 | 1/60 | 1/2 |

fraction of a second

ISO

Refers to the camera's level of sensitivity to available light. Higher sensitivity settings allow you to capture images in low-light conditions, but they may lead to more "noise" in the image.

Bright ⟷ Dim

| 100 | 200 | 400 | 800 | 1600 |

more noise

APERTURE

Refers to how wide the camera's lens is opened, which is measured in F-stops. Aperture settings control the depth of field in your image. A small f-stop number indicates a large aperture opening, with a short the depth of field, thus more of the background is blurred.

lens opening

| f/1.4 | f/1.2 | f/2.8 | f/5.6 | f/22 |

APPENDIX B
ADDITIONAL DIAGRAMS

MAGNITUDE

Doughnut
An open pie chart

33%

Modified Tree
A relatively modern approach for displaying magnitude

20
66
10
104

Concentric
Can be used to emphasize a smaller value

5%
10%
33%
52%

STAKEHOLDER

EMPLOYEE ACTIVITIES
collaborate
learn
focus
play

Stack Icon
Icons can be used to represent the people performing the tasks

collaborate
focus
EMPLOYEE ACTIVITIES
play
learn

Modified Matrix
Magnitude can be depicted by changing the scale of the text.

APPENDIX C
IMAGE FILE TYPES

There are a range of graphic and image file types that can be used in visual story props. Keep in mind, that higher-quality images result in larger file sizes.

UNCOMPRESSED
high quality, large file size

EPS
Encapsulated Post Script
— Vector-based graphic file, typically created in Adobe Illustrator.

TIFF
Tagged Image File Format
— Raster-based graphic file with a larger file size and higher resolution. Due to their high quality, TIFFs are frequently used in the print industry.

SVG
Scalable Vector Graphics
— Vector-based graphic file that is often used in web graphics and animations.

RAW
sometimes referred to as digital negatives
— An uncompressed image format that is essentially what the camera sees. Those using DSLR or mirrorless cameras often shoot photos in RAW formats due to their high quality and greater post-processing (editing) options.

COMPRESSED
reduced quality, smaller file size

JPEG
Joint Photographic Experts Group
— A very common, raster-based graphic file that uses a "lossy" compression which can result in a small loss of detail.

GIF
Graphics Interchange Format
— A raster-based lossless file format that supports both animated and static images, but interprets a small range of colors.

PNG
Portable Network Graphics
— A raster-based lossless file that is often used for web-formats. It contains an alpha channel allowing for a transparent background in both print or web viewing.

PDF
Portable Document Format
— A very common method of sharing files since the person receiving the file doesn't need to have the document's fonts installed on their computer or mobile device. Depending on where it was created, a PDF can be either vector- or raster-based. A PDF file is viewable on Adobe Acrobat (and compatible programs). The files can include interactive features such as hyperlinks, videos, and buttons.

BMP
Bitmap image file
— Raster-based uncompressed file. It is an older format, resulting in a larger file size, and is becoming less common.

APPENDIX D
VIDEO FILE TYPES

Higher-quality videos will result in larger file sizes.

3GPP	A multimedia format created primarily for viewing videos on mobile devices.
AVI Audio Video Interleave	An older, but still common file format which is universally accepted by most devices. AVI files are typically larger than other video formats.
FLV Flash Video File	A file that plays on an Adobe Flash enabled device. In the past, some video sharing websites did not support FLV files.
GIF *see Image File Type Appendix*	
MOV MPEG 4 for Apple Quicktime	The MOV file format was primarily designed and developed for Apple computers. In the past, some video sharing websites did not support MOV files.
MP4 MPEG-4	Similar to a MOV, but developed later, an MP4 can be played on either PCs or MACs. The format is supported by most video sharing websites and is often considered an industry standard.
WMV Windows Media Video	Designed for PCs, WMV formats result in a small file size, but a lower-quality video.

APPENDIX E
AUDIO FILE TYPES

WAV Waveform Audio File	A common format for high-quality, uncompressed audio tracks. WAV formats typically result in a large file size.
AIFF Audio Interchange File	A file format for high-quality uncompresssed tracks. AIFF formats typically result in a large file size.
MP3 MPEG Audio	A popular format for compressed, smaller sized files.
M4A MPEG 4 Audio	A compressed file format used by Apple iTunes and some voice memo programs. An M4A file can be played on a variety of platforms, though they are not always supported by video editing programs.

It is important to confirm that your editing software will support the file type you select.

APPENDIX F
GOOD READS ON STORY CRAFTING & DELIVERY

Contagious: *Why Things Catch On*
by Jonah Berger
Simon & Schuster

Give Your Speech, Change the World
How to Move Your Audience to Action
by Nick Morgan
Random House

If I Understood You, Would I Have This Look on My Face?
My Adventures in the Art and Science of Relating & Communicating
by Alan Alda
Harvard Business School Press

Made to Stick: *Why Some Ideas Survive and Others Die*
by Dan & Chip Heath
Random House

Presentation Zen: *Simple Ideas on Presentation Design and Delivery*
by Garr Reynolds
New Riders

Resonate: *Present Visual Stories that Transform Audiences*
by Nancy Duarte
John Wiley & Sons, Inc.

The Story Factor:
Inspiration, Influence, and Persuasion Through the Art of Storytelling
by Annette Simmons
Basic Books

The Storytellers Secret: *From TED Speakers to Business Legends, Why Some Ideas Catch on and Others Don't*
by Carmine Gallo
St. Martin's Press

Talk Like TED: *The 9 Public Speaking Secrets of the World's Top Minds*
by Carmine Gallo
St. Martin's Press

Thank You for Arguing: *What Aristotle, Lincoln, and Homer Simpson Can Teach Us About the Art of Persuasion*
by Jay Heinrichs

Winning the Story Wars
by Jonah Sachs
Harvard Business School Publishing

Wired for Story: *A Writer's Guide to Using Brain Science to Hook Readers from the Very First Sentence*
by Lisa Cron
Ten Speed Press

APPENDIX G
GOOD READS ON INFORMATION DESIGN

Beautiful Evidence
by Edward R. Tufte
Graphics Press

Information is Beautiful
by David McCandless
William Collins

Envisioning Information
by Edward R. Tufte
Graphics Press

Storytelling with Data
by Cole Nussbaumer Knaflic
John Wiley & Sons, Inc.

The Visual Display of Quantitative Information
by Edward R. Tufte
Graphics Press

Visual Explanations: *Images and Quantities, Evidence and Narrative*
by Edward R. Tufte
Graphics Press

APPENDIX H
GOOD READS ON STORY PROPS & VISUAL MESSAGES

COLOR

Color: *Messages & Meanings*
by Leatrice Eiseman
Handbooks Press

Foundations of Color
by Jeff Davis
Tempe Digital

Interaction of Color
by Josef Albers
Yale University Press

COMPOSITION & TYPOGRAPHY

Basics Design 01: *Book Series*
by Gavin Ambrose & Paul Harris
AVA Publishing

Grid Systems in Graphic Design
by Josef Müller-Brockman
Braun Publish, Csi

Graphic Design: *The New Basics*
by E. Lupton & J. C. Phillips
Princeton Architectural Press

Making & Breaking the Grid
by Timothy Samara
Rockport Publishers, Inc.

Thinking with Type
by Ellen Lupton
Princeton Architectural Press

MODEL BUILDING

3D Design Basics *Book Three*
by Donna L Fullmer
Fairchild/Bloomsbury

Design with Models
by Criss Mills
John Wiley & Sons

APPENDIX H, CON'T.
GOOD READS ON STORY PROPS & VISUAL MESSAGES

SKETCHING

Dinner for Architects
by Winfried Nerdinger
Big River Books

Sketching at the Speed of Thought
by Jim Dawkins & Jill Pable
Bloomsbury/Fairchild

VISUAL MESSAGING & THINKING

The Art of Looking Sideways
by Alan Fletcher
Phaidon

The Back of the Napkin: *Solving Problems and Selling Ideas with Pictures*
by Dan Roam
Portfolio/Penguin

Blah, Blah, Blah: *What to Do When Words Don't Work*
by Dan Roam
Portfolio/Penguin

Design As Art
by Bruno Munari
Penguin Global

Exercises in Visual Thinking
by Ralph E. Wileman
Hastings House

Relational Aesthetics
by Nicolas Bourriaud
Les Presse Du reel

Semiotics: *The Basics*
by Daniel Chandler
Routledge

Visible Signs: *An Introduction to Semiotics in the Visual Arts*
by David Crow
AVA Publishing

Ways of Seeing: *Based on the BBC Television Series*
by John Berger
Penguin Books

APPENDIX I
GOOD READS ON DESIGN PROCESS & FOCUS

100 Things Every Designer Needs to Know About People
by Susan Weinschenk
New Riders

The Design of Everyday Things
by Don Norman
Basic Books

Lateral Thinking: *A Textbook on Creativity*
by Edward de Bono
Penguin

The Process: *A New Foundation in Art and Design*
by Judith & Richard Wilde
Laurence King Publishing

Thoughts on Design
by Paul Rand
Chronicle Books

**How To Use Graphic Design to
Sell Things, Explain Things, Make Things Look Better, Make People Laugh,
Make People Cry, and (Every Once in a While) Change the World**
by Michael Bierut
Tempe Digital

Universal Principals of Design
by W. Lidwell, K. Holden, & J. Butler
Rockport Publishers

APPENDIX J
ADVANCED TOPICS

Bettman, J.R., & Kakkar, J. (1977). Effects of information presentation format on consumer information acquisition strategies. *Journal of Consumer Research 3*(4), 233–240.

Underpinnings
This article examines various types of information processing to study the effect of presentation format on consumers' information acquisition strategies.

Findings
Authors present findings from two studies. The first varied information presentation formats, and the second varied structure of information. Findings suggested the consumers seem to process information in the manner they find easiest.

Mayer, R. E. (2001). *Multimedia learning.* Cambridge, MA: Cambridge University Press.

Summary
While the book is intended for multi-media instructional designers, it provides helpful (and empirically tested) insights into information processing and communication constructs including: Coherence, Signaling, Redundancy, Spatial Contiguity Principle, Temporal Contiguity Principle, Segmenting Principle, Pre-training principle, Modality Principle, Multimedia Principle, Personalization Principle, Voice Principle, Image Principle.

Morton, J. (2006). The integration of images into architecture presentations: A semiotic analysis. *Art, Design, and Communication in Higher Education.* 5(1), 21–37.

Underpinnings
This article focuses on the role of visual communication within an architectural presentation.

Methods
A set of analytical techniques drawn from linguistics was used to investigate ten first-year architecture student presentations in an effort to understand the role of images and how novice students integrated images, words, and actions into a unified presentation.

The analysis had three foci: the conventions of discrete images; the composition of concurrently displayed images; and the relationship between the speakers and their images. The article also distinguishes successful from unsuccessful presentations.

Townsend, C., & Kahn, B. E. (2014). The "visual preference heuristic": The influence of visual versus verbal depiction on assortment processing, perceived variety, and choice overload. *Journal Of Consumer Research, 40*(5), 993–1015. doi:10.1086/673521

Underpinnings
The "visual preference heuristic" posits that consumers prefer visual to verbal (i.e. written) depictions of information. While images are assumed to be more pleasing, it is thought that they can result in information overload when choice sets (i.e., the information presented) are large and consumer preferences are unknown.

Methods
The authors compared Gestalt processing (i.e., processing information as a whole) vs. Piecemeal processing (i.e., sequential processing) of information using eye tracking software in five experimental studies.

Findings
Findings suggest that Gestalt processing of visual stimuli, facilitates faster, though more haphazard scanning of information. Thus, while processing information from visual presentation feels easier, it is not ideal for larger assortments of data. Consequently, the authors suggest that the preference for visual depictions may be over-applied.

APPENDIX K
STORYTELLING RESOURCES

There are many communities of storytellers that can provide you with inspiration, resources, and learning opportunities. Below is a sampling:

International Storytelling Center
Facility devoted solely to the tradition of storytelling.
Jonesborough, TN
http://www.storytellingcenter.net/experience/about-isc/

Future of Storytelling® (FoST)
Produces a *wide range of content and programming geared toward shaping the future of storytelling.*
https://futureofstorytelling.org/about

Illinois Storytelling Inc.
An organization *committed to increasing public awareness of the art, practice, and value of oral storytelling.*
http://storytelling.org/index.html

Narativ
Mission: *To take listening and storytelling as far as it can go* by merging it with new technologies while still appreciating the human quest to share experiences & insights.
http://narativ.com/

Radio Lab
A radio show about "curiosity," where stories that blur the lines between *science, philosophy, and the human experience* can be heard either by streaming online or on a local NPR station.
http://www.radiolab.org/about/

Story Corps
Mission: *To preserve and share humanity's stories in order to build connections between people and create a more just and compassionate world.*
https://storycorps.org/

Story District
Mission: *To turn good stories into great performances.*
http://storydistrict.org/about

Storytelling Association of California
An organization *dedicated to promoting storytelling as a living artform.*
http://www.storysaac.org/

TED
Mission: *To spread ideas.*
TED was initiated as a conference *where Technology, Entertainment, & Design converged.* Now covering an array of topics, speakers are usually on stage for 18–20 minutes and videos of their talks can be viewed free of charge.
https://www.ted.com/

The Storytelling Center of New York City
Mission: *To promote excellence in storytelling by providing opportunities to share resources, meet other storytellers, learn skills, and explore stories of enduring meaning.*
http://storytelling-nyc.org/index.html

Voices in the Glen
Mission: *To promote the art of storytelling and the enjoyment of stories.*
http://voicesintheglen.org/

APPENDIX L
EVENTS & FESTIVALS

It's likely that there is a storytelling festival near you. Below is a sampling of story-based events throughout the year; be sure to check local listings for details.

Florida Storytelling Festival
Spring, Florida
http://flstory.com/festival/

FoST Festival
Fall, New York
https://futureofstorytelling.org/fest

Georgia Mountain Storytelling Festival
Spring, Georgia
https://www.gamountainstoryfest.org/projects/

National Storytelling Festival
Fall, International Storytelling Center, Tennessee
http://www.storytellingcenter.net/festival/

Rocky Mountain Storytelling Conference
Spring, Colorado
http://rmstory.org/conference/overview/

Sarah Hauser Festival of Stories
Summer, Oregon
http://www.portlandstorytellers.org/festival-stories/

Sierra Storytelling Festival
Summer, California
http://sierrastorytellingfestival.org/

St. Louis Storytelling Festival
Spring, Missouri
http://extension.missouri.edu/storytelling

Southern Ohio Storytelling Festival
Fall, Ohio
http://www.sostoryfest.com/

Teton Storytelling and Arts Festical
Summer, Wyoming
http://tetonstorytelling.org/

Timpanogos Storytelling
Summer, Utah
http://timpfest.org/

Toronto Storytelling Festival
Spring, Ontario, Canada
http://torontostorytellingfestival.ca/2017/

University of Illinois iSchool Storytelling Festival
Spring, Illinois
https://ischool.illinois.edu/events/2017/04/15/storytelling-festival

GLOSSARY

A

Ad-libbing

Additive making
a method of model building in which items are added and fastened until the desired

Anecdote

Affective primer
the process of manipulating the emotions of an audience before the message is

Antagonist

Appositives

Arbitrary Cues (or symbols)
signals that bear little physical resemblance to that which they represent (Chapter 6).

Assets
in videography, the term refers to clips, materials, or files that will be used within a

Attractiveness, soundness, & utility
qualities of design set forth by Roman architect Vitruvius (Chapter 6).

Audience segmentation
a technique of identifying and analyzing audience characteristics (Chapter 2).

Augmented reality
a communication method in which an image or design representation is superimposed

Authoritative arc
of a declarative sentence to reinforce credibility (Chapter 5).

B

Body copy
a term for the main body of text in a graphic composition (Chapter 6).

Boom
a long pole-like mic attachment used to position the mic close to the source of the

Brand identity

B-roll

C

Cast-in-place making

Causal reasoning
the process of identifying relationships between a cause and a corresponding ▮▮▮▮▮▮▮▮▮▮

Channel
▮▮▮▮▮ ▮▮▮▮▮▮▮▮▮▮▮▮ ▮▮▮▮▮▮▮▮▮▮▮▮ ▮▮▮ ▮▮▮▮▮▮▮▮ ▮ ▮▮▮▮▮▮▮▮▮▮▮

Cinevate slider
▮▮▮▮ ▮▮▮▮ ▮▮▮▮▮▮▮▮▮ ▮▮▮▮▮▮ ▮▮▮▮▮▮▮▮▮▮ ▮▮▮▮▮▮▮▮▮▮▮▮▮

Cliché
▮▮▮▮▮▮▮▮▮▮▮▮▮▮▮▮▮▮▮4.▮

Clip
▮▮▮▮▮▮▮▮▮ ▮▮▮▮▮▮▮ ▮▮▮▮▮▮▮▮▮▮▮▮▮▮

Clips
▮▮▮▮▮▮▮▮▮▮▮▮ ▮▮▮▮▮▮▮▮▮▮▮▮▮▮

CMYK
▮▮▮▮▮ ▮▮▮▮▮ ▮▮▮▮▮▮ ▮▮▮ ▮▮▮▮▮▮▮▮▮▮▮▮▮▮ ▮▮▮▮▮▮▮▮ ▮▮▮▮▮▮ ▮▮▮▮ ▮▮▮▮▮▮▮▮▮▮▮▮▮

Compositional cues
signals within a document's layout that help direct the eye and focus attention ▮▮▮▮▮▮▮▮▮

Compression
▮▮▮▮▮▮▮▮s of reducing file size by eliminating redundant information (Chapter 9).

Concept model
a physical representation of a design concept (Chapter 8).

Conflict
▮▮▮▮▮▮▮▮▮▮▮▮ ▮▮▮▮ ▮▮▮▮▮▮▮▮▮▮▮▮▮▮▮▮▮▮▮▮▮▮▮

Conjunction
▮▮▮ ▮▮▮▮▮▮▮▮▮▮▮▮▮▮▮ ▮▮▮▮▮▮▮▮▮▮▮▮▮▮▮▮▮▮▮▮▮▮▮▮▮▮▮▮▮▮▮▮▮ ▮▮▮▮▮▮4.▮

Contextual labels or labeling
labels that are positioned near the object to which they are describing (Chapter 6).

Continuity editing
editing a video to make time and space continuous from one scene to the next ▮▮▮▮▮▮▮▮▮

Copy
a term for the text within a graphic composition (Chapter 6).

Crawling or crawler
text moving horizontally across the screen (Chapter 9).

Credit roll
list of names acknowledging contributors at the end of a film or video (Chapter 9).

Crossfade
▮▮▮▮▮▮▮▮▮▮▮ ▮▮▮▮▮▮▮▮▮▮▮▮▮▮▮▮▮▮▮▮▮▮▮▮

Cut(s)
a filmmaking term used to refer to individual clips within a video (Chapter 9).

D

Data
descriptive or statistical information (Chapter 8).

Demographics
background information about a group of people (Chapter 2).

Directional mic
a microphone that picks up incoming sound from a specific direction (Chapter 9).

Discontinuity
a filmmaking term that refers to differences in clips (Chapter 9).

Display type
attention (Chapter 6).

Dolly
on wheels that allows the camera to move while filming (Chapter 9).

Dry media

E

Elevator pitch

Euphemism
a mild (and often more congenial) word substituted for a harsh term or phrase

Exploded view

F

Firmographics
background information about a business, firm, or company (Chapter 2).

Font
of characters in a particular style of type (Chapter 6).

Form model
representation of objects and/or massing (Chapter 8).

Framerate

Frame
a term that can be used to refer to a scene's composition (Chapter 9).

G

GIFs (Graphic Interchange Format)
a digital file format comprised of bitmap images, often used for short animations on

Glyph
an individual character of a font, such as a letter, number, or dingbat symbol (Ch. 6).

Golden hour, or magic hour
tography terms describing the period of time just after sunrise and just before sunset when the quality of light is warmer and softer than normal (Chapter 9).

H

Haptic
relating to the sense of touch and/or manipulation of objects (Chapter 8).

Head credits
opening titles before a film or video begins (Chapter 9).

Hedging
a term used to describe the qualifying of a term with conditions or exceptions (Chapter 4).

Heuristics
an approach to information processing that utilizes mental shortcuts (Chapter 7).

Hyperbole
an exaggeration of a statement or description (Chapter 4).

I

Idiom
a phrase or expression which has a different meaning than its words, such as "it's raining cats and dogs" (Chapter 4).

Inbetweening
a term used in motion graphics to describe the frames between the starting and ending position of an object that give it the appearance of smooth movement (Chapter 9).

Interactive Media
a method of communication that responds to a viewer's actions (Chapter 7).

Intercutting
a term in video editing that refers to cutting back and forth between scenes (Chapter 9).

Isometric
a method of drawing in which an object is illustrated from a three-dimensional perspective (Chapter 6).

J

Jargon
specialized or technical terms used by members of a specific group (Chapter 4).

Jib arm
a device that holds a camera, allowing it to move smoothly while filming (Chapter 9).

Jump cuts
giving the illusion of time progression in a film or video by cutting from one clip to another and changing the camera's position (Chapter 9).

K

Kerning
the horizontal spacing between two glyphs (Chapter 6).

Key framing
an animation term that describes the process of defining the beginning and ending position of an object in terms of time, form, color, etc. (Chapter 9).

L

Lavalier mic, or lapel mic

Leading
vertical spacing between lines of text (Chapter 6).

Linear sequence
when a video follows a start-to-finish story sequence (Chapter 9).

Live-action
a filmmaking term that describes the filming of real people, animals, or environments as opposed to animation (Chapter 9).

Logline
a term in filmmaking used to describe a one sentence summary that conveys the

Longitudinal
research the term refers to information collected over a period of time (Chapter 7).

Lower thirds
a graphic overlay located at the bottom of the screen which displays an individual's name and title (Chapter 9).

M

Maquette

Marker
a tag, such as a QR code, which is used to trigger augmented reality depictions

Maslow's Hierarchy of Needs
theory of human motivation, asserting that basic needs must be met before one can attain self-actualization (Chapter 1).

Modifier
a word or phrase that qualifies or describes another (Chapter 4).

Motion graphics
a filmmaking term that refers to using animated digital footage in storytelling

Multivariate
information invo

N

Negative space, or white space
empty space in a graphic composition, which often surrounds important objects

NLEs
a filmmaking term to describe non-linear digital editing systems in which the original

Noise
a term used by Shannon and Weaver to describe potential distractions keeping the receiver from getting an accurate message (Chapter 5).

Noise (graphic)
refers to irrelevant information, textures, or patterns in a composition (Chapter 6).

Non-linear sequence
when a story follows multiple plots or makes use of foreshadowing and flashbacks

Non-restrictive clauses
words or phrases that add non-essential information (Chapter 4).

Notes
a term filmmakers often use to describe feedback or critique (Chapter 9).

O

Open type
fonts which are designed to be compatible in both MAC and PC environments

Orthographic views
elevations, and sections (Chapter 8).

P

Parable
a short didactic story used to illustrate a moral (Chapter 5).

Parallel construction
constructing sentences to follow the same grammatical structure (Chapter 4).

Parallel projection
a method of drawing where objects are projected onto a fixed plane (Chapter 8).

Parti model
a physical representation of a design's basic schema or geometry (Chapter 8).

Picture Superiority Effect
a theory positing that information shared via images is more likely to be recalled than information expressed in words (Chapter 6).

Pitch

Post-production
the stage in filmmaking where footage is edited (Chapter 9).

Pre-production
the planning stages of filmmaking (Chapter 9).

Prior knowledge

Production
the stage in filmmaking when footage is filmed or content generated (Chapter 9).

Progressive disclosure
sharing aspects of information at predetermined times in order to maintain the attention of the audience (Chapter 1).

Protagonist

Prototype

222

Psychographics
psychological characteristics about an audience such as attitudes, aspirations, and values (Chapter 2).

Pull out text, or pull quote
an excerpt of text that has been pulled out from the body copy and emphasized with a larger or different font (Chapter 6).

Q

Qualifier(s)
a word that modifies the next word (Chapter 5).

Qualitative data
descriptive data typically in the form of words or descriptions (Chapter 7).

Quantitative data
measurable information such as statistics or counts (Chapter 7).

R

Raster
[illegible] when increased in size (Chapter 6).

Receiver
[illegible]

RGB
color management format style for web-based work (Red, Green, Blue) (Chapter 6).

Rough cut
a version of a film or video that begins to resemble the finished product, yet does not include refinements such as transitions (Chapter 9).

S

Score
a filmmaking term that refers to the soundtrack or background music, often written specifically for a film (Chapter 9).

Scrolling
a filmmaking term which refers to credits that move vertically on the screen [illegible].

Scrubbing
a term used in film editing to describe playing through footage while in an editing [illegible].

Section oblique
[illegible]

Section perspective
a perspective view that slices through an object (Chapter 8).

Semiotics
[illegible]

Sender
[illegible]

Sensory Cues (or symbols)
[illegible]

Speaker triggers
cues within a composition that are designed to help the speaker recall information

Stereoscopic
a virtual reality term used to describe two views positioned at slightly different

Study model
a quick model generated for self-study of spatial relationships (Chapter 8).

Subtractive making
a method of model building in which a larger form is cut and sculpted until only

Supers
a filmmaking term used to describe the superimposing of titles over video footage

Syntax

T

Table read
loud in the same manner they will during filming (Chapter 9).

Talent

Timeline
an area in video editing software that shows each clip's duration and its position

Tone

Tracking
the horizontal space between a string of glyphs which affects the appearance of

Typeface

V

Vector
images built via mathematical calculations which can be scaled up infinitely

Virtual reality
a communication technology in which a user wears a headset in order to be immersed within a different environment (Chapter 8).

Voiceover
a narration not accompanied by the image of the speaker (Chapter 9).

W

Wet media

ABOUT THE AUTHOR

Amy Huber, IDEC, LEED AP, CDT, NCIDQ

As an Assistant Professor at Florida State University, Huber teaches in the areas of Advanced Visual Communications, Technology, and Design Studios.

She has presented on the topic of Design Communications at both national and international venues such as NeoCON, the European Academy of Design, the International Conference on Communication & Media Strategies, and the International Interior Design Educators Council (IDEC). Her research has been published in the *Journal of Interior Design*, *International Journal of Architectural Research*, and *International Journal of Designs for Learning*.

As a practitioner, Huber was a Senior Designer with Gensler in Denver, Colorado. While there, she been recognized on state and national venues, including a 2014 AIA National Merit Award.

ideas in settings ranging from elevators to

Huber lives in Tallahassee, Florida, with her husband, Todd, and their son Ethan.

Photo courtesy of Christine Titus

REFERENCES

Chapter 1

[1] Duarte, N. (2010). *Resonate: Present visual stories that transform audiences.*

[2] Winning the story wars. Boston, MA: Harvard Business Review Press, p. 7.

[3] Contagious: Why things catch on.

[4] Winning the story wars. Boston, MA: Harvard Business Review Press., p. 60.

[5] Story smart: Using the science of story to persuade, influence, inspire, and teach. Santa Barbara, CA: Libraries Unlimited, p. 31.

[6] Tooby, J., & Cosmides, L. (2001). Does beauty build adapted minds? Toward an evolutionary theory of aesthetics, fiction, and the arts. *SubStance, 30*, 6–27. Retrieved from http://www.cep.ucsb.edu/papers/beauty01.pdf

[7] Ibid.

[8] Ibid.

[9] Gazzaniga, M. (2008). *Human: The science behind what makes us unique.*

[10] Emler, N. (1994). Gossip as moral talk. In R.F. Goodman & A. Ben-Ze'ev (Eds.), *Good gossip*. Lawrence, KS: University of Kansas.

[11] Ibid.

[12] Dunbar, R. (1998). *Grooming, gossip, and the evolution of language.* Cambridge, MA: Harvard University Press.

[13] Ayim, M. (1994). Gossip as moral talk. In R.F. Goodman & A. Ben-Ze'ev (Eds.), *Good Gossip*. Lawrence, KS: University of Kansas Press.

[14] Baumeister, R.F., Zhang, L., & Vohs, K.D. (2004). Gossip as cultural learning. *Review of General Psychology, 8*(2), 111-121. doi: 10.1037/1089-2680.8.2.111

[15] Gazzaniga, M. (2008). *Human: The science behind what makes us unique.*

[16] Ben-Ze'ev, A. (1994). The vindication of gossip. In R.F. Goodman & A. Ben-Ze'ev (Eds.), *Good Gossip* 11–24). Lawrence, KS: University of Kansas Press.

[17] The happiness hypothesis.

[18] Djikic, M., Oatley, K., Zoeterman, S., & Peterson, J. (2009). On being moved by art: How reading fiction transforms the self. *Creativity Research Journal, 21*. doi: 10.1080/10400410802633392

[19] Tamir, D., Bricker, A.B., Dodell-Feder, D., & Mitchell, J.P. (2016). Reading fiction and reading minds: The role of simulation in the default network. *Social Cognitive and Affective Neuroscience, 11*(2), 215–224. doi:10.1093/scan/nsv114

[20] Bal P.M., & Veltkamp, M. (2013). How does fiction reading influence empathy? An experimental investigation on the role of emotional transportation. *PLoS ONE 8*(1): e55341. https://doi.org/10.1371/journal.pone.0055341

[21] Mar, R. A., Oatley, K., & Peterson, J.B. (2010). Exploring the link between reading fiction and empathy: Ruling out individual differences and examining outcomes. *Communications, 34*.

[22] Kidd. D.C, & Castano, E. (2013). Reading literary fiction improves theory of mind. *Science, 342*, 377–380. doi: 10.1126/science.1239918

[23] Read, S.J. (1987). Constructing causal scenarios: A knowledge structure approach *Journal of Personality and Social Psychology, 2*.

[24] Trabassco, T. S., Secco, T., & van den Broek, P. (1982). Causal cohesion and story coherence. In H. Mandl, Stein, N.L., Trabassco, T.S. (Eds.), *Learning and comprehension of text*. York, NY: Laurence Erlbaum Associates.

[25] Cron, L. (2012). *Wired for story.* Berkley, CA: Ten Speed Press, p. 146.

[26] Ibid.

[27] Montague, R. (2006). *Your brain is (almost) perfect: How we make decisions.* New York, NY.: Plume.

[28] Speer, N.K., Reynolds, J.R., & Swallow, K.M., Zaks, J.M. (2009). Reading stories activates neural representations of visual and motor experiences. *Psychological Science, 20*.

[29] Zak, P. J. (2012, October). Empathy, neurochemistry, and the dramatic arc: Paul Zak at the future of storytelling. [Video File]. Retrieved from https://www.youtube.com/watch?v=q1a7tiA1Qzo

[30] Zak, P.J. (2014, October 28). Why your brain loves good storytelling. *Harvard Business Review*. Retrieved from https://hbr.org/2014/10/why-your-brain-loves-good-storytelling

Chapter 1 con't.

[30] Decety, J., & Gr'ezes, J. (1999). Neural mechanisms subserving the human perception of actions. *Trends in Cognitive Science, 3*.

[32] Sachs, J. (2012). *Winning the story wars.* Boston, MA: Harvard Business Review Press., p. 4.

[33] Haidt, J. (2006). *The happiness hypothesis.*

[34] Gazzaniga, M. (2008). *Human: The science behind what makes us unique.*

[35] Richter, T.A., Appel, M., & Calio, F. (2014). Stories can influence the self-concept. *Social Influence, 9*.

[36] Appel, M., & Richter, T. (2007). Persuasive effects of fictional narratives increase over time. *Media Psychology, 10*.

[37] Ibid., 114.

[38] Lewis, B. (2011). *Narrative psychiatry: How stories can shape clinical practice.* Baltimore, MD: John Hopkins University Press, p. vii.

[39] Sachs, J. (2012). *Winning the story wars.* Boston, MA: Harvard Business Review Press, p. 226.

[40] Ibid., 112.

[41] Ibid., 114.

[42] Ibid., 115.

[43] Maslow, A. H. (1943). A Theory of human motivation. *Psychological Review, 50*.

[44] Sachs, J. (2012). *Winning the story wars.* Boston, MA: Harvard Business Review Press, p. 98.

[45] Cron, L. (2012). *Wired for story.* Berkley, CA: Ten Speed Press, p. 142.

[46] Ibid., 2.

[47] Bal, P. M., Butterman, O.S., & Bakker, A.B. (2011). The influence of fictional narrative experience on work outcomes: A conceptual analysis and research model. *Review of General Psychology, 5*(4).

[48] Small, D. A., & Loewenstein, G. (2003). Helping a victim or helping the victim: Altruism and Identifiability. *The Journal of Risk and Uncertainty, 26*.

[49] Hutchens, L. (2014). *Story smart: Using the science of story to persuade, influence, inspire, and teach.* Santa Barbara, CA: Libraries Unlimited.

[50] Sachs, J. (2012). *Winning the story wars.* Boston, MA: Harvard Business Review Press., p. 190.

[51] Hutchens, L. (2014). *Story smart: Using the science of story to persuade, influence, inspire, and teach.* Santa Barbara, CA: Libraries Unlimited.

Chapter 2

[1] Lupton, E. (2011). *Graphic design thinking.* New York, NY: Princeton Architectural Press.

[2] Roam, D. (2008). *The back of the napkin.* New York, NY: Portfolio, p. 13.

[3] Murray, R. (2015, June 3). Heartbreaking video sends powerful message about organ donation. *Today.* Retrieved from http://www.today.com/health/viral-video-sends-powerful-message-about-organ-donation-t24461

[4] Truth/American Legacy Foundation. Catmageddon. [Video]. Retrieved from https://www.thetruth.com/articles/videos/catmageddon

[5] Duarte, N. (2010). *Resonate: Present visual stories that transform audiences.*

[6] Simmons, A. (2006). *The story factor.* Cambridge, MA: Basic Books, p. 3.

[7] Maslow, A.H. (1943). A Theory of human motivation. *Psychological Review, 50*.

[8] Olson, R. (2009). *Don't be such a scientist: Talking substance in the age of style.* Washington, DC.:Island Press.

[9] English, K. S., Sweetser, K.D., & Ancu, M. (2011). YouTube-ification of political talk: An examination of *American Behavioral Scientist, 55*.

[10] Smith, V. (2007). Aristotle's classical enthymeme and the visual, argumentation of the twenty-first *Argumentation and Advocacy, 34*.

[11] Demirdöğen, Ü. D. (2010). The roots of research in (political) persuasion: Ethos, pathos, logos and the Yale studies of persuasive communications. *International Journal of Social Inquiry, 3*.

[12] Scotto di Carlo, G. (2015). Ethos in TED talks: The role of credibility in popularized texts. *Lingiuistics and Literature, 81*.

Chapter 2 con't

[23] Demirdöğen, Ü. D. (2010). The roots of research in (political) persuasion: Ethos, pathos, logos and the Yale studies of persuasive communications. *International Journal of Social Inquiry, 3*.

[24] Petty, R. W., Wells, G.L., Brock, T.C. (1976). Distraction can enhance or reduce yielding to propaganda: Thought disruption verses effort justification. *Journal of Personality and Social Psychology, 34*.

[25] Lounsbury, M., & Glynn, M.A. (2001). Cultural entrepreneurship: Stories, legitimacy, and the acquisition. *Strategic Management Journal, 22*.

[26] Bronstein, J. (2013). Like me! Analyzing the 2012 presidential candidates' Facebook pages. *Online Information Review, 37*.

[27] Holt, R. & Macpherson, A. (2010). Sensemaking, rhetoric and the socially competent entrepreneur. *International Small Business Journal, 28*.

[28] Bronstein, J. (2013). Like me! Analyzing the 2012 presidential candidates' Facebook pages. *Online Information Review, 37*.

[29] Scotto di Carlo, G. (2014). The role of proximity in online popularizations: The case of TED Talks. *Discourse Studies, 16*.

[20] Berger, J. & Milkman, K. (2012). What makes online content viral? *Journal of Marketing Research, 49*.

[21] Berger, J. (2013). *Contagious: Why things catch on.*

[22] Donovan, J. (2014). *Give your speech and change the world.* Cambridge, MA: Harvard Business School Press.

Chapter 3

[1] Duarte, N. (2010). *Resonate: Present visual stories that transform audiences.*

[2] Tharp, T. (2003). *The creative habit: Learn it and use it for life.* New York, NY: Simon & Schuster Inc.

[3] Lupton, E., & Phillips, J.C. (2011). *Graphic design thinking.* New York, NY: Princeton Architectural Press, p. 15.

[4] Duarte, N. (2010). *Resonate: Present visual stories that transform audiences.*

[5] Ascher, S., & Pincus, E. (2013). *The filmmaker's handbook.* New York, NY: Penguin, p. 524.

[6] Booker, C. (2004). *The seven basic plots: Why we tell stories.*

[7] Lamb, N. (2014). *Story smart: Using the science of story to persuade, influence, inspire, and teach.* Santa Barbara, CA: Libraries Unlimited, p. 159–162.

[8] Ascher, S., & Pincus, E. (2013). *The filmmaker's handbook.* New York, NY: Penguin, p. 524.

[9] Lamb, N. (2014). *Story smart: Using the science of story to persuade, influence, inspire, and teach.* Santa Barbara, CA: Libraries Unlimited, p. 38.

[10] Lupton, E., & Phillips, J.C. (2011). *Graphic design thinking.* New York, NY: Princeton Architectural Press, p. 15.

[11] Lamb, N. (2014). *Story smart: Using the science of story to persuade, influence, inspire, and teach.* Santa Barbara, CA: Libraries Unlimited, p. 148.

[12] Olson, R. (2009). *Don't be such a scientist: Talking substance in the age of style.* Washington, DC: Island Press.

[13] Lamb, N. (2014). *Story smart: Using the science of story to persuade, influence, inspire, and teach.* Santa Barbara, CA: Libraries Unlimited, p. 88.

[14] Ibid., 88.

[15] Sachs, J. (2012). *Winning the story wars.* Boston, MA: Harvard Business Review Press.

[16] Ibid.,155.

[17] Lamb, N. (2014). *Story smart: Using the science of story to persuade, influence, inspire, and teach.* Santa Barbara, CA: Libraries Unlimited.

[18] Ibid.,130.

[19] Ibid., 2.

[20] Ibid., 60.

[21] Ibid., 163-164.

Chapter 4

[1] Zinsser, W. (2006). *On writing well: The classic guide to writing nonfiction.*

[2] Ibid., 84.

[3] Ibid.

[4] Ibid., 208.

[5] Ibid., 24.

[6] Ibid., 22.

[7] Ibid., 36.

[8] Ibid., 69.

[9] Eakins, P. (2005). *Writing for interior design.*

[10] Zinsser, W. (2006). *On writing well: The classic guide to writing nonfiction.*

[11] Ibid., 56.

[12] Ibid., 55.

[13] Strunk, W. & White, E. (2000). *Elements of style.* New York, NY: Pearson.

[14] Zinsser, W. (2006). *On writing well: The classic guide to writing nonfiction.*

[15] Ibid., 55.

[16] Ibid., 68.

[17] Ibid., 70.

[18] Ibid., 71.

[19] Ibid., 72.

[20] Ibid., 72.

[21] Ibid., 74.

[22] Strunk, W. & White, E. (2000). *Elements of style.* New York, NY: Pearson.

[23] Tufte, E. (2006). *Beautiful evidence.* Graphics Press, LLC: Cheshire, CT.

[24] Zinsser, W. (2006). *On writing well: The classic guide to writing nonfiction.*

[25] Tufte, E. (2006). *Beautiful evidence.* Graphics Press, LLC: Cheshire, CT, p. 142.

[26] Zinsser, W. (2006). *On writing well: The classic guide to writing nonfiction.*

Chapter 5

[1] Edward, P. *Classical rhetoric for the modern student* (4th ed.). Cambridge: Oxford University Press.

[2] Morgan, N. (2005). *Give your speech and change the world.* Cambridge, MA: Harvard Business Press.

[3] Shannon, C. & Weaver, W. (1964). *The mathematical theory of communication* (3rd ed.), Urbana, IL: University of Illinois University Press.

[4] Morgan, N. (2005). *Give your speech and change the world.* Cambridge, MA: Harvard Business Press, p. 38.

[5] Conger, J. (2008). *The necessary art of persuasion.* Cambridge, MA: Harvard Business School Publishing.

[6] Minnick, W. *The art of persuasion.* Cambridge, MA: The Riverside Press.

[7] Morgan, N. (2005). *Give your speech and change the world.* Cambridge, MA: Harvard Business Press, p. 34.

[8] Morgan, N. (2005). *Give your speech and change the world.* Cambridge MA: Harvard Business Press.

[9] Morgan, N. (2005). *Give your speech and change the world.* Cambridge, MA: Harvard Business Press, p. 40.

Chapter 5 con't.

[10] Fleming, N.D., & Mills, C. (1992). Not another inventory, rather a catalyst for reflection. *To Improve the Academy, 11,* 137–149.

[11] Morgan, N. (2003). *Give your speech and change the world.* Cambridge, MA: Harvard Business Press, p. 14.

[12] VARK Learn Limited (n.d.). VARK: A guide to learning: Retrieved from http://vark-learn.com

[13] Minnick, W. (1957). *The art of persuasion.* Cambridge, MA: The Riverside Press.

[14] Morgan, N. (2003). *Give your speech and change the world.* Cambridge, MA: Harvard Business Press, p. 88.

[15] Ibid., 44.

[16] Ibid., 90.

[17] Ibid., 92.

[18] Ibid., 95.

[19] Ibid., 95.

[20] Tannen, D. (1995). The power of talk: Who gets heard and why. *Harvard Business Review, 73*(5), 138–148.

[21] Morgan, N. (2003). *Give your speech and change the world.* Cambridge, MA: Harvard Business Press, p. 58.

[22] Ibid., 59.

[23] Williams, G.A., & Miller, R.B. (2002). Change the way you persuade. *Harvard Business Review, 80*(5), 64–73.

[24] Morgan, N. (2003). *Give your speech and change the world.* Cambridge, MA: Harvard Business Press, p. 155.

[25] Ibid., 155.

[26] Gross, T. (2015, July 23). From upspeak to vocal fry: Are we "policing" young women's voices? [Fresh Air]., NPR/WHYY-FM. Philadelphia, PA. Transcript retrieved from www.npr.org/2015/07/23/425608745

[27] Minnick, W. (1957). *The art of persuasion.* Cambridge, MA: The Riverside Press, p. 105.

[28] Cialdini, R. (2001). *The necessary art of persuasion.* Cambridge, MA: Harvard Business School Publishing.

[29] Morgan, N. (2003). *Give your speech and change the world.* Cambridge, MA: Harvard Business Press, p. 155.

[30] Hall, E.T. (1990). *The hidden dimension* (2nd ed.). New York, NY: Anchor Books.

[31] Morgan, N. (2003). *Give your speech and change the world.* Cambridge, MA: Harvard Business Press, p. 125.

[32] Reynolds, G. (2012). *Presentation zen* (2nd ed.). Berkeley, CA: New Riders.

[33] Morgan, N. (2003). *Give your speech and change the world.* Cambridge, MA: Harvard Business Press, p. 43.

[34] Minnick, W. (1957). *The art of persuasion.* Cambridge, MA: The Riverside Press, p. 87.

[35] Morgan, N. (2003). *Give your speech and change the world.* Cambridge, MA: Harvard Business Press, p. 155.

[36] Ibid., 155.

[37] Minnick, W. (1957). *The art of persuasion.* Cambridge, MA: The Riverside Press, p. 96.

[38] Duarte, N. (2010). *Resonate: Present visual stories that transform audiences.* Hoboken, NJ: John Wiley & Sons, Inc.

[39] Morgan, N. (2003). *Give your speech and change the world.* Cambridge, MA: Harvard Business Press, p. 22.

[40] Morgan, N. (2008). How to become an authentic speaker. In R. Cialdini (Ed.), *HBR's 10 must reads on communication* (pp. 105–114). Cambridge, MA: Harvard Business Review.

[41] Morgan, N. (2003). *Give your speech and change the world.* Cambridge, MA: Harvard Business Press, p. 20.

[42] Ibid., 115.

[43] Wenner, M. (2009, September). Smile! It could make you happier. *Scientific American.* Retrieved from https://www.scientificamerican.com/article/smile-it-could-make-you-happier/

[44] Morgan, N. (2003). *Give your speech and change the world.* Cambridge, MA: Harvard Business Press, p. 22.

Chapter 6

[1] Ware, C. (2012). *Information visualization: Perception for design* (3rd ed.). Amsterdam: Elsevier Inc., p. 2.

[2] Ibid.

[3] Vande Moere, A., & Purchase, H. (2011). On the role of design in information visualization. *Information Visualization, 10*(4), 356–371.

[4] British Library (n.d.). *Vitruvius's theories of beauty.* Retrieved from http://www.bl.uk/learning/cult/bodies/vitruvius/proportion.html

[5] Hrehovcsik M., & van Roessel, L. (2013). Using Vitruvius as a framework for applied game design. In Schouten B., Fedtke S., Bekker T., Schijven M., & Gekker A. (Eds.), *Games for health.* Springer Vieweg, Wiesbaden. doi:10.1007/978-3-658-02897-8_10

[6] Malamed, C. (2015). *Visual design solutions: Principles and creative inspiration for learning professionals.* Hoboken, NJ: John Wiley & Sons, Inc.

[7] Pieters, R. & Wedel, M. (2004). Attention capture and transfer in advertising: Brand, pictorial, and text-size effects. *Journal of Marketing, 68*(2), 36–50.

[8] Lazard, A. A., & Atkinson, L. (2015). Putting environmental infographics center stage: The role of visuals at the Elaboration Likelihood Model's critical point of persuasion. *Science Communication, 37*(2), 6–33. doi: 10.1177/1075547014555997

[9] Green, M. &. Myers, K. (2010). Graphic medicine: Use of comics in medical education and patient care. *British Medical Journal, 340,* 540–577, p. 540. doi: https://doi.org/10.1136/bmj.c863

[10] Avgerinou, M.D. (2009). Re-viewing visual literary in the "Bain d' Images" era. *Tech Trends: Linking Research and Practice to Improve Learning, 53*(2), 28–34.

[11] Norman, D.A. (2013). *Design of everyday things* (2nd ed.). New York, NY: Basic Books.

[12] Duarte, N. (2010). *Resonate: Present visual stories that transform audiences.* Hoboken, NJ: John Wiley and Sons, p. 107.

[13] Standing, L., Conezio, J., & Haber, R.N. (1970). Perception and memory for pictures: Single-trial learning of 2500 visual stimuli. *Psychonomic Science, 19,* 73–74. doi:10.3758/BF03337426

[14] Reynolds, G. (2012). *Presentation zen* (2nd ed.). Berkeley, CA: New Riders, p. 144.

[15] Hockley, W.E. & Bancroft, T. (2011). Extensions of the picture superiority effect in associative recognition. *Canadian Journal of Experimental Psychology, 64*(4), 236–244. doi: 10.1037/a0023796

[16] Mayer, R.E. (2009). *Multimedia learning* (2nd ed.). Cambridge, UK: Cambridge University Press.

[17] Levin, J. & Mayer, R. (1993). Understanding illustrations in text. In B. W. Britton, A. Woodward, & M. Binkley (Eds.), *Learning from textbooks* (pp. 95–113). Hillsdale, NJ.: Lawrence Erlbaum Associates Inc.

[18] Carney, R.N. & Levin, J.R. (2002). Pictorial illustrations still improve students' learning from text. *Educational Psychology Review, 14*(5). doi:10.1023/A:1013176309260

[19] Malamed, C. (2015). *Visual design solutions: Principles and creative inspiration for learning professionals.* Hoboken, NJ: John Wiley & Sons, Inc.

[20] Huber, A. (2016). Is seeing intriguing? Practitioner perceptions of research documents. *Journal of Interior Design, 41*(1), 13–32. doi:10.1111/joid.12067

[21] Tufte, E. (2001). *Visual display of quantitative information.* Graphics Press: Cheshire CT, p. 190.

[22] Roam, D. (2009). *The back of a napkin.* London, UK: Marshall Cavendish Business.

[23] Malamed, C. (2015). *Visual design solutions: Principles and creative inspiration for learning professionals.* Hoboken, NJ: John Wiley & Sons, Inc., p. 5.

[24] Ibid., 5.

[25] Roam, D. (2009). *The back of a napkin.* London, UK.: Marshall Cavendish Business, p. 37.

[26] Ware, C. (2012). *Information visualization: Perception for design* (3rd ed.). Amsterdam: Elsevier Inc., p. 9.

[27] Roam, D. (2009). *The back of a napkin.* London: Marshall Cavendish Business, p.72.

[28] Ibid., 37.

[29] Ware, C. (2012). *Information visualization: Perception for design* (3rd ed.). Amsterdam: Elsevier Inc., p. 6.

[30] Roam, D. (2009). *The back of a napkin.* London, UK: Marshall Cavendish Business, p. 14.

[31] Wileman, R. E. (1980). *Exercises in visual thinking.* New York, NY: Hasting House Publishers.

[32] Malamed, C. (2015). *Visual design solutions: Principles and creative inspiration for learning professionals.* Hoboken, NJ: John Wiley & Sons, Inc., p. 161.

Chapter 6, con't.

[22] Levin, J.R. (1981). On functions of pictures in prose. In F.J. Pirozzolo & M.C. Wittrock (Eds.), *Neuropsychological and cognitive processes in reading* (pp. 203–228). New York, NY: Academic Press.

[34] Vande Moere, A. & Purchase, H. (2011). On the role of design in information visualization. *Information Visualization, 10*...

[35] Levin, J.R. (1981). On functions of pictures in prose. In F.J. Pirozzolo & M.C. Whittrock (Eds.), *Neuropsychological and cognitive processes in reading* (pp. 203–228). New York, NY: Academic Press.

[36] ...2... *Visual design solutions: Principles and creative inspiration for learning professionals.* ...John Wiley & Sons, Inc., p. 102.

[37] Brumberger, E.R. (2003). The rhetoric of typography: The persona of typeface and text. *Technical Communication, 30*...

[38] Taylor, C., Clifford, A. & Franklin, A. (2013). Color preferences are not universal. *Journal of Experimental Psychology. 142*...

[39] Wright, B., & Rainwater, L. (1962). The meaning of color. *Journal of General Psychology, 67*,...

40 Gorn, G.C., Chattopadhyay, A., Yi, T., & Dahl, D.W. (1997). Effects of color as an executional cue in advertising: They're in the shade. *Journal of Management Sciences,* 43...400...

41 Tucker, J. (1987). Psychology of Color. *Target Marketing, 10*...

42 Valdez, P., & Mehrabian, A. (1994). Effects of color on emotions. *Journal of Experimental Psychology: General, 123*...

[43] ...2... *Visual design solutions: Principles and creative inspiration for learning professionals.* ...John Wiley & Sons, Inc., p. 140.

44 Ibid.

[45] Ciotti, G. (2016, April 13). The psychology of color in marketing and branding. *Entrepreneur.* Retrieved from https://www.entrepreneur.com/article/233843

[46] Clifford, C. (2015, December 19). What the Color of Your Logo Says About Your Company (Infographic). *Entrepreneur.* Retrieved from https://www.entrepreneur.com/article/247783

[47] ...2... *Visual design solutions: Principles and creative inspiration for learning professionals.* ...John Wiley & Sons, Inc., p. 137.

[48] Gorn, G.C., Chattopadhyay, A., Yi, T., & Dahl, D.W. (1997). Effects of color as an executional cue in advertising: They're in the shade. *Journal of Management Sciences,* 43...400...

[49] Healey, C. (1996). Choosing an effective color set. In R. Yagel & Nielson, G. M. (Eds.), *Proceedings of the 7th Conference on Visualization.* (pp. 263–270). Los Alamitos, CA.

[50] ...2... *Visual design solutions: Principles and creative inspiration for learning professionals.* ...John Wiley & Sons, Inc., p. 138.

[51] Reynolds, G. (2012). *Presentation zen* (2nd ed.). Berkeley, CA: New Riders.

[52] ...2... *Information visualization: Perception for design* (3rd ed.). Amsterdam: Elsevier Inc., p. ...

[53] Weber, A. (2016). Is seeing intriguing? Practitioner perceptions of research documents. *Journal of Interior Design, 41*(1), 13–32. doi:10.1111/joid.12067

Chapter 7

[1] Tufte, E. (2001). *Visual display of quantitative information* (2nd ed.). Graphics Press: Cheshire, CT, p. 51.

2 Evans, J. S. B. T., & Stanovich, K. (2013). Dual-process theories of high cognition: Advancing the debate. *Perspectives on Psychological Science, 8*...

[3] Heinström, J. (2006). Broad exploration or precise specificity: Two basic information seeking patterns ... *Journal of the American Society for Information Science and Technology, 57*(11), 1440–1450. doi: 10.1002/asi.20432

4 McGuinness, D. and Symonds, J. (1977). Sex differences in choice behavior: The object–person ... *Perception, 6,* ...

Chapter 7, con't.

[1] 2014. *An introduction to information design.* [e-book version]. London, UK: Laurence King Publishing. Retrieved from https://login.proxy.lib.fsu.edu/login?url=http://search.credoreference.com/content/entry/lkingid/defining_the_audience/0?institutionId=2057

[2] Ibid.

[3] Ibid.

[4] Ibid.

[5] Tufte, E.R. (2001). *Visual display of quantitative information* (2nd ed.). Graphics Press: Cheshire, CT, p. 177.

[6] Ibid., 29

[7] Tufte, E.R. (2001). *The visual display of quantitative information* (2nd ed.). Graphics Press: Cheshire, CT, p. 13.

Chapter 8

[1] Huber, A. (2017). Persuasive sway of rendering media. Paper presentation at the European Architectural Envisioning Association. Glasgow, Scotland.

Chapter 9

[1] ...ber, A. (2014). 75 million daily hits: How are design firms leveraging online video marketing? In John Turpin, Ph.D. (Ed.), *Interior Design Educators Council National Conference* ... 40...42... Interior Design Educators Council. Retrieved from http://www.idec.org/wpress/documents/Final_2014_Proceedings.pdf

[2] Ibid.

[3] Pable, J. (2012). Beyond the final studio presentation: Multimedia project storytelling as portfolio enhancement. In *Interior Design Educators Council National Conference,* Baltimore MD (pp. 388–393). Indianapolis, IN: Interior Design Educators Council.

[4] Ascher, S., & Pincus, E. (2013). *The filmmakers handbook.* New York, NY: Plume.

[5] 200... *Motion graphic design: Applied history and aesthetics* (3rd ed.). Burlington, MA: Focal Press.

[6]200... *In the blink of an eye* (2nd ed.). Los Angeles, CA: Sileman-James Press, p. 57.

[7] Ibid., 4.

[8] Ibid., 15.

[9] Ibid., 68.

[10] Ibid., 17.

[11] Tharp, T. ...200... *The creative habit: Learn it and use it for life.* New York, NY: Simon & Schuster Inc.

[12]200... *In the blink of an eye* (2nd ed.). Los Angeles, CA: Sileman-James Press.

IMAGE CREDITS

IMAGE	CREDIT
Chapter 1 Intro	RawPixel LTD-stock.adobe.com
Figure 1.0	Jacob Lund-stock.adobe.com
Figure 1.1	RaxPixel LTD-stock.adobe.com
Figure 1.2	Jacob Lund-stock.adobe.com
Figure 1.3	Amy Huber
Figure 1.4	Amy Huber
Figure 1.5	Amy Huber
Contributor/J. Pogue McClaurin	Janet Pogue/Gensler
Chapter 2 Intro	RawPixel LTD-stock.adobe.com
Figure 2.0	Erik Lam-studio.adobe.com
Figure 2.1	Amy Huber
Figure 2.2	Amy Huber
Figure 2.3	Amy Huber
Figure 2.4	Amy Huber
Contributor Photo/R. Hunn	Ron Hunn
Chapter 3 Intro	RawPixel LTD-stock.adobe.com
Figure 3.0	Amy Huber
Figure 3.1	Amy Huber
Figure 3.2	Rawpixel LTD-stock.adobe.com
Chapter 4 Intro	Rawpixel LTD-stock.adobe.com
Chapter 5 Intro	Rawpixel LTD-stock.adobe.com
Figure 5.1	Amy Huber
Figure 5.2	Amy Huber
Figure 5.3	Amy Huber
Figure 5.4	Amy Huber
Figure 5.5	Amy Huber
Figure 5.6	Amy Huber
Chapter 6 Intro	Amy Huber from Anna Osborn's work
Figure 6.0	Amy Huber
Figure 6.1	Amy Huber
Figure 6.2	Amy Huber
Figure 6.3	Amy Huber
Figure 6.4	Amy Huber
Figure 6.5	Amy Huber
Figure 6.6	Amy Huber
Figure 6.7	Amy Huber
Figure 6.8	Amy Huber
Figure 6.9	Amy Huber
Figure 6.10	Amy Huber
Figure 6.11	Amy Huber
Figure 6.12	Amy Huber
Figure 6.13	Amy Huber
Figure 6.14	Amy Huber
Figure 6.15	Amy Huber
Figure 6.16	Amy Huber
Figure 6.17	Amy Huber
Figure 6.18	Amy Huber
Figure 6.19	Amy Huber
Figure 6.20	Amy Huber
Figure 6.21	Amy Huber
Figure 6.22	Amy Huber
Figure 6.23	Amy Huber
Figure 6.24	Amy Huber
Figure 6.25	Amy Huber
Figure 6.26	Amy Huber
Contributor Photo/E. Ibsen	Erik Ibsen
Figure 6.27	Amy Huber

IMAGE	CREDIT
Chapter 7 Intro	Rawpixel LTD-stock.adobe.com
Figure 7.0 (top)	Lisa Waxman
Figure 7.0 (bottom)	Amy Huber
Figure 7.1	Amy Huber
Figure 7.2	Amy Huber
Figure 7.3	Amy Huber
Figure 7.4	Amy Huber
Figure 7.5	Amy Huber
Figure 7.6	Amy Huber
Figure 7.7	Amy Huber
Figure 7.8	Amy Huber
Figure 7.9	Amy Huber
Figure 7.10	Amy Huber
Figure 7.11	Amy Huber
Figure 7.12	Amy Huber
Chapter 8 Intro	Emily Swerdloff
Figure 8.0	Amy Huber
Figure 8.1	Amy Huber
Figure 8.2	Amy Huber/Emily Swerdloff
Figure 8.3	Amy Huber
Figure 8.4 (bottom)	Emily Swerdloff
Figure 8.5 (top)	Amy Huber
Figure 8.6 (bottom)	s4svisuals-stock.adobe.com
Figure 8.6	Amy Huber
Figure 8.7	Amy Huber
Figure 8.8	Amy Huber
Figure 8.9	Amy Huber
Figure 8.10	Amy Huber
Chapter 9 Intro	victor27-stock.adobe.com
Figure 9.0	Amy Huber
Figure 9.1	Amy Huber
Figure 9.2	Amy Huber
Figure 9.3	Amy Huber
Figure 9.4	Amy Huber
Figure 9.5	Amy Huber
Figure 9.6	Amy Huber
Figure 9.7	Amy Huber
Figure 9.8	Amy Huber
Figure 9.9	Amy Huber
Figure 9.10	Amy Huber
Figure 9.11	Amy Huber
Figure 9.12	Amy Huber
Figure 9.14	Amy Huber
Figure 9.15	Amy Huber
Figure 9.16	Amy Huber
Figure 9.17	Amy Huber
Figure 9.18	Amy Huber
Figure 9.19	Amy Huber
Contributor Photo/A Tully	Annette Tulley
Appendix A	Merijar-adobe.stock.com
Author's Image	Christine Titus

INDEX

"S"tory Development, 43–44
"I have a dream," 76
1-point Perspective, 162
2-point Perspective, 162
3-point Lighting Scheme, 189
3-point perspective, 162
4D Depictions, 165
6 E's of Info. Engagement, 104–105
7 Basic Plots, 44

A
Accumulated Experience, 78
Active Voice, 61
Additive Making, 159
Adject...
Agent of Authenticity, 9
Ad-libbing, 176
Advantage-Disadvan. Sequence, 42
Adverbs, 68
Affective Primer, 4
Aiding Recall, 51
Alignment, 113
Ambiguity, 60
Analogous Palette, 120
Ancient Greece, 75, 89
Anecdote, 81
Annotation, 136
Antagonist, 14
Aperture, 203
Appositives, 69
Approaching Information, 132
Arbitrary Cues, 107
Archetype(s), 47
Aristotle, 27
Assets (Video), 185
Attentive Storyteller, 22
Attraction & Persuasion, 102
Attractiveness, Soundness, Utility, 102
Attributing Quotes, 69
Audience, 24
 Characteristics, 25
 Contextual Information, 25
 Demographics, 25
 Motivations, 25
 Psychographics, 25
 Rewards, 26
 Segmentation, 24
Audience-focused, 22
Audio Capture, 178
Augmented Reality, 160
Aural, Preference, 81, 83–85
Authoritative Arc, 88

B
Back Light, 189
Back Lighting, 187
Booker's Seven Basic Plots, 44
Brand Identity, 125
Buzz Words, 62

C
Camera Angle, 182
Camera Distance, 181
Camera Lens, 181
Camera Orientation, 182
Captain (Archetype), 47
Causal Reasoning, 7
Cause-effect Sequence, 42
Changes to Time (Video), 183
Changing Camera Position, 183
Character Types, 46
 Fictionalized, 46
 Prototypical, 46
 Real, 46
Collaboration, 52
Color Connotations, 119
Color Filters & Gels, 179
Color Palette Resources, 120
Color Palette, 120
Color Perceptions, 119
Color Temperature, 187
Color, Psychology of, 119
Complementary Palette, 120
Compositional Cues, 107
Conceptual Drawings, 154–155
Conflict, 12
Contextual Labeling, 122
Continuity Editing, 195
Contractions, 69
Conviction, 88
Coordinating Conjunctions, 69
Correlative Expressions, 49
Cortisol, 8
Creative Brief, 29
Creative Process, 20
Cron, Lisa, 7, 12,
Cues (Arbitrary vs. Sensory), 107

D

Data, 134
Data of Magnitude, 138
Data Visualization, 116
Defender (Archetype), 47
Design Communication Tactics, 4
Design Concept Statements, 65
Design Criteria Diagram, 136, 142
Design Presentation Areas of Focus, 34
Designing the Story, 40
Desirable Sounds, 190
Details, Event Specific, 48
Details, Scenic, 48
Details, Sensory, 48
Developing, 106
Diagram(s) 136–145, 152–153
Diagram Creation, 145
Diagrams, Outcomes, 152–153
Dictation, 87
Digitize, 153
Directional Mics, 186
Discontinuity, 194
Display Type, 118
Distance, 76
Distorting Messages, 78
Doers (Audience), 24
Dolly, 179, 183
Dopamine, 8
Dress Rehearsal, 92, 94
Drones, 179
Dry Media, 164
Duarte, Nancy, 24, 38

E

Editing (Story), 42–43
Editing (Writing), 70
Editing (Video), 193–198
Editing Video, Steps, 194
Elements of Good Writing, 59
Elevation Oblique, 161
Elevator Pitch, 80
Empowerment Marketing, 10
Environmental Information Design, 135

Evolution of Speaking, 76
Exclamation Point, 68

Exploded View, 161
Expressing Ideas, 150

F

Fictional Stories, 6
File Type, 185
Fill Light, 187, 189
Filming an Interview, 184

Finale, The, 82
Finding Your Confidence, 92

Flow Lines, 112

Considerations, 118

Four-Dimensional Depictions, 165

Frame Rate, 185
Frames of Reference, 78
Framing the Problem, 20

Front Lighting, 188
Full Side Light, 188

G

Gestures
GIFs, 163
Glyph, 117
Golden Ratio, 112
Gossip, 6
Grid, 112

H

Haptic, 160
Hardware, Digital Editing, 194

Haven's Story Types, 44

Heuristics, 132

Hunn, Ron, 29

I

Ibsen,
Icon, 108
Idea Generation, 20
Idea Generators (Audience), 24
Ideas for Writing, 70
Idioms, 62, 63
If, Then, Therefore, 7
Imagining, 106, 108
Inadequacy Marketing, 10
Inbetweening, 192
Index (Semiotics), 108
Influence of Rendering Style, 151
Influencers (Audience), 24
Information Design, 132–133
Information Significance Sequence, 41
Interactive Media, 110, 135
Intercutting, 194
Internal Noise Sources, 91
Intimate Space, 89
Inverted Text, 121
Isometric(s), 161

J

Jester (Archeytpe), 47
Jib Arm, 179
Job Interviews, 96

K

Key Light, 189
Kinesthetic Preference, 81, 83–85

L

Launch, 13, 45, 58
Lavalier Mics, 186
Leading Lines, 181
Leading, 115
Lighting, 177–178, 182, 187-189
Light, Direction, 188
Lighting Scheme, 3-point, 189
Lighting Scheme, Single Fixture, 188
Lighting, Color Temperature, 187
Lighting, Types, 187
Lincoln, Abraham, 76
Line Weights, 157
Linear Sequence (Video), 175
Live-action, 174, 177, 189
Load, 13, 48, 58
Location Diagram, 140
Logline, 173–174
Logo, 125-127
Logos (Appeal), 27
Long Shots, 180
Longitudinal, 141

M

Magician (Archetype), 47
Martin Luther King, 76
Maslow, Abraham, 11
Micro Reading, 134
Modifiers, 60
Monochromatic Palette, 120
Motion Graphic, 174, 191–192
Motion Graphic, Production 191
Muse (Archeytpe), 47

N

Negative Facial Expressions, 90
NLE Programs, 195
 Graphic, 113
 Inattentive, 91
 Semantic, 91
Non-linear Sequence (Video), 175
Non-Restrictive Clauses, 69
Norman, Donald, 103

O

Olson, R
Open Type, 118
Organizational Info. Diagram, 136, 140
Organizing Graphic Real Estate, 111
Orientating the Audience, 123
Orthographic Drawings, 156–157
Orthographic Views, 156

P

Pan (Camera), 183
Paper, 164
Parable, 81
Paragraph Linking Strategies, 64
Paragraphs, 64
Parallel Construction, 60
Parallel Projection, 161
Parenthetical Expressions, 69
Parti Model, 159
Passive Voice, 61
Pathos, 27
Period, 68
Personal Space, 89
Perspectives, 162
Persuasion, 78–79
Persuasive Appeals, 27–28
Physical Models, 110
Picture Superiority Effect, 103
Pioneer (Archetype), 47
Pitch, 88
Plan Oblique, 161
Plot, 12
Podium, 89
Pogue McClaurin, Janet, 15
Point of View, 34–35
Positive Facial Expressions, 90
Positive Tone, 49
Post-production, 172, 193–197
Posture, 90
Preparation, 92
Preparing for an Interview, 184
Prepping Talent, 184
Pre-production, 172–184
Presentation Design, 34
Presentation Goals, 77
Presentation Stages, 82
Presenter-focused, 22
Pre-television vs. Post-television, 76
Print Media, 110, 135
Prior Knowledge, 45
Problem, The, 82
Problem-solution Sequence, 41
Process Diagram, 136–137
Production (Video), 172, 185–193
Progressive Disclosure, 12
Project Summary, 34, 36
Project/Position Pitch, 34, 37
Pronouns, 60
Protagonist, 14
Prototype, 159
Proxemics, 89
Public Space, 89
Public Speaking, 75, 77
Pull-out Quote, 117
Pull-out Text, 117
Punctuation, 63, 68

Q
Q&A, 86
Qualifiers, 87
Qualitative Data, 136
Quantitative Data, 136
Questions about the Audience, 92

R
Raster, 108
Read/Write Preference, 81, 83–85
Rebel (Archetype), 47
Receiver, 77
Reciprocity, 6
Reflecting, 20
Rehearsals That Don't Count, 94
Rehearsing, 92–94
Relevance, 79
Rendering, 164
Rendering Tools, 164
Repetition, 87
Representational Styles, 109
Residual Resolution Emotion, 49
Resolution/Size, 186
Rewriting, 70
RFID, 165
RGB, 121
Rhythm, 64
Roam, Daniel, 106
Role of Video in Design, 170
Room Quadrants, 89
Room Tone, 190
Rough Cut, 194, 196
Rule of Thirds, 112, 181

S
Sach's Character Types, 47
Scaffolding, 103
Scene Composition, 181
Scotto di Carlo, Giuseppina, 28
Scouting Locations, 177
Screen-based Presentations, 110, 135
Screening, Video, 197
Section Oblique, 163
Section Perspective, 163
Securing Attention, 79
Seeking Inspiration, 38
Semiotics, 108
Sensory Vs. Arbitrary Cues, 107
Sequence (Video), 175
Sequential Sequence, 40
Shared Understanding, 22

Slide Decks, 122
Social Space, 89 Software, Digital Video Editing, 194 Software,
Motion Graphic, 193
Solution, 20, 82
Sound, Video, 190
Spatial Sequence, 41
Speaker Triggers, 122
Special Presentation Types, 96
Split Complementary Palette, 120
Stakeholder Criteria Diagram, 136, 139
Story for Organizing Information, 7
Story for Social Connections, 6
Subtractive Making, 159
Suggestions Diagram, 136, 143
Suppliers (Audience), 24

T
Table Read, 176
Tannen, Deborah, 87
Technical Issues of Filming, 185–186
TED Talks, 28
Testing and Refining, 20
Things to Avoid in Storytelling, 51
Tilt (Camera), 183
Timeline, 194
Timing, 87
Tone & Timing, Rehearsal, 92, 93
Tone, 28, 29,
Tone (color), 121
Tone, in
 Conceptual Imagery, 155
 Typology, 116
 Visual Messages, 150
 Video 172–174, 192, 194
 Writing, 58, 59, 61, 67
Tools & Transitions, Rehearsal, 92, 93
Tools of Emphasis, 111
Top Lighting, 188
Topic Sentence, 64
Tracking, 117
Transitions, Video, 197
Trends Diagram, 136, 141
Tripod, 178
Tufte, Edward, 69, 132–134
Tully, Annette, 198
Typeface, 117
Types of Audience change, 24
Typology, 116

U
Under
Undesirable Sounds, 186
Universal Truths, 23, 76, 82, 97, 107, 173
Up Lighting, 188

V

Values Types, 11
Values, 10
Vanishing Point, 162
VARK, 81
Vector, 108
Venues for Design Writing, 65
Verbs, 68
Video Capture, 178
Video Conferencing, 97
Video Work Flow,
Video, 110, 135, 169–199
Virtual Modeling, 160
Virtual Reality, 160
Visual Brain Dumping, 39
Visual Hierarchy, 111
Visual Messages, 101–102
Visual Thinking, 106
Visual, Preference, 81, 83-85
Vitruvius, 102
Voice (Writing), 61
Voice, 88
Voice-over, 185
Volume, 76

W

Wide Angles, 180
Word Length, 62
Word Rhythm, 62
Word Selection, 62
Word to Image Relationship, 116

Z

Zinsser, William, 58, 59, 60, 61, 64, 68,
Zoom (Camera), 183

Printed in Great Britain
by Amazon